THE ART OF
BEATRIX POTTER

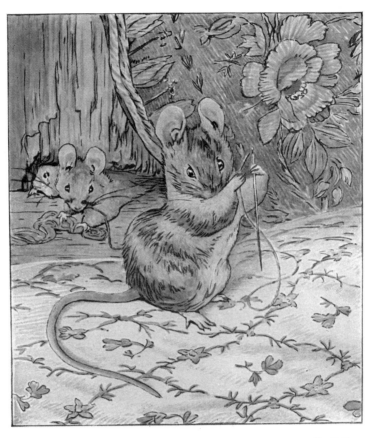

'One-and-twenty button-holes — and who should come
to sew them'

THE ART
OF
BEATRIX POTTER

With an Appreciation by Anne Carroll Moore
and Notes to each Section by
Enid and Leslie Linder

FREDERICK WARNE & CO LTD · London
FREDERICK WARNE & CO INC · New York

Direct reproductions of Beatrix Potter's preliminary studies and finished drawings, selected and arranged by L. LINDER and W. A. HERRING

LIBRARY OF CONGRESS CATALOG CARD
NO 78-81149

ISBN 0 7232 1457 3

Printed in Great Britain by W. S. Cowell Ltd, Ipswich

1510.776

ACKNOWLEDGEMENTS

For the very full representation of the drawings in colour and monochrome of the late Beatrix Potter, the Publishers are greatly indebted to members of her family and friends who have made possible the reproduction of so many examples of this Artist's work, showing her great versatility.

Special thanks are due to the Executors of the late Mrs. W. Heelis (Beatrix Potter) for permission to reproduce her drawings and manuscript. Thanks are due to Capt. K. W. G. Duke, R.N., and Mrs. Duke for allowing access to a number of portfolios from which many of these pictures have been selected. We are indebted to the Tate Gallery for the loan of examples of her pictures from *The Tailor of Gloucester* now in their possession.

To the Armitt Library of Ambleside, the Publishers acknowledge the loan of examples of the Artist's drawings of Fungi.

The Publishers are also grateful to Mr. L. Linder who has loaned a number of the original drawings, and who has produced the photographs of Hill Top and Sawrey, the places associated with Beatrix Potter's life and her books.

From Mr. C. H. D. Acland of the National Trust, Messrs. E. and E. A. Heelis, Mrs. Ludbrook, Mrs. W. F. Gaddum, and Mr. W. A. Herring (who had been closely associated with the production of her books from the beginning), and others, much help and information has been received and is greatly appreciated.

PUBLISHERS' NOTE

As Beatrix Potter's picture letters, miniature letters and manuscripts have been fully dealt with in *A History of the Writings of Beatrix Potter*, these items have been omitted from this revised edition of *The Art of Beatrix Potter*.

Reproductions of many new drawings and paintings have been added, together with descriptive notes to each section; also a brief account of Beatrix Potter's development as an artist.

It is hoped that this revised and enlarged edition will be of interest to all admirers of Beatrix Potter and her work.

<div align="right">July, 1972</div>

CONTENTS

PART ONE
BEATRIX POTTER – HER WORK
AS AN ARTIST

PART TWO
BEATRIX POTTER – HER ART
IN RELATION TO HER BOOKS

AN APPRECIATION

The Art of Beatrix Potter is a revelation of the hidden sources of her power as a creator of children's books of great originality and timeless value.

The living truth is here because her art is true and the selection and arrangement of the drawings permit the artist to tell her own story in line, colour and form with a reality far more convincing than the words of any writer.

It is the gift of a good book about a real person to stimulate the desire to know more. No doubt Margaret Lane's biography, *The Tale of Beatrix Potter*, with its delightful illustrations from many photographs of the artist as a child, at seventeen, in middle age and old age – and its revealing glimpses of a strong personality, may have led Mr Leslie Linder and Mr W. A. Herring to explore the familiar as well as the unpublished work of Beatrix Potter which lends peculiar distinction to this book. They have done so with a sure instinct for art values and an imaginative understanding of the self-development of an artist who went straight to the natural world for inspiration and to children for an appreciation of her art.

The arrangement of these direct reproductions of preliminary studies and finished drawings is by groups indicative of Beatrix Potter's strongest interests during the years she was growing up and in the period preceding the publication of her books. It is a singularly happy arrangement for it focuses attention on the artist's own approach to her work and the infinite pains she took to achieve such mastery of subject as may be found under the group headings of Houses, and Village Scenes, Interiors, Microscopic Work, Fungi, etc., of Part 1.

Although Beatrix Potter had been drawing and painting from early childhood, her first efforts were in copying pictures of birds, butterflies and animals from books with colour plates of natural history. With her discovery of the natural world during northern holidays came the desire to give expression to what she saw so clearly in flower, animal and landscape. It was then that learning how to draw became important to her and her signature takes on significance. The flower

drawing on page 14 signed and dated at the age of nine and the landscape in pencil showing exceptional talent at eleven are of especial interest since she began signing her drawings with her full name or with the initials H. B. P. when she was about nine years old.

Born in London on July 28, 1866, Beatrix Potter never went to school but was taught at home by governesses under whose sympathetic guidance during her teens the drawings reproduced here under the heading of Early Work were done. Shortly before her fifteenth birthday she received an Art Student's Certificate from the Science and Art Department of the Committee of Council on Education. This certificate, dated July 1, 1881, certifies that in freehand drawing, practical geometry, linear perspective and model drawing Helen B. Potter was of Second Grade.

From that time onward she seems to have kept on drawing whatever interested her wherever she was, investing each subject with reality. The power to give life, colour and texture to the inanimate is found to be increasingly pronounced throughout this period.

The selective skill and the grouping by subject which give form, coherence and cumulative interest to the first part of this book which adds a new dimension to the name of Beatrix Potter is fully sustained in the second part – Her Art in Relation to Her Books. Here under Imaginary Happenings in the Animal World, we find such enchanting fantasies as the Rabbits' Christmas Party, the Christmas Dinner (for Mice), the Guinea Pigs Go Gardening.

Beatrix Potter at play with rabbits, mice and guinea pigs begins also to play with ideas for illustrated books. Three Little Mice Sat Down to Spin, and a series of drawings for Uncle Remus appear among others under Early Ideas for Illustrated Books.

Picture-Letters, to which the origin of her own writing and illustrating for children may be directly traced, give an insight into Beatrix Potter's treatment from an idea to the finished book. Her search for the right word was as carefully determined as her choice of the right sketch to put into each picture.

Derwentwater is the setting for *Squirrel Nutkin* and the two background water-colours, on pages 285 and 286, were taken from a

sketchbook in which all the Nutkin scenery is recorded. The original Squirrel Nutkin Story-Letter was sent to Noah Moore.*

Norah's sister, Freda, was the happy recipient of *The Tailor of Gloucester*. The story was written in a stout exercise book, with the water-colour paintings pasted in, and sent with a letter of dedication which appeared in the published book in 1903. Since of all her books *The Tailor of Gloucester* was Beatrix Potter's favourite and contains some of her best work, the frontispiece of this book has been chosen from it.

Her books are presented in the order of their publication. With the reproductions from the original full scale drawings are shown also duplicate originals which were not used and many preliminary studies of exceptional interest. The reproduction from original drawings for her books, most important in their restoration of full colour values, are all significant in tracing a detail of background or incident to a sketch or a drawing made years before the picture for a particular book was painted.

To those who have known Beatrix Potter's books from childhood and have shared them with children, turning these pages becomes a veritable treasure hunt for the familiar and a fresh discovery of the artist herself.

For the young artist and designer of picture books *The Art of Beatrix Potter* is an inexhaustible source of inspiration and a constant reminder of the good draughtsmanship she admired and insisted upon.

'Illustrators soon begin to go down hill,' she wrote to her publishers in reply to a suggestion that she might illustrate other work than her own. 'I will stick to doing as many as I can of my own books.'

Since it was Mr Herring who saw every one of the Beatrix Potter books through the press, it is most fortunate that his judgement and experience in the reproduction of her published work could be extended also to the hitherto unpublished work of this volume. I met Mr Herring for the first time at the offices of Frederick Warne & Co. in London,

* Reproductions of many of Beatrix Potter's picture-letters, including the Squirrel Nutkin story-letter are included in *A History of the Writings of Beatrix Potter* by L. Linder, F. Warne & Co. Ltd, 1971.

in 1921. He was then seeing through the press a very beautiful book, *Kate Greenaway's Pictures* from originals presented by her to her friends. Later I was to learn from Leslie Brooke of the fine understanding and technical skill Mr Herring had given to his picture books during the many years of Mr Brooke's association with the House of Warne.

The series of excellent photographs which form the final section of *The Art of Beatrix Potter* were taken by Mr Linder during the preparation of this volume which reflects his especial interest in books for young children and his admiration for an artist whose work he has studied intensively and felt a strong desire to preserve. Scenes made familiar by Jemima Puddle-duck, Tom Kitten, Duchess of *The Pie and the Patty-pan,* and *The Roly-Poly Pudding* will be recognised in the photographs by those familiar with the pictures in the books.

For those who know and love the Lake Country the views of Hill Top and the surrounding countryside are a reminder of its quiet beauty and its hold on mind and heart. For those who have yet to discover the Lake District they provide a strong incentive for a rewarding pilgrimage to the home Beatrix Potter made for herself in the village of Near Sawrey.

'My brother and I were born in London,' she once wrote, 'but our descent, our interest and joy were all in the north country.' Here the happiest years of her life were spent and when she died on December 22, 1943, as the wife of William Heelis, Hill Top Farm House with all the treasures she had so lovingly placed in it over the years was left to the National Trust of the United Kingdom with explicit directions for its arrangement and perpetual care.

Mr Linder and Mr Herring have not only paid a worthy tribute to Beatrix Potter as an artist, they have also added a record of compelling interest to children's books of the twentieth century. Whenever possible they have illuminated the record by reproduction of Beatrix Potter's comment in her own handwriting and by identification of the place where, and the date when, a drawing was made.

Since this record is also one of peculiar interest to American readers who have grown up with a sense of the importance of the continuity of English literature and art for children no less than for

adult readers I have ventured to tell my own story of Beatrix Potter.

My story begins with the discovery of *The Tailor of Gloucester* among the new children's books sent over from London to an American children's library at Christmas-time 1903.

Far and few were the new books for little children at the turn of the century. Here was one of such exceptional quality and charm that it could be shared on equal terms with the head of the art department, with which this children's library was vitally connected, and the children to whom I first read it aloud in the children's room of the Pratt Institute Free Library in Brooklyn, New York. I have continued to read it every Christmas since then and it has lost none of its freshness as a work of art or as a Christmas story.

Enjoyment of books within the library itself was one of the main features of this children's library. The freedom from any restriction of age or custom gave parents as well as young children a natural free access to books in a homelike setting.

A children's library was a new idea and picture books played a major role in its development. The best ones obtainable from England, France and Germany were chosen to provide standards of excellence in art and incentives to the love of reading. Picture books which had hitherto been regarded as luxuries for those who could afford to buy them for their children were now seen to come alive in the same way in the hands of children from bookless homes and it became a thrilling experience to learn to see in a book what a child sees, regardless of his home environment.

I have always been glad that my own first impressions of Beatrix Potter as an artist were taken from *The Tailor of Gloucester* and from *Squirrel Nutkin*, published in the same year, rather than from *Peter Rabbit*. The individuality of character and setting of each little book remains clearer in mind in consequence and the value of her contribution to children's books, as her own direct communication of the natural world to children, more fully appreciated. To me they have always been Beatrix Potter's books rather than the Peter Rabbit books.

First visual impressions haunt the memory. I met Peter Rabbit for the first time in a hideous pirated American edition bearing all the

stigmata of the new comic strip that was filling the vacuum before American publishers began to give any attention to the production of children's books as works of art. Peter Rabbit lent himself so readily to imitation, caricature and exploitation as a comic character as to obscure his importance to an educational world in which nature and art had been dead for a very long time. The important thing about Peter Rabbit was that he was alive and true to the nature of a rabbit, as was quickly recognised by the children as soon as the authorised English edition with Beatrix Potter's own pictures took its place in their library. Children who had never read before burst into reading as they turned the pages just as they did in hundreds of American homes where Peter Rabbit was taken to bed every night.

From the intimacy of daily association with children and their books in Brooklyn I went to New York, at the height of a fresh tide of immigration, to offer a similar natural free access to books, without age limit, in the children's rooms of The New York Public Library and its many branches. These were largely in foreign neighbourhoods but my confidence in picture books as first aids in creating a spontaneous desire to read was now firmly established. Picture books were indispensable.

With the opening of its impressive central building in 1911 the selection of picture books in the children's reading room attracted international interest, and the American children's library came to be regarded as 'a new idea in education' for other countries. The first European library for children was opened in Stockholm the same year.

The First World War brought a shortage of picture books which called for serious measures of conservation on the part of the library. Children must not be deprived of enjoyment of the books but the life of each book must be prolonged by loving care and a renewed sense of its value on the part of everybody. The response of children and librarians was a wonderful tribute to the books of Caldecott, Kate Greenaway, Leslie Brooke and Beatrix Potter.

At the end of the war no visitor was more welcome than Mr Fruing Warne, of Frederick Warne and Company, who came straight from the ship to the library and who brought good news of the reprinting of old favourites and the promise of new books from Beatrix Potter

and Leslie Brooke. Then he told me that Beatrix Potter lived in the Lake District and that the illustrations for several of her books were from familiar scenes near her home, that the animals were all from living models – many of them her pets.

But when I asked where Beatrix Potter lived in the Lake District, Mr Warne said that her publishers could give no personal information about her. 'She is very averse to publicity of any kind,' he said. 'She is married now but continues to use her own name for her books. They have been remarkably successful. She has bought a farm from the royalties of *Peter Rabbit* and others.' Mr Warne had given me the first clue to the mystery of Beatrix Potter.

A year later I paid a return visit to Mr Warne in Bedford Court, where he proved as gracious a host in London as he had been a visitor in New York, taking me behind the scenes to see new books in the making and to the shipping department to discover *Peter Rabbit* and *Benjamin Bunny* in French.

I had just come from searching the bookshops of Paris for picture books for the children's libraries which had been opened in wooden *baraques* on the ruins of homes and schools in northern France. Picture books, good picture books, seemed more important than ever before and translations of those with universal appeal an imperative need of the time. That Beatrix Potter's publishers were recognising the importance of her work by translation was good news. Since *Pierre Lapin* and *Jeannot Lapin* were not yet available in France, I had the pleasure of ordering fifty copies to be sent to La Bibliothéque Populaire de Soissons, knowing well with what joy they would be received in the villages which were then being served by that library with the assistance of an American committee.

Before leaving Mr Warne's office I told him that I was to spend the next fortnight in Grasmere and that I wished to write to Beatrix Potter from there introducing myself. 'I can only wish you luck,' Mr Warne said but he gave me a slip of paper on which he had written Mrs William Heelis, Sawrey, Ambleside. From the Moss Grove at Grasmere I wrote Mrs Heelis a letter telling her of American children and French children and their love of picture books. I told her of my delight in

finding *Pierre Lapin* and *Jeannot Lapin* in London and I spoke of some beautiful photographs of French children and their grandmothers looking at picture books together. Would she like to see the pictures? By return came the following letter:

June 24, 1921

Dear Miss Moore,

We shall be very glad to see you. Can you come for lunch on Monday? It is not a long notice but a pity to miss fine weather and we have not much hay cut at present. I wonder how you will get here? [Two pages of explicit directions follow with an offer to send to the Ferry should I choose to come by boat.]

Excuse a scribble, I have just come out of the hay. It is uncommonly warm.

Yours sincerely,
Beatrix Heelis

I like the French translations, it is like reading someone else's book – refreshing!

On that beautiful June morning I chose to walk up the long hill leading from the Ferry to the village of Sawrey. Wild roses were blooming in the hedgerows and the air was fragrant with new-mown hay. And suddenly, just as I had hoped she might, Beatrix Heelis came 'out of the hay' to greet me, looking for all the world as Beatrix Potter should look. She was wearing a broad-brimmed straw hat and she carried a rake in her hand. On her feet were Lancashire clogs with buckles. Her sturdy figure was dressed for the hay field and not for company. Her bright blue eyes sparkled with merriment and her smile was that of a child who shares a secret, as indeed she did. She spoke with the tang of the north country. No welcome could have been more cordial than hers to Hill Top Farm. Beatrix Heelis was in the mid-fifties at that time but her cheeks were as rosy as those of a young girl and her eyes as clear and expectant.

Long before we came to the top of the lane leading to Castle Cottage I felt as if I had known her always. The familiar flower garden of her picture books tempted us to linger there, for the foxgloves were in their glory. 'But it's time for lunch,' said my hostess. 'Mr Heelis likes to be on time.' William Heelis, tall and gentle in manner, with the ease of a man who belonged to that countryside, had just come

from his law office in Ambleside.

I have no recollection of anything we ate or talked about at that mid-day meal but I was conscious of a fine reserve of quiet humour on the part of Mr Heelis. He showed no surprise, but looked amused, when his wife turned to me with an expectant look and said, 'If Mr Heelis would drive you to Bowness afterward, couldn't you stay on for tea? It would give more time to look about.' I needed no urging to 'stay on.'

Looking about began with feeding Emily and Tapioca, leaders of a large family of turkeys, descendants of Charles the rooster, Pigling Bland and others. It meant seeing Hill Top Farm as Jemima Puddle-duck and Tom Kitten saw it.

Fascinating as it was to follow the farmyard trails with Beatrix Potter herself, the best was yet to come when from her study in Castle Cottage she brought out one portfolio after another and left me free to browse at will among the pencil sketches, pen and ink drawings, the crayons, the water-colours from which the pictures in her books had grown. 'I can see that you are enjoying yourself,' she said. 'My portfolios are not in order but I can always find what I'm looking for when I need it. You may choose any one you think your children in New York would like.'

When I chose a small water-colour of rabbits playing in the snow with their sleds, Beatrix Potter was reminded of sitting out in the scorching summer sunshine painting snow scenes for *The Tailor of Gloucester*. I was absorbed in a portfolio of wild flowers – bluebells, primroses, daisies – when my hostess left me for an hour. When she came back she brought a portfolio of the fungi drawings. 'I know these are good,' she said quietly. 'I made a great many of them, hoping they might illustrate a book I was not qualified to write. It needed a scientist. Some of the funguses are very rare. They made a fascinating study for a number of years. My eyes no longer permit me to do such fine work. I did enjoy finding them and painting them and they give me pleasure whenever I take time to look at them and recall the places they came from. The drawings fill seven portfolios and were done years before any of my books for children.'

Admiration for the exquisite water-colours, revealing the eye of the naturalist for each individual species and the feeling of the artist for the beauty and faery-like quality of the subject, led me to ask if she had ever exhibited her work. 'No,' Beatrix Potter replied. 'I have never cared to exhibit my work. Very few people have ever seen the funguses. I am happy to know that you appreciate them.' There was barely time to visit the dairy and watch Beatrix Heelis skim rich yellow cream for the strawberries which lent colour and fragrance to our tea. Nowhere out of the Lake District would one find such a tea.

Behind the tea-pot, with Mr Heelis across the table, Beatrix Heelis turned to me, eyes sparkling with fun, and whispered, 'If you had a nightie and toothbrush, couldn't you stay all night?' Still dazed by all I'd seen that afternoon, I suddenly realised that the visit had turned into an adventure for Beatrix Potter herself as well as for me. I looked in vain for some sign of dissent or disapproval from Mr Heelis who must have heard the whisper. 'I think the nicest way of having company is to ask them to stay on after they come instead of before,' Mrs Heelis continued. 'You haven't seen the half of Hill Top and I want to look at the French pictures again and hear more about the New York children. Please stay with us.'

Who could resist such an invitation? As we rose from the tea-table it was Beatrix Potter who handed me a huge door key. The key to her own Hill Top Farm House. 'Now, run on down the lane and unlock the door and *rummage* to your heart's content and you'll be able to tell the children in New York that you've seen every nook and corner of Tom Kitten's House. You'll not be disturbed by any of Samuel Whiskers' relations. Enjoy yourself!'

And so I entered Hill Top Farm House alone and found it exactly as it is pictured in *The Roly-Poly Pudding* – the kitchen chimney up which Tom Kitten jumped, the cupboard where Moppet and Mittens were shut, the staircase on which Mrs Tabitha Twitchit pattered up and down, the very same carpet and curtains, the mysterious attic where Ribby and Tabitha heard the roly-poly noise. I opened doors, peeked into cupboards and chests until I began to hear roly-poly noises myself. Then it was I discovered one after another the things Beatrix

Potter had put into other books, the clock on the staircase, a chair in *The Tailor of Gloucester*, the very teacups the mice had peeped out from under, a wonderful old dresser. I explored the house all over again for signs of her own daily life there before she became Beatrix Heelis, and the house responded, as old houses will sometimes when one is quite alone and receptive.

As I locked the door and stepped into the lane, it was not of 'Samuel Whiskers and his wife on the run with the wheel-barrow,' I was thinking but of Beatrix Potter herself. She seemed as completely identified with the old house as with the pictures I had seen in the portfolios. In giving me freedom to explore both myself, she had given me friendship and trust.

We took a long walk with Mr Heelis after that and watched the sun go down behind the Langdales from the top of the hill. Then back to Castle Cottage for a hot supper cooked by Beatrix Heelis herself.

The photographs of French children and their grandmothers enjoying pictures together led to many questions. Beatrix Potter had never been in France. 'I've never been out of the British Isles,' she said. When I told her of the old women I had seen who had chosen to live on in the ruins of their homes on their own land rather than take shelter with relatives or friends in the city, she exclaimed, 'That is just what I should do if my home was destroyed – stay on the land.'

Pictures of children looking at picture books, pictures of children listening to stories in France or in New York libraries, pictures of children making their own free choice of books from the shelves of public libraries excited her interest and wonder as something new and strange.

We visited the 'Ginger and Pickles' shop together next morning and before I went on my way we stopped at Hill Top Farm House where Beatrix Heelis inscribed a copy of *The Roly-Poly Pudding* with my name 'from "Beatrix Potter" in remembrance of Hill Top Farm, Sawrey, June 27, 1921.' It is the edition of larger size in which the book was first published.

'You will always be welcome at Hill Top whenever you come to England,' she said, 'and you may send any of the storytellers in your

children's libraries. I know they would be coming for the sake of the children and not out of mere curiosity.'

It was in May 1937, after the Coronation celebrations in London, that I came to Hill Top again for a visit as memorable as, but entirely different from, the first round-the-clock one of 1921.

'It will be a pleasure and an interesting event to see you again,' Beatrix Heelis had written on May 4th. 'I wish you had been here this week – the country has been looking so lovely – cherry blossom, whitethorn, damson all out in bloom together. . . . The bluebells will be out next week. . . . The hawthorns will be very fine; buds just showing. I will show you the Troutbeck woods if we have time. . . . I can send to meet the 5.15 at Windermere an old-fashioned black and green Talbot saloon and an aged chauffeur. We hope for a very fine pleasant visit this time.'

Whoever knows England at Coronation time will recall the after-glow of the great day in the villages. It still lingered in Sawrey. Beatrix Heelis, radiant at seventy, welcomed me in holiday mood. This time she came out of her Pringle Wood to tell me the bluebells were in bloom. The hedgerows were white with hawthorn, lilacs scented the air, and every garden in the village was bright with tulips and late daffodils.

There was much to talk about during the long first evening. Our sixteen-year-old friendship had been kept warm by exchange of letters and books at Christmas-time and at other times. Beatrix Heelis had bought one farm after another beyond the boundaries of Hill Top during those years. She had become a widely respected and honoured sheep farmer of the north country. Had her interest in Herdwick sheep completely absorbed Beatrix Potter the creative artist? If her letters had left a doubt it would have been dispelled by the talk of this evening and of days that followed.

'I want to show you the farms which have the most beautiful views,' she said. 'We'll take a drive every morning, rain or shine.' And so to Skelwith, Coniston, Little Langdale we were driven by the aged chauffeur who sat patiently waiting while we looked about old farms and cottages which seemed a part of the landscape.

The high point for me on that wonderful guided tour of the Lake

District was reached at Troutbeck Park Farm where a sheep shearing was going on outside and a knot of shepherds had gathered from neighbouring farms. Mrs Heelis regarded her sheep with an appraising eye to their condition after a hard winter. Few words were spoken but she exchanged greetings with each one of the shepherds and mingled with them to watch the shearing.

Inside the Shepherd's cottage, high above the old-fashioned open cooking stove, hung a very large oil painting of sheep in the Scottish Highlands. 'It is one of my brother's paintings,' said Beatrix Heelis, 'It was too large for the room I set apart at Hill Top for his pictures. The Shepherd's wife seems to enjoy having it here. She says it gives her a lift to look as far as Scotland when she feels she has too much to do.'

When I spoke of a fine old chest in another room of the cottage, Beatrix Heelis gave it a loving pat. 'I cannot resist the old oak cupboards and chests at an auction so I buy them and fit them in wherever I can.'

Troutbeck Park Farm stands at the head of the long curving Troutbeck Valley. Beyond it tower High Street and Ill Bell. I had often passed the lonely farm on my walks on the fells in the summer of 1906, the very summer Beatrix Potter was getting Hill Top Farm House ready to live in.

At the other end of the Valley stands Town End, the house of an old statesman family, handed down from father to son from the Elizabethan age. It was there I had spent many happy months and had learned from its owner, a retired sheep farmer who had won many medals for his Herdwick sheep, a great deal about the Lake District and its people, for Mr George Browne was an antiquarian who cherished his inheritance and took great pride in keeping his ancestral home unchanged.

'We could stop at Town End if you like,' said Beatrix Heelis. 'Miss Clara Browne is still living there I am told. I have never been inside the house. Would you care to see it again?' I hesitated, it was twenty-five years since I last stayed there, but I realised Beatrix Heelis would really like to see it. The ancient 'house-place' in whose

restoration Mr Browne had taken such pride was just as he had left it. And while Beatrix Heelis looked around, I stole upstairs to find that the mysterious little oak writing room, which opened into my bedroom, was still there.

That evening our talk was all of Troutbeck. It was then that Beatrix Heelis told me of her wanderings over Troutbeck fell, of the dance of the wild fell ponies about the thorn tree. 'It was finding their little fairy foot-marks on the old drove road that first made me aware of the Fairy Caravan,' she said. She had wandered farther into the wilderness behind Troutbeck Tongue than I had, but for each of us as we had walked alone, without loneliness, there remained a memory of complete enchantment.

On Saturday Mr Heelis took a holiday and drove us to Hawkshead where he unlocked the door of the old Grammar School. Wordsworth attended this school and was possibly its most famous pupil. Mr Heelis showed us the Letters Patent granted to the school by Queen Elizabeth I in 1585. He also showed us the old cottages of special interest for their human associations. I realised more fully that day how much Beatrix Potter must have learned from William Heelis about that countryside.

'You would like to see Buttermere again, wouldn't you?' Beatrix Heelis said on Sunday morning. 'It's a rare day and there is a little matter of business to take me there. Let's make a day of it, Willie!'

What a glorious day it is to recall! Beatrix Heelis seated comfortably on the back seat 'with room to spread out.' William Heelis driving with the ease of one enjoying the countryside and quite ready to stop for a view at any moment. Over Brathay Bridge, through Ambleside, past Rydal Water to Grasmere, where we lingered for some time; then on past Thirlmere to Keswick, still gaily decorated for the Coronation, and Derwentwater.

Between Keswick and Cockermouth we stopped for a leisurely luncheon at the Golden Pheasant and took a rest by feasting our eyes on the primrose banks of a lovely stream. Few words were spoken the whole day long. It was a day of utter contentment in a world of beauty.

We came to Buttermere at last and to the farm at the foot of Honister Pass, and while Beatrix Heelis attended to her little matter

of business, Mr Heelis and I left the car to climb higher for another view.

On the way home we stopped for tea at a cottage under Helvellyn and again at the tiny church at Wytheburn. There was another pause at Grasmere, for the evening light on the hills was very beautiful and Grasmere, like Troutbeck, had memories we shared.

Beatrix Potter rested in the afternoons and on one of them I explored Pringle Wood for signs of Pony Billy on 'the fairy hill of oaks.' 'How blue the bluebells were: a sea of soft pale blue; tree behind tree; and beneath the trees, wave upon wave, a blue sea of bluebells.'

On another day I wandered through Codlin Croft orchard with *The Fairy Caravan* and came back to read with fresh delight the conversation between Charles the cock and the hens, Selina Pickacorn, Tappie-tourie and Chucky-doddie. Re-reading *The Fairy Caravan* at Hill Top led me to speak of its richness and variety, of its true relation to each one of the little books. 'It puts the very life of the England they came out of behind them and it gives Beatrix Potter her own place in it,' I said. 'You did not mention it when I was here before.'

'No, at that time I thought of it as too personal to be of interest to anyone else,' Beatrix Heelis replied. 'I am very slow about making up my mind about things. It takes years sometimes for an idea to take shape. It was so with several of the books – years between a picture-letter idea and the book. When I look back I realise it was Miss Bertha Mahony, of the Bookshop in Boston, with her questions about Beatrix Potter and how she came to write and illustrate *Peter Rabbit* and the others, who set me thinking outside myself. I found her questions very perplexing at the time and I sent a short answer, through my publishers, telling her very little she wanted to know.'

Miss Mahony had also fortunately sent Beatrix Potter copies of the magazine she was editing, the Horn Book, a magazine devoted to children's books which carried a reproduction of a drawing from Caldecott's *Three Jovial Huntsman* on the cover. Beatrix Potter was pleased that Caldecott was being remembered in America.

'I have always had the greatest admiration for Caldecott as an

artist,' she said. 'At one time I tried in vain to copy him. We had all his picture books as they came out and my father bought many of his original drawings at a sale after Caldecott's death.

'I found the Horn Book pleasantly written and in good taste. Gradually I began to see a reason for Miss Mahony's questions. She was very tactful and did not press them but she kept on sending the magazine and I continued to read it for about two years.

'Then I had a problem I thought she might understand. I wanted to help save that strip of land on the shore of Windermere – we stopped there for the beautiful view on our way home from Troutbeck. I had given all the money I could afford to the fund that was being raised for the purpose. And so I wrote a letter to Miss Mahony with the assistance of Peter Rabbit, and offered to send an autographed drawing in return for a contribution of a guinea to the fund. She reproduced my letter in the Horn Book (August, 1927) and gave it a title, "Peter Rabbit and his Homelands." The Bookshop quickly sold the fifty drawings I sent. That was the beginning of my personal correspondence with Bertha Mahony.'

There were many American visitors to Hill Top after that letter appeared. Two of them wrote of their visits in the Horn Book. One of them, a twelve-year-old boy from Boston, gave a circumstantial account of his visit in which he mentioned seeing in Beatrix Potter's portfolios 'Unpublished pictures just as fascinating as those printed in the books.'

It was he who discovered the unfinished story of guinea pigs which became the first chapter in *The Fairy Caravan* and it is to him, Henry P., the book is dedicated. The other visitor was Miss Helen Dean Fish, editor of children's books for a New York publishing house, who told Beatrix Heelis that *The Tailor of Gloucester* had always been her favourite among the little books. This was welcome news from a discriminating American editor who wrote of Hill Top out of the deep feeling for England which had made her a contributor to the National Trust.

Bertha Mahony made a happy choice of words when she renewed an early request and asked for the 'roots' of Beatrix Potter and her

books. Her letter brought the reply for which she had waited patiently and expectantly for four years. Under the title *The Roots of the Peter Rabbit Tales, by Beatrix Potter*, it was published in the Horn Book in the same year the first chapter of *The Fairy Caravan* appeared there under the title *Over the Hills and Far Away*. The book was first published in Philadelphia in 1929.

'I should never have dared to risk the book without Miss Mahony's belief in its interest for those who have cared for my work. It required a personal visit from an American publisher to bring about its publication there, to be sure, but I should never have consented to part with it if I had not been told it was wanted and needed to complete my story of England and my books which had seemed so trivial for so many years on both sides of the Atlantic.

'Bertha Mahony Miller and I have never met, yet I feel that I know her very well as a person, we like so many of the same things. I am glad she has kept on with the Horn Book since her marriage. The Bookshop she originated had to go. One cannot keep on with everything. But one never gives up a real interest in children or "a firm belief in fairies",' she added with a lovely smile.

The visit lasted nearly a week and there was time for good talk of books other than her own, time to explore her bookshelves and discover how varied her book interests had been. 'I have been thinking of the importance of saving books as well as scenery,' she said one day. 'Books are soon lost or forgotten and children's books are the most perishable of all. It makes me happy to feel mine are being saved in libraries overseas.'

Little did we dream that another war would so soon threaten the lives of picture books in every country. That American libraries would again be put to the test of conserving for the future while heeding the call of the present generation to see what a country is like from its picture books. Beautiful picture books had come to the children's libraries in the 1920s – from Italy, Sweden, Holland, Poland, Czechoslovakia and other countries.

The remarkable development of picture books conceived and produced as works of art by publishers in America, which began during

the same decade, was greatly stimulated by seeing the foreign picture books in the hands of children who also delighted in the books of Walter Crane, Randolph Caldecott, Kate Greenaway and Boutet de Monvel. Language is no barrier to enjoyment of a picture book in which the artist conveys true impressions of his country to children.

Beatrix Potter was interested in the development of picture books in America. The freedom for experiment in technique and methods of reproduction appealed to her. 'There is bound to be a waste to arrive at anything worth while,' she said. 'No doubt American artists and publishers will find that out in time, with the help of the children.'

In her letters during the war years she often spoke of children's books. In response to a copy of *To Think That I Saw It on Mulberry Street,* she wrote, 'I think it the cleverest book I have met with for many years. The swing and merriment of the pictures and the natural truthful simplicity of the untruthfulness . . . Too many story books for children are condescending, self-conscious inventions – and then some trival oversight, some small incorrect detail gives the whole show away. Dr Seuss does it thoroughly.'

'It is very interesting to read about the beginnings – like St Nicholas. I had it to read but not in the earliest days. I had the *Silver Skates,* which I have unfortunately lost. I have most of Mrs Ewing's and Mrs Molesworth's books – very old copies carefully kept. They were as good as the American books but less humorous . . . I have been re-reading *Huckleberry Finn.*'

'Let us hope for peace before another New Year,' she wrote in conclusion to this letter in 1940. 'But we will just stick it out whatever happens . . . People take it calmly, with temper, not fear. The sheep and cattle take no notice.'

For three more years she continued to write with an eye undimmed for the beauty of her countryside and a faith unshaken by fear of invasion or destruction. Facing the red glare in the sky of Liverpool and Manchester burning, she could say, 'If it were not for pity one might say it was a fine sight.'

September 1955 Anne Carroll Moore

Beatrix Potter – the Artist

BEATRIX POTTER THE ARTIST
(b. 1866, d. 1943)

It was from her father that Beatrix Potter inherited her talent for drawing. A sketch book of Rupert Potter dated 1853, when he was twenty-one years of age, shows that he was a fine craftsman. On its pages are delicate line drawings in sepia ink of birds, sheep, hens, and a fine etching of a gazelle. Perhaps the most interesting page, however, shows a flight of ducks – one of which has a 'Jemima' shaped bonnet tied round its neck, while another wears a hat and has a human face.

Etching by Rupert Potter, from his Sketch Book, September 1853

It may have been sketches such as these which gave Beatrix Potter the idea of dressing her animals in clothes.

When Beatrix Potter was a child her father would draw pictures to amuse her. After her death one of these pictures – a sheet of outline sketches of ducks, swans, pelicans etc., evidently a treasured possession, was found amongst her papers at Hill Top, Sawrey. On this sheet she had written, 'by Rupert Potter, father of Beatrix Potter, note the direct work and touch, abt. 1872 or 73.' This would be when she was six or seven years old.

All through her childhood Beatrix Potter must have spent much of her time drawing and painting. In due course Miss Hammond her first governess realised that she had an exceptional gift in this direction, and encouraged and helped her in every way she could.

In November 1878 Beatrix Potter had her first drawing lesson from a Miss Cameron, and these lessons continued for the next four and a half years until she was nearly seventeen. Of them Beatrix Potter wrote, 'I have great reason to be grateful to her, though we were not on particularly good terms for the last good while. I have learnt from her free-hand, model, geometry, perspective and a little water-colour flower painting. Painting is an awkward thing to teach except the details of the medium. If you and your master are determined to look at nature and art in two different directions you are sure to stick.'

During this period she obtained an Art Student's Certificate of the Second Grade from the Science and Art Department of the Committee of Council on Education. It was granted on the first day of July 1881, No. 10,420, and certified that she had passed a satisfactory examination in Freehand Drawing, Practical Geometry, Linear Perspective and Model Drawing.

In November 1883 at the age of seventeen Beatrix Potter attended a course of twelve lessons in oil painting. 'Can have no more,' she wrote, 'because Mrs A's charge is high.' Rupert Potter had heard of her new teacher from Lady Eastlake, wife of the late President of the Royal Academy.

Beatrix Potter was somewhat critical of these lessons with Mrs A. She realised that only the technical side of any art could be taught –

'perspective, anatomy and the mixing of paints and medium' – for that she would owe a great deal to her teacher; but the style of Mrs A's work did not appeal to her. 'Of course, I shall paint just as I like when not with her,' she wrote.

Apart from two unsigned oil paintings attributed to Beatrix Potter, and an unfinished oil painting which was later redrawn and used as a head-piece to Chapter XXI of *The Fairy Caravan*, none of her work in oils appears to have survived. It is interesting to note that in her Journal she wrote, 'Have begun a head of myself which promises surprisingly well'. Occasionally Beatrix Potter touched up her water-colours with white oil paint to heighten the effect.

Although Beatrix Potter mentioned that she learnt figure drawing at these lessons, her one regret in later life was that she had never seriously studied human anatomy. 'I am not good – or trained – in drawing human figures,' she wrote, 'they are a terrible bother to me when I have perforce to bring them into the pictures for my own little stories', but 'it is a great help in drawing to model, particularly if one knows no anatomy.'

Apart from her lessons in art, Beatrix Potter found a great deal of interest in and sometimes inspiration from her numerous visits to the Grosvenor and other picture galleries.

Once as a child she visited the National Gallery with her father, and although when revisiting it some years later, she had forgotten the building, the pictures had made a deep impression on her mind. 'It is strange how deeply the mind is impressed when excited. I was just beginning to take an interest in pictures then,' she wrote. 'We only had about half an hour this afternoon, and went into the cellar to see the Turner drawings for which we had principally come . . . I think Turner is the greatest landscape painter that ever has lived.'

Now that she was older, she and her father regularly visited the Winter and Summer Exhibitions of the Royal Academy. Here she spent hours studying the pictures, and the early pages of her Journal are full of comments and criticisms of those which interested her.

At one exhibition she was critical of the landscapes – 'Most land-scapes are in bits,' she wrote, 'stuck together with more or less skill, a

cloud, a field, a tree, which may be good separately, but are not fitted together in the least. There is such complete unity in nature, nothing out of place or without a use.'

Of one of Millais' pictures she noticed 'one thing not quite right in *News from the Sea*; children who habitually go barefoot always have the toe-joint larger, and, I am afraid, are generally flat-footed. Very few artists notice this.'

In pondering over Millais' picture *Ophelia*, she wrote, 'Nature, with the exception of water and air, is made of colour. There is no such thing as its absence. It shows the work of one who understood that perfection is beauty. What we call highest and lowest in nature are both equally perfect. A willow bush is as beautiful as the *human form divine*.'

Of one of Holman Hunt's pictures she wrote, 'my father objects to it that he can't understand it, but I had rather a picture I can't understand than one with nothing to be understood.'

On two occasions Beatrix Potter mentions the effect which a visit to the Academy made on her – 'It has raised my idea of art, and I have learnt some things by it', and a few weeks later – 'Been to the Academy again this afternoon, with a much better light, more pleased than before. I *will* do something sooner or later.'

She was also influenced by her personal contacts with Millais, who was a friend of the family. He lived in Palace Gate, Kensington, quite close to Bolton Gardens, and Beatrix Potter sometimes accompanied her father when he visited him.

She first went to his studio one Sunday in November 1883 when she was seventeen years of age. She was excited at the idea of going and somewhat nervous. 'After thinking in a sleepy way about the chance of going, it's coming true seems like a dream. He was very kind indeed,' she wrote.

Millais was interested in her drawing, but she was too shy to show much of it to him. 'Seeing Mr Millais paint so often and easily prevents me showing much of my attempts to him, and I lose much by it.'

However, she listened when he and her father talked together, and remembered his remarks. When her father 'said something about the

difficulties of drawing alone from a model, Mr Millais said "It is surprising how much is to be learnt alone. . . . There are different kinds of drawing, there is some that may be quite correct, but it isn't beautiful, it wants the divine spark."'

When Millais died in 1896 Beatrix Potter wrote in her Journal, 'I shall always have a most affectionate remembrance of Sir John Millais, though unmercifully afraid of him as a child . . . He gave me the kindest encouragement with my drawings (to be sure he did to everybody!) . . . but he really paid me a compliment for he said that "plenty of people can *draw*, but you have observation."'

During her late teens Beatrix Potter was completely absorbed in her art work, 'I can't settle to anything but my painting,' she wrote in her Journal, 'I lost my patience over everything else . . .' and in the following quotation, also from her Journal, written eighteen months later, she tells of the part that drawing and painting played in her life:

'It is all the same, drawing, painting, modelling, the irresistible desire to copy any beautiful object which strikes the eye. Why cannot one be content to look at it? I cannot rest, I must draw, however poor the result, and when I have a bad time come over me it is a stronger desire than ever, and settles on the queerest things, worse than queer sometimes. Last time, in the middle of September, I caught myself in the back yard making a careful and admiring copy of the swill bucket, and the laugh it gave me brought me round.'

PART ONE

BEATRIX POTTER – HER WORK AS AN ARTIST

I

Early Work

EARLY WORK

This section contains examples of the early work of Beatrix Potter, drawn or painted between the ages of eight and seventeen. Apart from the last three pages, it is arranged in order of age.

The earliest examples of her work to survive are contained in two small sketch books. The first, made when she was eight, consists of a number of sheets of paper of the kind used for lining shelves, sewn together, with edges roughly cut to a size of $6\frac{1}{2} \times 6$ inches. On the cover Beatrix Potter has written in pencil – 'Dalguise, Dunkeld, Perthshire'.

The second, made a year later, measures $5\frac{3}{4} \times 4\frac{1}{2}$ inches, and consists of sheets of good quality note paper sewn together. On the front is her name 'Helen Beatrix Potter, March 1876' and underneath a drawing of the family crest – a sea-horse couchant.

Dalguise House is a seat on the banks of the river Tay, situated in the midst of beautiful scenery, which Mr Potter rented for the fishing and where the family stayed for eleven consecutive summers. Here Beatrix Potter, who loved the country, found plenty of scope for nature study. In her first sketch book are drawings of birds' eggs, butterflies and caterpillars – also paintings of the garden of Dalguise House and the surrounding country.

The page reproduced shows a variety of caterpillars, some on leaves and one crawling up a stem. On the back of this page Beatrix Potter has written the following notes:

Tiger moth.
1. The caterpillar of the Tiger feeds on the nettle and hawthorn and is found in June they are covered with black, white and red. They are found by road sides and lanes.

Drinker.
2. The cat. is a dark brown with orange dots. I dont know what it eats, but I think it is the flowering nettle. It is found by hedges in May and June

Bombycidal
3 The caterpillar eats sloe, it is a rare moth, the caterpillar is brown with yellow rings, it is hairy and found in June.

Yellow tail
4 The cat. feeds on haw-thorn, it is yellow with a blue line along its side and black dots. It is found on hedges in June.

The second sketch book is even more interesting because the picture which shows rabbits skating on ice, walking upright and pushing each other on sledges, foreshadows Beatrix Potter's future work – her animal fantasies and book pictures. There are also sketches of a girl driving two cows, a horse, sheep, etc., and a flower painting inscribed 'March 21st, 1876'. The latter can be seen amongst the pictures in this section.

Amongst the remaining drawings, the rabbit painted in 1880 is believed to be the original Benjamin Bunny, commonly called 'Bounce'. The frieze was probably some of the work done by Beatrix Potter when an art student studying under Miss Cameron.

Of the picture of the Pineapple and Lizard, there is an amusing anecdote in her Journal. The Potters gave a dinner party on June 21st 1883, the pineapple being part of the dessert – 'Small dinner,' wrote Beatrix Potter, 'am painting the pineapple etc., Mr Halliday was cutting it up on a plate behind me. I felt fit to kick under my chair. I thought there would be none left.' The little lizard in this picture had been 'brought from Ilfracombe' and gave Beatrix Potter a 'great deal of pleasure'. It was called Judy.

When she was fourteen Beatrix Potter experimented with a transfer process. Three of these transfers, which were printed in mauve ink, are shown. In the picture of dogs, one is believed to be a Lhasa (Tibetan) Aspo, a rare dog in England at that time.

Beatrix Potter was six years old when her brother Bertram was born. The sketches shown were made when he was nine or ten, and beginning to be a companion to her. They had many interests in common – natural history, drawing and painting, and both enjoyed keeping pets.

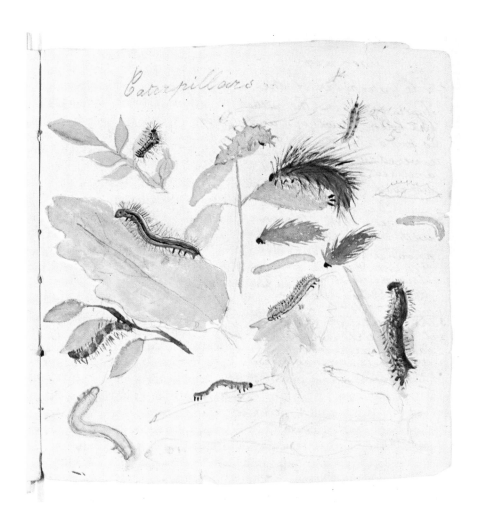

Caterpillars – from a Sketch Book *Age 8*

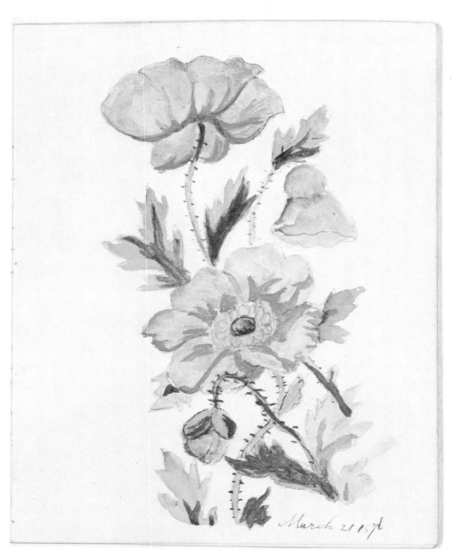

Flower Study – from a Sketch Book *Age 9*

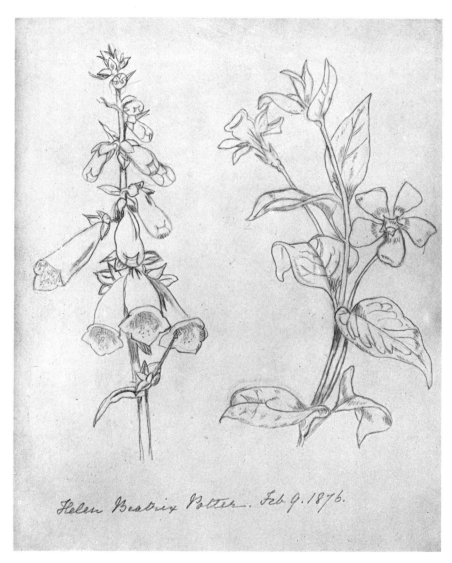

Helen Beatrix Potter. Feb 9. 1876.

Foxglove and Periwinkle *Age 9*

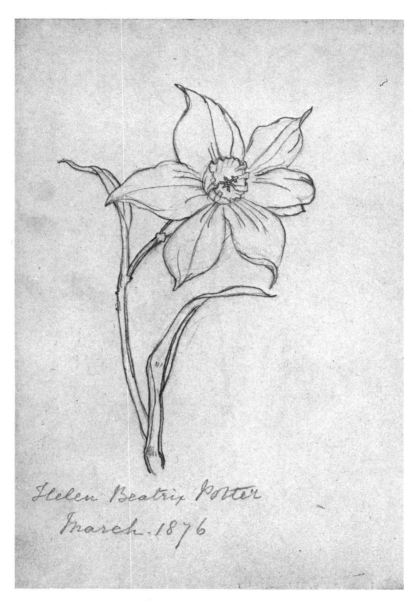

Helen Beatrix Potter
March. 1876

Narcissus *Age 9*

Age 9

Pages from a Sketch Book

Age 11

Landscape

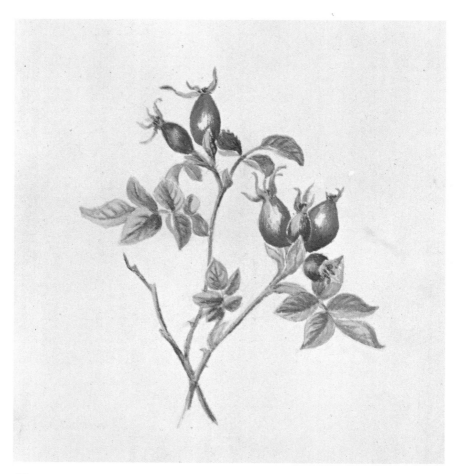

Hips *Age 12*

Age 13

Rabbit

Age 14

September 9th 1880.

Carnations

September 27th 1880

Age 14

Bramble Leaves

Age 15

Frieze

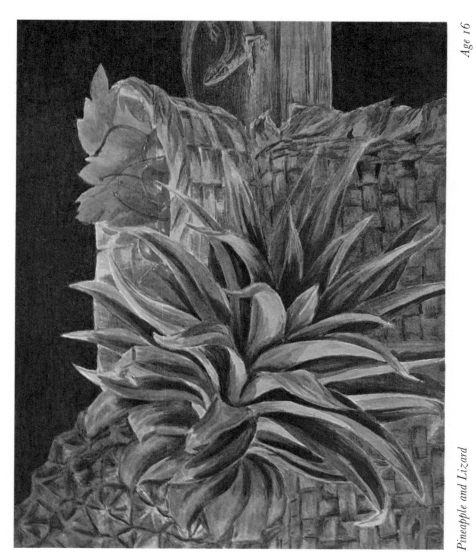

Age 16

Pineapple and Lizard

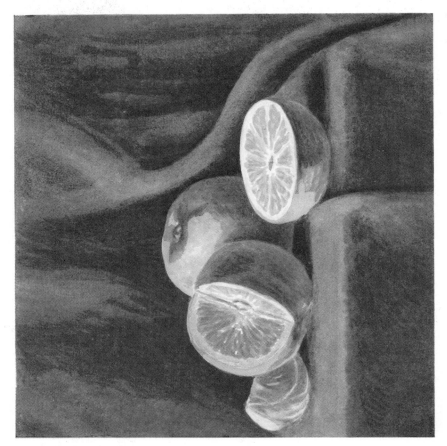

Age 16

Oranges

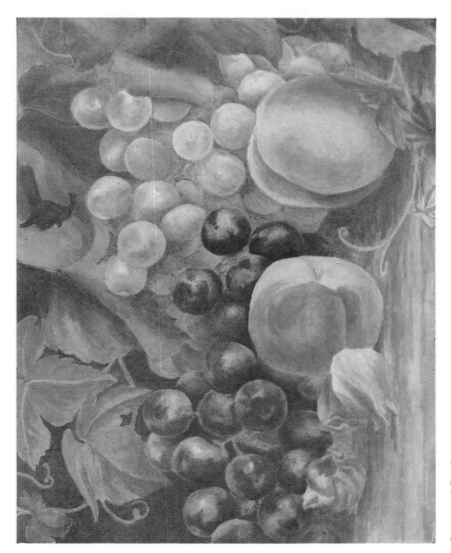

Age 17

Grapes and Peaches

Transfer Print of Horse's Head *1880*

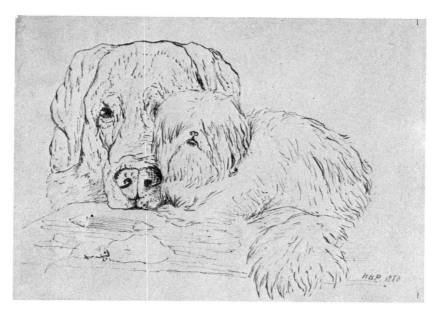

Transfer Print of Dogs *1880*

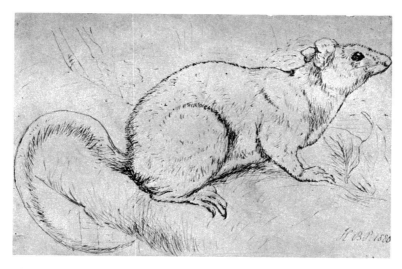

Transfer Print of Dormouse *1880*

1882

Sketches of Bertram at the Age of Nine or Ten

2

Interiors

INTERIORS

Beatrix Potter loved old houses and old furniture. As early as 1884 when she and her mother were staying at Oxford she wrote, 'If ever I had a house I would have old furniture, oak in the dining room, and Chippendale in the drawing room. It is not as expensive as modern furniture, and incomparably handsomer and better made.' During their stay they visited an old shop that sold china and furniture, and Beatrix Potter was charmed with this house. 'The house itself was worth seeing,' she wrote, 'such stairs and passages.' This section contains mainly pictures of the interiors of houses.

Of particular interest is the pen-and-ink drawing of a corner of the schoolroom at Bolton Gardens, made when Beatrix Potter was nineteen. All through her childhood she kept pets, so it is not surprising to find a tortoise on the hearth-rug in front of a Victorian fire-guard, and two birds in cages. This fire-guard is now at Hill Top, Sawrey.

Other pictures of interest are interiors of houses belonging to relations, in which she stayed, or of ones rented when the family went on holiday. These houses were in very different parts of the country.

There was Camfield Place at Essenden in Hertfordshire, the home of her grandmother, the place she loved 'best in the world.' The original part of the house was an immense age and the manor existed in the Middle Ages, but most of it had been pulled down and rebuilt by her grandfather, Edmund Potter.

Beatrix Potter gave a detailed description of the interior of Camfield Place in her Journal. It was the old part she loved best. The original house was 'a good-sized small-roomed old house . . . the outside, red brick, white-washed,' she wrote. An oak panelled room had been destroyed during Elizabeth's reign. The old part was mainly in the back premises, 'the only large room left now is the kitchen'. There were flagged passages, a large scullery with a stone oven, and a little old room with 'linen cupboards up to the ceiling, doors opening in the panels without rhyme or reason.'

The only picture she appears to have drawn of the interior of Camfield Place, was of bedroom number four. Under this picture she

pencilled – 'No. 4, where I always slept. After my grandmother's death I asked for the bedstead with green hangings – the chairs, the looking glass and eight pictures were given me. I still have them – also the alabaster figure of Ariadne riding the leopard, which was under a glass shade on the mantelpiece. The red bed quilt also I used many years at B. Gardens.'

It is interesting to note that this same bed may be seen in Beatrix Potter's drawing of 'The Rabbit's Dream' (Section 7), and the chair by the bed appears in the series of paintings illustrating the verse 'Three little mice sat down to spin' (Section 8).

Then there was the house at Gwaynynog near Denbigh, Wales, which belonged to her uncle Fred Burton. She often stayed here. It was a very old house dating back to 1571, 'the front black and white, and the more modern garden-front, stone. Two large rooms, dining-room and music room 1776, the most modern. Upstairs all up and down and uneven, low beams and long passages, some very fine chimney-pieces and one room panelled.' The house had a literary association with Dr Johnson. Her uncle had furnished it in perfect taste. 'I never saw rooms more faultless in scheme of colour or Sheraton more elegant without being flimsy,' she wrote. Two pictures of the interior of this house are shown – a painting of one of the living rooms, and a sepia pen-and-ink drawing of a Welsh dresser, dated 1696.

It can be noted that at the end of Section 4, amongst the pictures of Still Life, there is a painting of porcelain belonging to her uncle Burton and inscribed 'Old Staffordshire figures, Gwaynynog, Sept 19–23. 08.'

Beatrix Potter also frequently stayed at Melford Hall, Suffolk. The house belonged to Sir William Hyde-Parker who had married her cousin Ethel Leech. It was a very different type of house from Gwaynynog – a beautifully proportioned red brick manor house which dated back to Elizabethan times. The house was full of art treasures – paintings, ornaments, wood-carvings, furniture etc. Two pictures of the interior are shown. One, in colour, but unfinished, shows a faint outline of her cousin's little girl, Stephanie, sitting on the hearth-rug by the fire. Beatrix Potter has faintly pencilled the colouring of the unfinished hearth-rug – red and yellow – a procedure she often followed when

drawing backgrounds for her book pictures. This, and a sepia pen-and-ink drawing, give some idea of the grandeur of the fine old house.

On one occasion when staying at Melford Hall, Beatrix Potter was working on her book paintings for *The Pie and the Patty-pan*, and as a special treat Stephanie was allowed to put some red paint on the cushion on which Duchess was standing. When relating this incident, she added – 'I wonder if cousin B removed it afterwards!'

Of the houses at which Beatrix Potter stayed when on holiday, there are five interiors of Derwent Cottage at Winchelsea, an old-world village a mile or two from Rye in Sussex. Derwent Cottage stands in a line of houses on one side of a large square of grass and fine old trees, in the centre of which is a great ivy-covered church dating back to the thirteenth and fourteenth centuries. Derwent Cottage has been renamed 'Haskards' and has been much altered inside since Beatrix Potter stayed there.

In a picture letter to Freda Moore from Derwent Cottage, Beatrix Potter wrote, 'I am staying in such a funny old cottage . . . Mrs Cooke, the landlady, and her family go to bed up a sort of ladder stair-case, and I can hear them scuffling about upon the rafters just above my head! The ceiling of my bedroom is so low I can touch it with my hand, and there is a little lattice window just the right size for mice to peep out of. Then there are cupboards in the walls . . . and steps up and down into the rooms, and doors in every corner; very draughty!' In the drawings in this picture letter Mrs Cooke the landlady and her family are depicted as little mice!

In the summer of 1891 the Potters stayed at Bedwell Lodge, near Hatfield. Three pictures have been reproduced: one of the fine old staircase; one of a back passage, which was used as the setting for her picture of 'The Mice in Their Storeroom' (Section 7); and a drawing of an old barn in which there are three farm cats.

The summer of 1894 was spent at Lennel near Coldstream, in Berwickshire. The picture reproduced shows a passage on an upper floor of the house in which the Potters stayed. Beatrix Potter described this house as 'large rambling, roundabout', she spent the day after her arrival, unpacking and 'trying to learn the way to the stairs at either

end of the house'. The approach to both staircases can be seen in the picture.

Another interior is of the hall and stairs at Lingholm, near Keswick, on the shore of Derwentwater. Lingholm was a favourite summer resort of the Potters.

Of the other pictures in this section, there is a colourful painting of the library at Wray Castle; it was while staying at Wray Castle in 1882 that the Potters became acquainted with Canon Rawnsley, who was soon to be co-founder of the National Trust, and who later helped Beatrix Potter to find a publisher for her first book *The Tale of Peter Rabbit*.

There is also a painting of the dining-room at 8 Bedford Square, London, the home of the Warne family. Here Norman Warne, who helped Beatrix Potter in the planning of her earlier books, lived with his mother and unmarried sister, Millie.

This is followed by a picture of a turret staircase which shows Beatrix Potter's skill in the art of perspective.

The crayon drawing of a water-mill, showing the grinding machinery, dates back to the summer of 1884 when the Potters were staying at Bush Hall near Hatfield.

The painting of a four-poster bed is from a page in one of Beatrix Potter's sketch books.

<div align="center">* * * *</div>

Beatrix Potter's early dream of having an old house with old furniture began to come true in 1905 when she bought Hill Top Farm. The old farmhouse dated back to 'somewhere about 1602', and she filled it with old furniture in the years that followed.

The rooms and furnishings at Hill Top can be recognised in many of the pictures in *The Tale of Tom Kitten* and in *The Roly-Poly Pudding*.

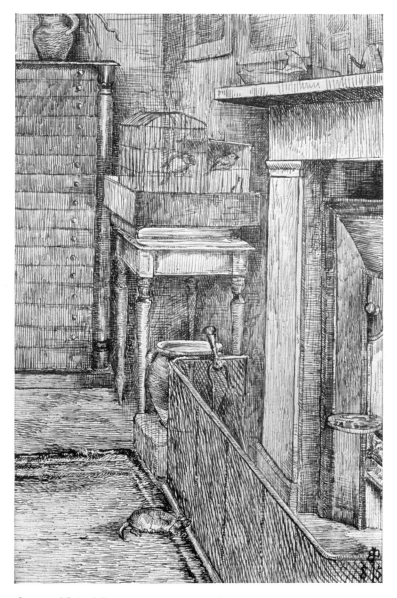

Corner of School Room *2 Bolton Gardens, Nov. 26th, 1885*

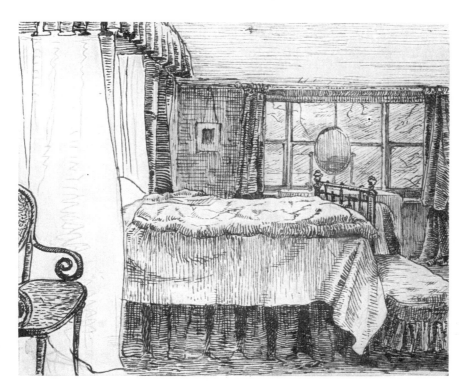

Bedroom, Camfield Place, Hatfield, Herts

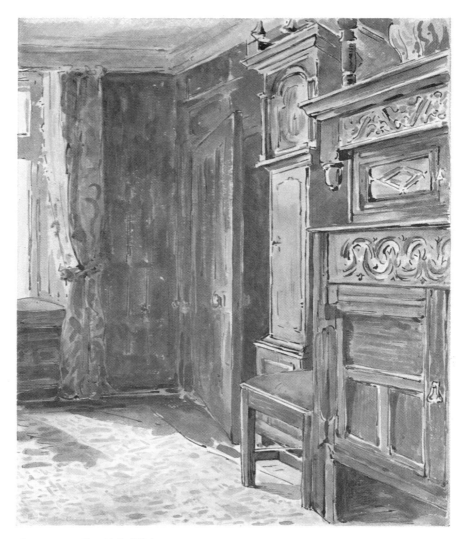

Gwaynynog, Denbigh, Wales *March, 1904*

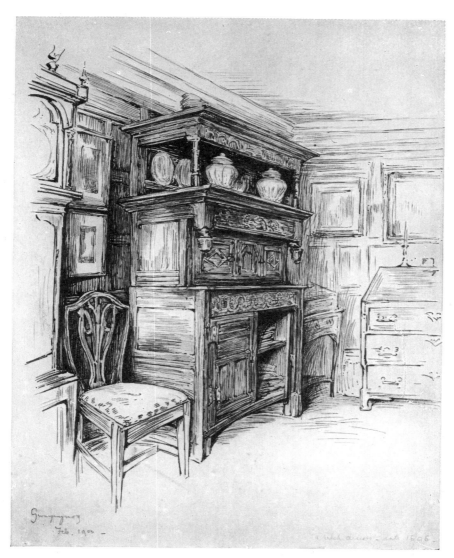

Gwaynynog, Denbigh

'A Welsh dresser, date 1696'
Feb. 1903

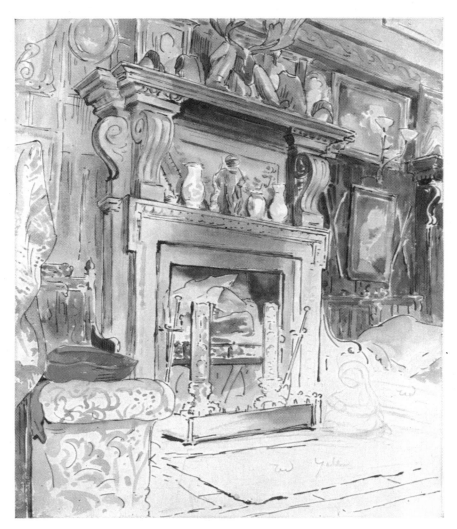

Melford Hall, Suffolk (*Unfinished*)

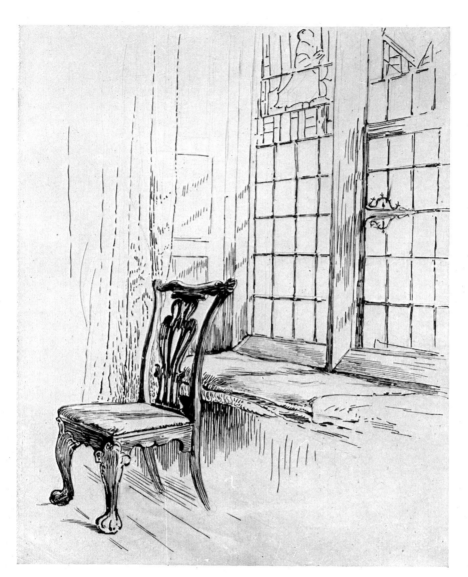

Melford Hall, Suffolk

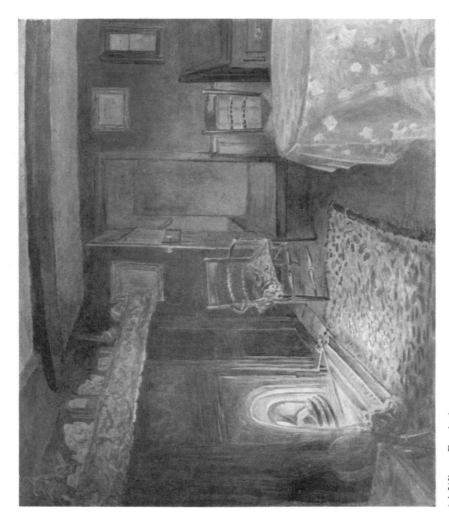

'Old house at Winchelsea, Sussex'
(Derwent Cottage, 1900)

'A Winter Evening'

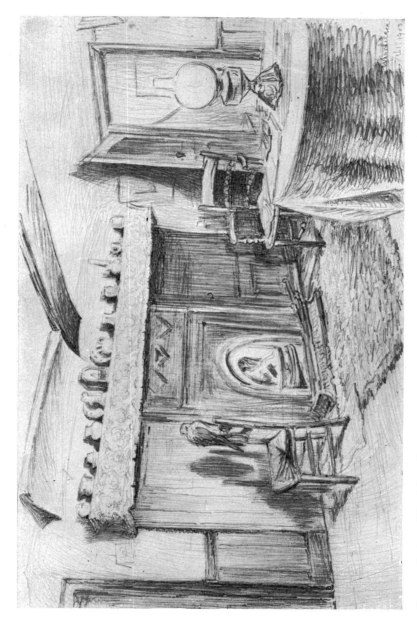

Feb. 1st, 1900

Derwent Cottage, Winchelsea, Sussex

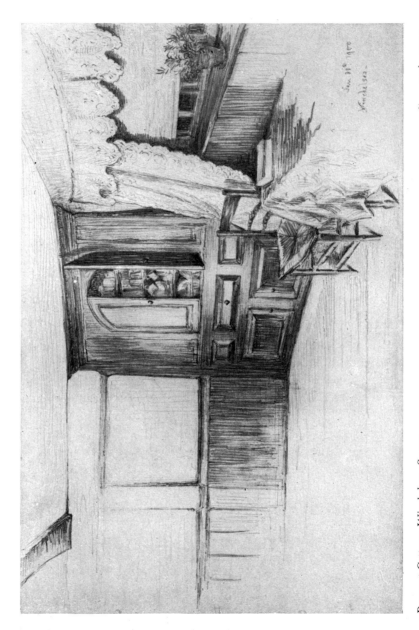

Jan. 30th, 1900

Derwent Cottage, Winchelsea, Sussex

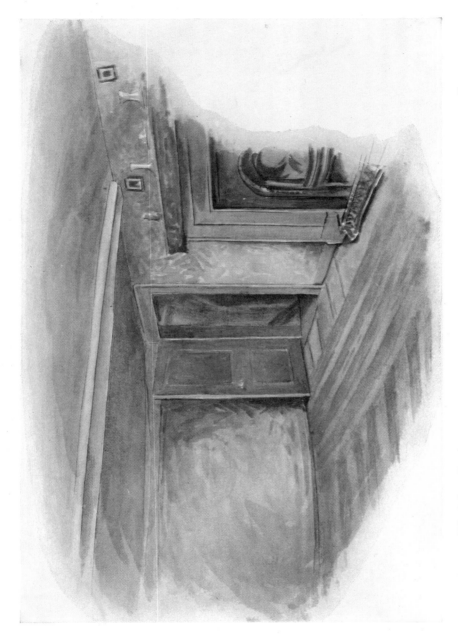

January, 1900

Derwent Cottage, Winchelsea, Sussex

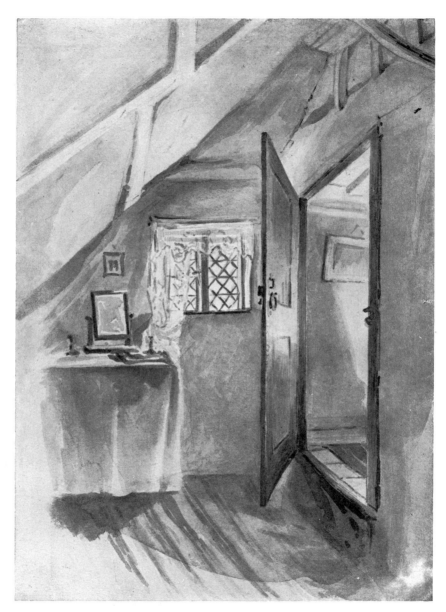

Derwent Cottage, Winchelsea, Sussex *1900*

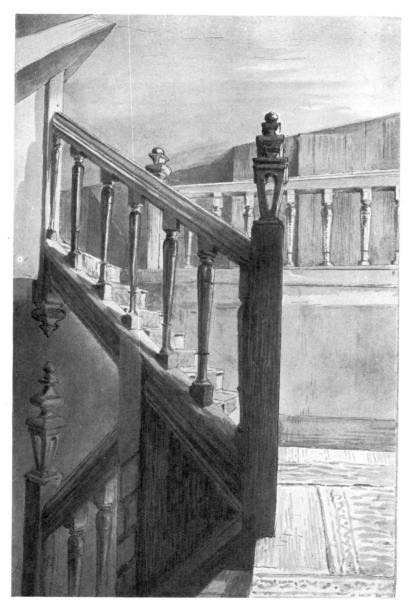

Bedwell Lodge, near Hatfield *September, 1891*

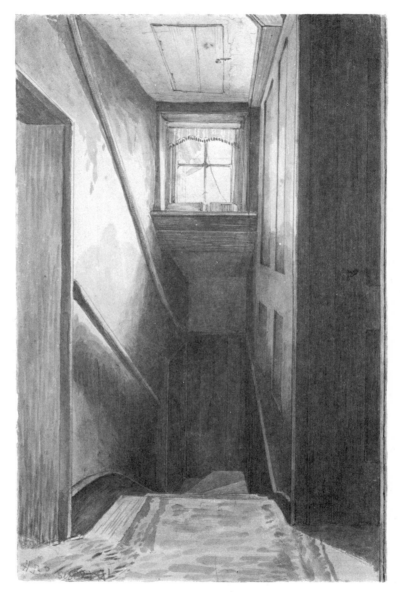

Bedwell Lodge, near Hatfield *September, 1891*

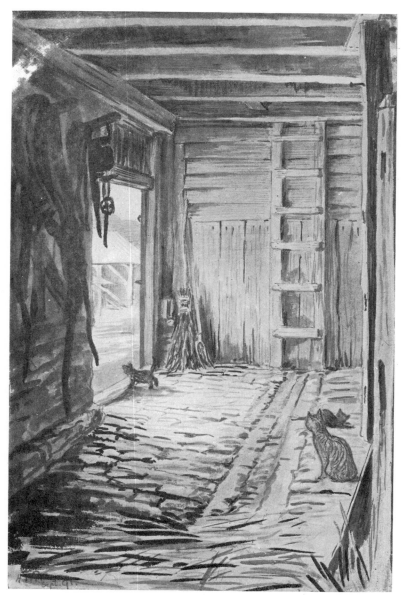

An old Barn, Bedwell Lodge, near Hatfield *September, 1891*

Summer, 1894

Lennel, Coldstream, Berwickshire

Lingholm, Keswick

49

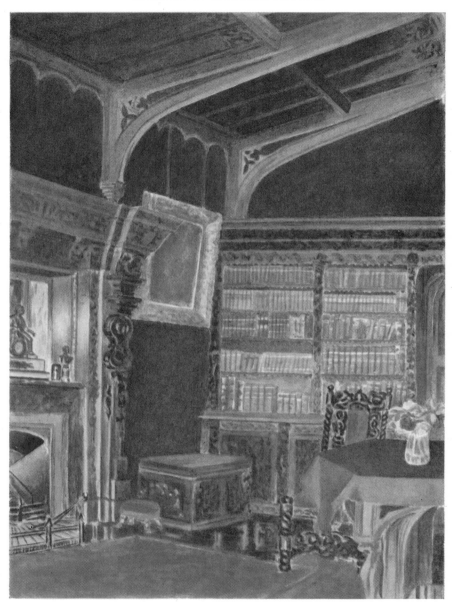

The Library at Wray Castle *1882*

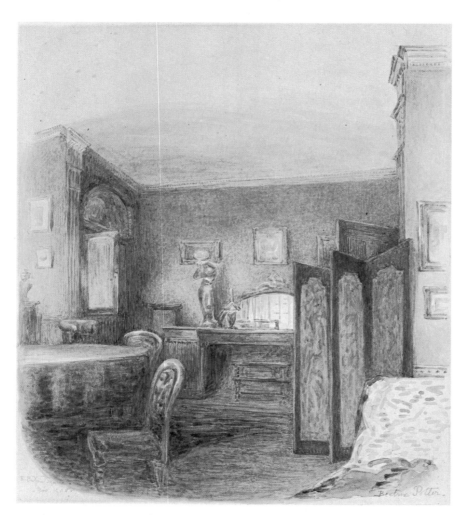

The Home of the Warnes at 8 Bedford Square *Nov. 1905*

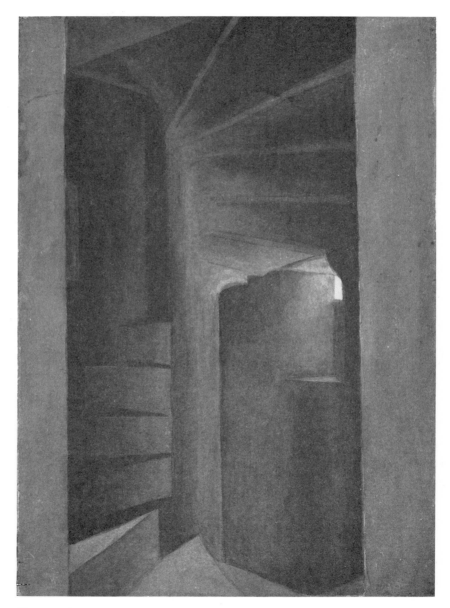

Turret stairs

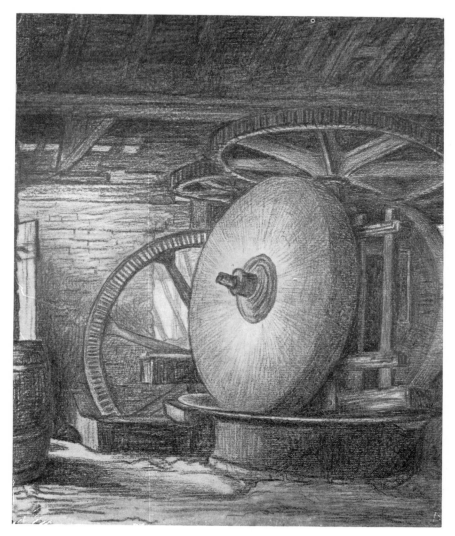

A Water Mill in Hertfordshire *Oct. 1884*

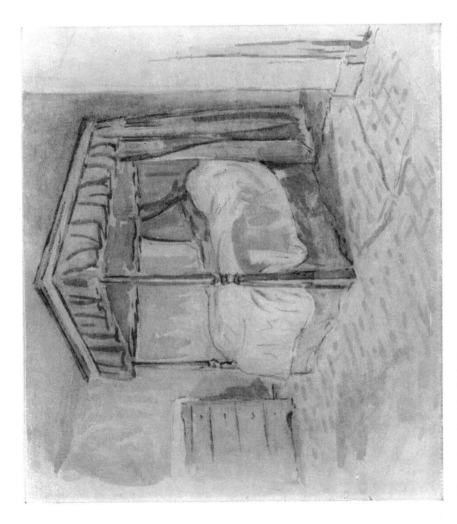

1902

A Page from Her Sketch Book

3

*Houses, Village Scenes
and Landscape*

HOUSES, VILLAGE SCENES AND LANDSCAPE

The pictures in this section have been selected to show the wide scope of Beatrix Potter's work as a landscape artist. The scenes vary from Scotland to the West Country and from the Lake District to East Anglia.

The first five pictures were drawn at Bush Hall near Hatfield, where the Potters stayed from August to September 1884. The house belonged to Lord Salisbury. It 'is an extraordinary scrambling old place,' wrote Beatrix Potter, 'red brick, two and three stories, tiled, ivied, with little attic windows, low rooms and long passages. . . . It has been much added to, but parts are probably as old as Hatfield House.' She described 'a piece of private trout fishing in the Lea, which goes past the back door at four or five yards distance from the house. It is very picturesque.'

Many years later, on the back of one of these drawings, she wrote, 'These chalk drawings, in singularly good perspective, must have been done when I was 18. We had a house on the Lea near Hatfield for 3 months.'

Bush Hall was only a few miles from Camfield Place, and on one of her visits there Beatrix Potter painted a picture of the view from the drawing-room window. When describing this view, she wrote of 'the long green slope of meadow down to the ponds' and 'the beech-wood over against the ponds. Farther east, beyond the sweep of grass-land and scattered oaks, the blue distance opens out, rising to the horizon over Panshanger Woods . . . In summer the distant landscapes are intensely blue.'

The other view from Camfield Place was painted in autumn, and Beatrix Potter also described the beauty of the place at that time of year. 'The autumn frost spreads a ruddy glow over the land,' she wrote. 'I shall never forget the view I once saw from Essenden Hill, miles upon miles of golden oak wood, with here and there a yellow streak of stubble, and a clump of russet walnut trees behind the red gable, and thin blue smoke of a farm.' Beatrix Potter not only painted pictures in colour, but also in words.

It was probably in her late twenties that she joined 'a small drawing society'. At intervals, a portfolio containing pictures by the various members was circulated for criticism, each member signing their comments with a pen-name. Beatrix Potter's pen-name was 'Bunny'! Typical names were Sphinx, Gollywog, Stuffed Monkey, Sixpence, Hoo?, etc.

At that time Beatrix Potter was completely unknown as a writer and artist, and for this reason the comments are of particular interest. Four of the pictures she submitted are reproduced – one in this section and three in Section 4.

The one in this section, called 'Harvest', shows Esthwaite Water, with a cornfield in the foreground and the Coniston fells in the far-distance. It was the view seen from Lakefield, Sawrey (now Ees Wyke), where the Potters were staying at the time.

A sheet attached to the back of the drawing bears the members' comments, some of which are as follows:

The distance is *very* nice, the foreground might have been made more important	(no name)
Charming – specially the other side of the water	*Stuffed Monkey*
A very pretty picture; only the foreground looks as if it had been finished in a hurry	*Eve*
If the picture were cut in half, the top half would be charming. The foreground spoils it	*Jessamine*
I really have seen something like that	*Hoo?*
Hay or corn I fear much discoloured	*Sixpence*
Very good, especially distance	*Sphinx*

Beatrix Potter must at some time have submitted pictures of animals, for in one of her letters to Norman Warne she wrote, 'I notice that those with a bit of landscape are the favourites. Nobody cares for the cocks and hens, and it comes rather near Caldecott's Cat & Fiddle, and comparisons are undesirable.'

The unfinished painting of sheaves of corn, which faces 'Harvest', is Redmayne's field next to Far Sawrey. The barn and roof of Castle Cottage where Beatrix Potter lived after her marriage to William

Heelis, can be seen in the distance. On the back she has written, 'Cut a little before Grasmere games – rained 15 days – Monday to Saturday 9th. Sept. dry – some carted 9th. rain night.'

In July 1902 Beatrix Potter spent a week at Laund House Farm, Bolton Abbey. Two paintings made at Laund House are shown. In a letter to Freda Moore she told about the surrounding country – 'I have been such a fine long walk this morning right up on to the top of a hill, where there was heather and lots of grouse. We could see a very long way, hills and hills one behind another and white roads going up and down from one valley to the next. There is a beautiful old church called Bolton Abbey about a mile off. Most of it is in ruins, but there is a little piece in the middle where they have service. The river winds round about it and at the end of the lawn below the abbey there are stepping stones . . . such a width, I did not try to cross. I thought I should fall in.'

In April 1904, when spending a fortnight at Burley, Lyme Regis, Beatrix Potter wrote – 'There is a splendid view from this little house, it is at the top of the steep street and has a nice sunny garden. I have been able to sit on the verandah. . . . The weather has been delightful, quite hot in the sun.'

Her delight in the quaint old town can be seen in the two sepia pen-and-ink drawings reproduced in this section, and in others which she made at the same time. Many of these Lyme Regis drawings were used as backgrounds for *The Tale of Little Pig Robinson* – 'the steep street looking down into the sea, and some of the thatched cottages were at Lyme Regis,' she wrote.

The picture of the beach at Sidmouth has an old-world flavour, with a Victorian nanny sitting at work in the foreground, while her charges, amply clothed, stroll sedately along the beach!

There is a painting called 'Rain' in which we get a glimpse of Lingholm, and distant mountains shrouded in mist and rain. The Potters stayed there no less than nine times between the years 1885 and 1907. It was surrounded by beautiful Cumberland scenery which provided backgrounds for *The Tale of Mrs Tiggy-Winkle*. The grounds sloped down to Derwentwater, and in the distance was St Herbert's Island – both the shores of Derwentwater and St Herbert's Island were

used as backgrounds for *The Tale of Squirrel Nutkin*.

Three paintings of Melford Hall, Suffolk are included. A distant view of the beautiful Elizabethan manor house can be seen in one of the pictures. It was this house which was used as the setting for Beatrix Potter's version of Aesop's Fable of *The Fox and the Stork*. The stork nested at the top of one of the red brick towers – also some of the fine oak panelling appears in another picture for this fable. It was never published in Beatrix Potter's lifetime.

The other two paintings show a side entrance and the red brick buttress wall separating the garden from the main road.

The charm of the two paintings made of Amersham, Buckinghamshire, is the delicacy of their colouring. The Market House was built by Sir William Drake in 1682. One of the lower arcades was enclosed to make a lock-out. Above the Market House is the room which was the meeting place of the town. Inside the turret is a bell which also dates back to 1682.

There were comparatively few pictures of snow scenes in Beatrix Potter's portfolios. Two typical examples are shown, painted in January 1913. Most of her other snow scenes were painted in March 1909 when the ground was deep in snow. In the first week of that month she spent no less than five out of six consecutive days painting water-colour sketches of the country-side in and around Sawrey, including some of Hill Top Farm.

Two oil paintings have been reproduced as they are the only finished pictures in this medium which appear to have survived. The one of the West Country coast hung for many years in the entrance passage to Castle Cottage, Sawrey, Beatrix Potter's home after her marriage. The other was given to a Mr Bowe of Swinside Farm, Keswick, who lived not far from Lingholm.

The setting of the pen-and-ink drawing of paddle-steamers is the railway quay at Holyhead. It is interesting to know that while Beatrix Potter was drawing the picture, her father was taking a photograph of the same scene – but *his* photograph shows the whole sweep of the quay including another paddle-steamer and the platform of the railway terminus on the left-hand side.

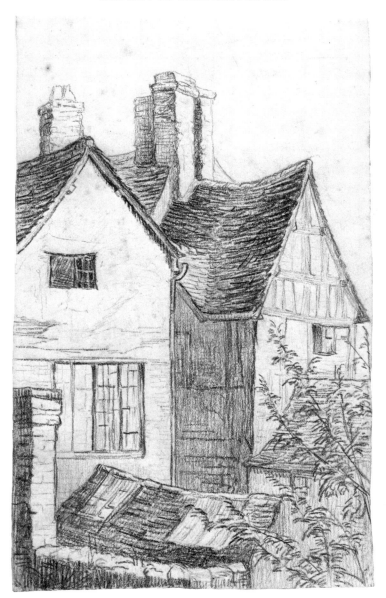

Bush Hall, near Hatfield *Summer 1884*

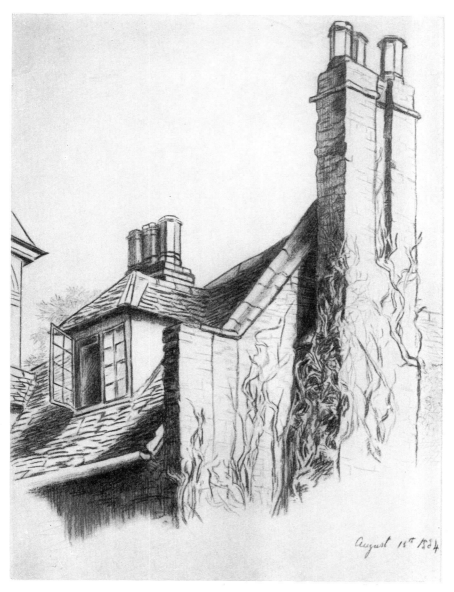

August 15th 1884

Bush Hall, near Hatfield *August 15th, 1884*

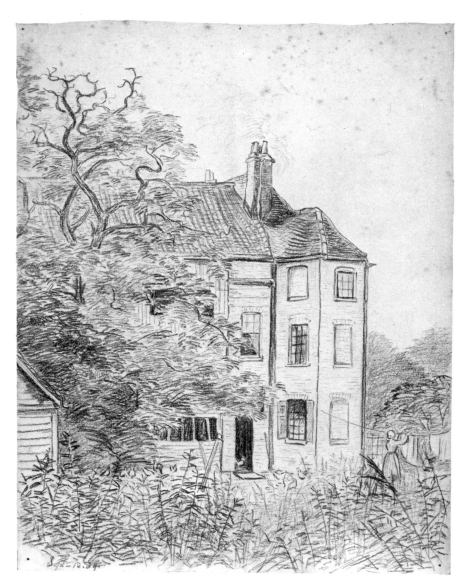

Bush Hall, near Hatfield *Sept. 12th, 1884*

Original

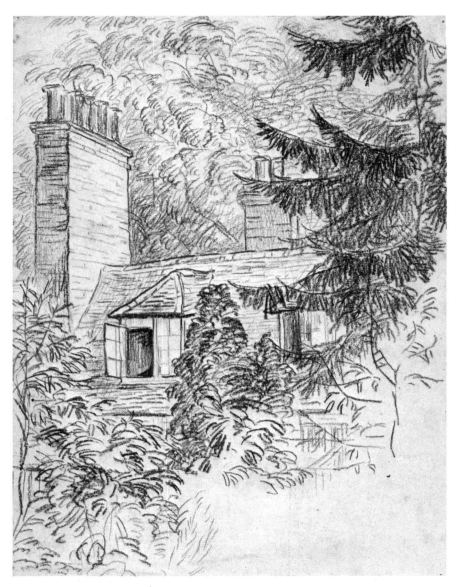

Bush Hall, near Hatfield *Summer 1884*

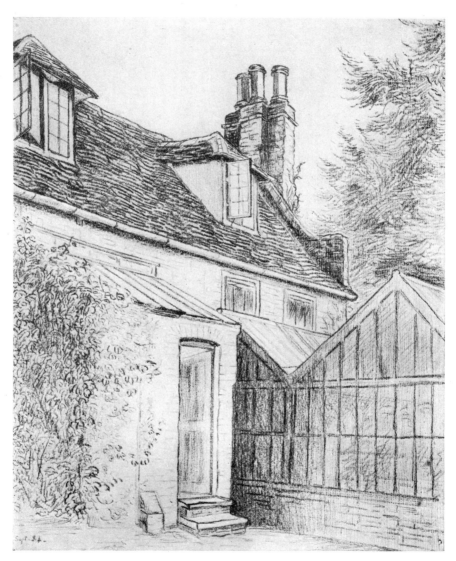

Bush Hall, near Hatfield *September, 1884*

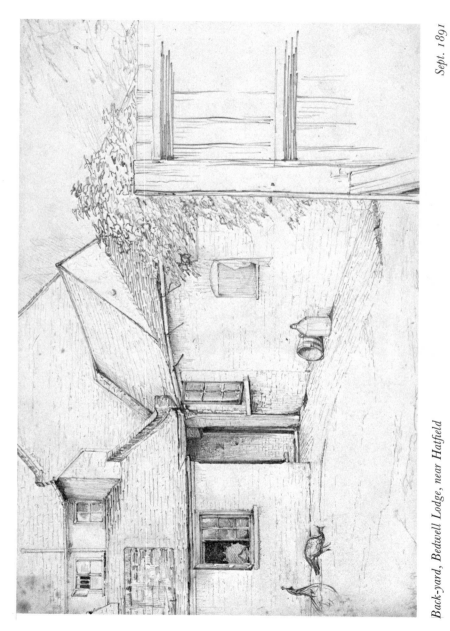

Sept. 1891

Back-yard, Bedwell Lodge, near Hatfield

'View from the drawing-room window at Camfield, Herts'

December 9th, 1884

Terrace at Camfield Place

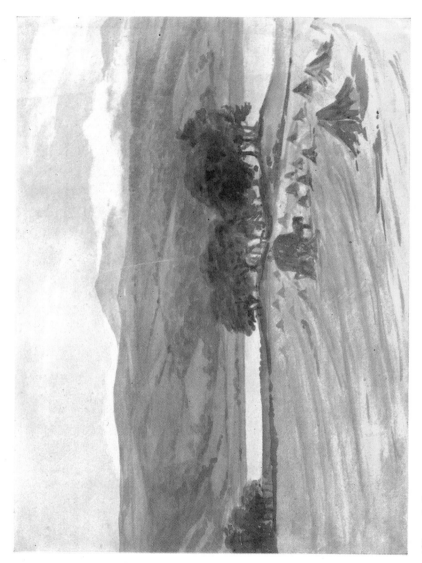

'Harvest', Sawrey

Cornfield, Sawrey

'Laund House, Bolton Abbey'
(July 2nd to July 8th, 1902)

A Page from her Sketch Book

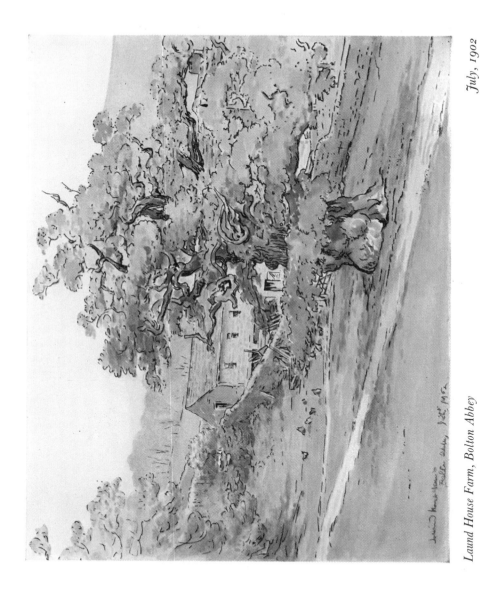

July, 1902

Laund House Farm, Bolton Abbey

71

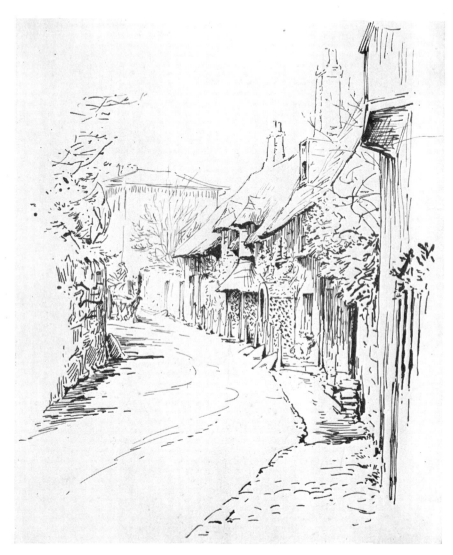

Lyme Regis, Dorset

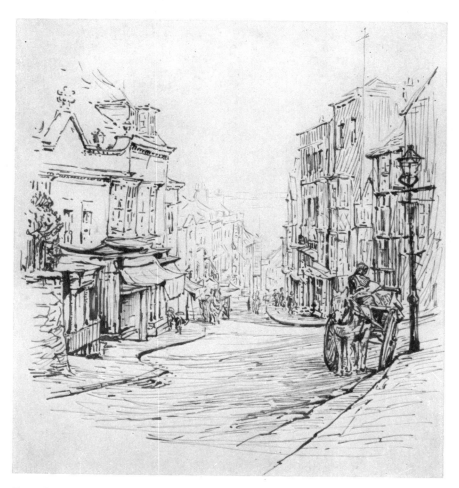

Lyme Regis, Dorset

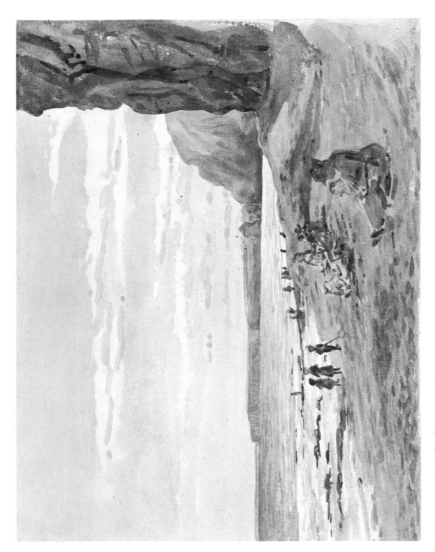

April 15th, 1902

'Like some tall cliff', Sidmouth, Devon

'Rain' Lingholm, Keswick *Aug., 1898*

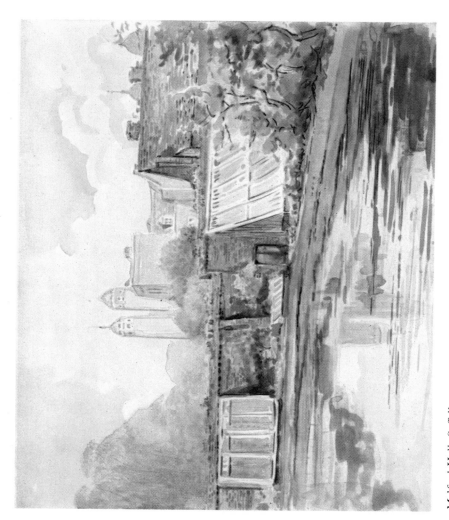

Melford Hall, Suffolk

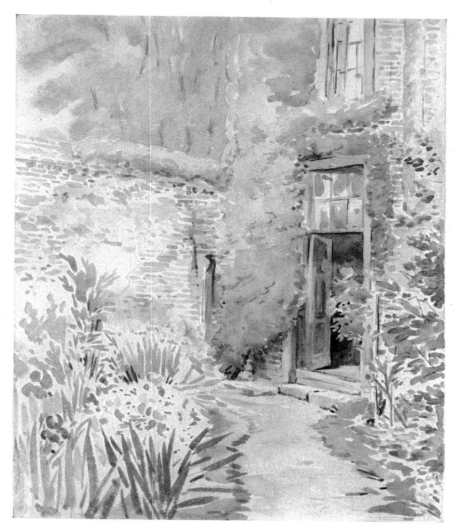

Melford Hall, Suffolk

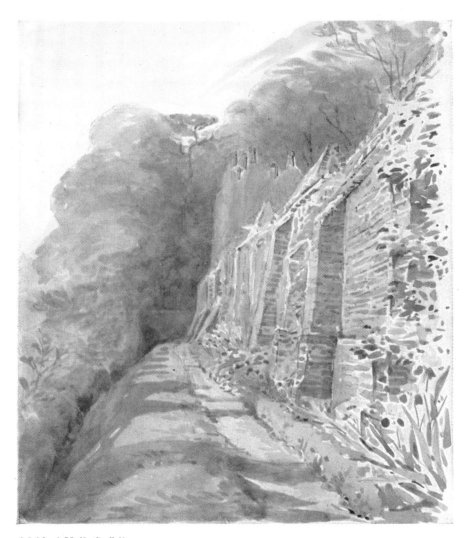

Melford Hall, Suffolk

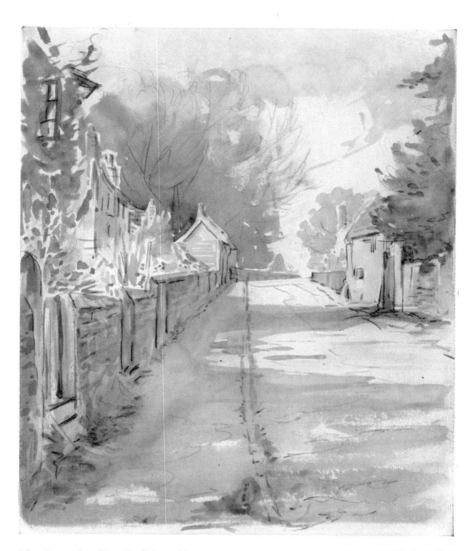

'On the road to Bury St Edmunds' *Long Melford, Suffolk*

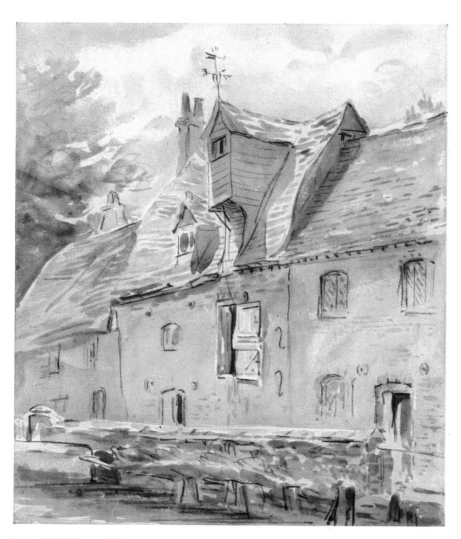

'An old Mill on the Stour' *Suffolk*

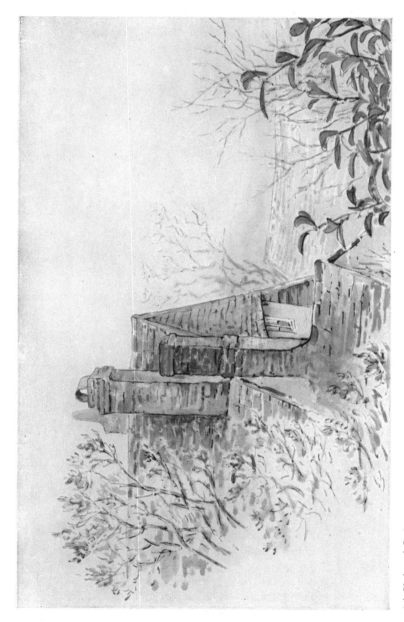

'A Sheltered Cot'

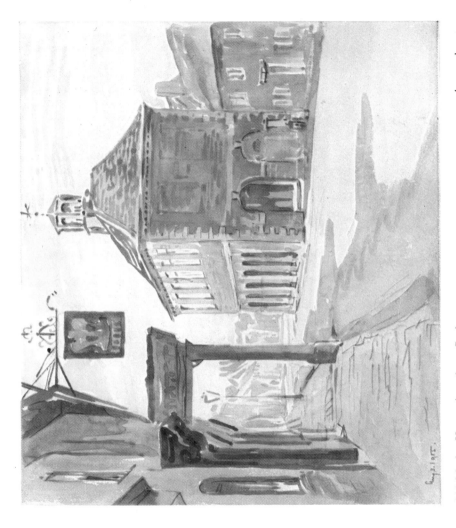

Aug. 3rd, 1905

Old Market House, Amersham, Bucks.

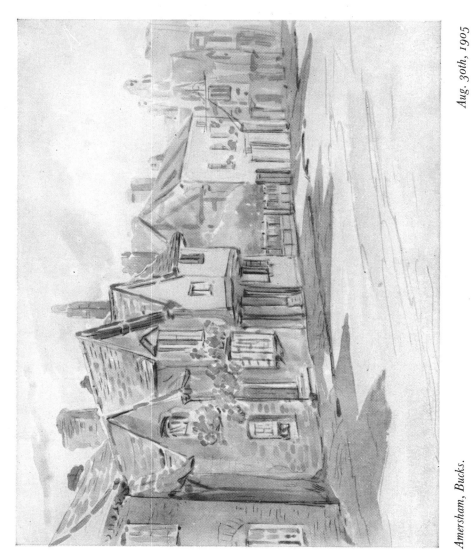

Aug. 30th, 1905

Amersham, Bucks.

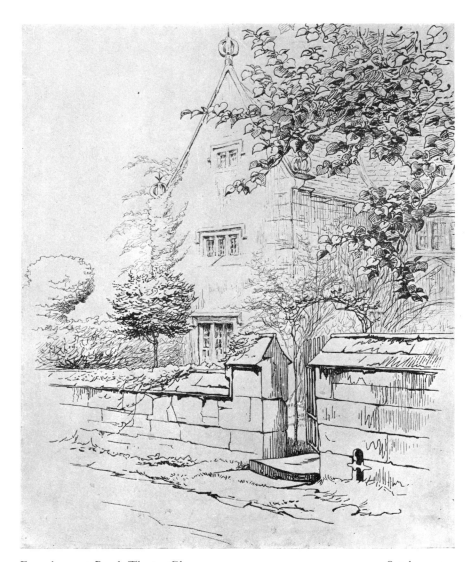

Farm-house at Brook Thorpe, Glos. *October, 1904*

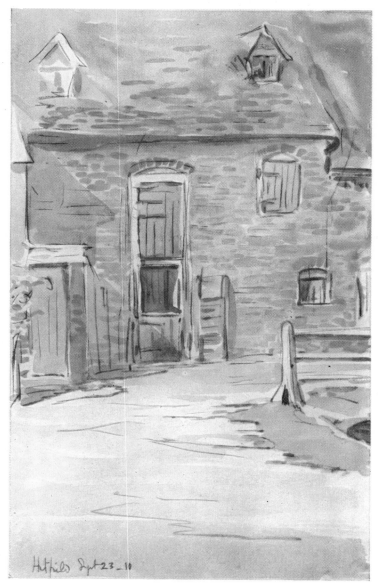

'A Hertfordshire Farm', Hatfield　　　　　　　　　　*Sept. 23rd, 1910*

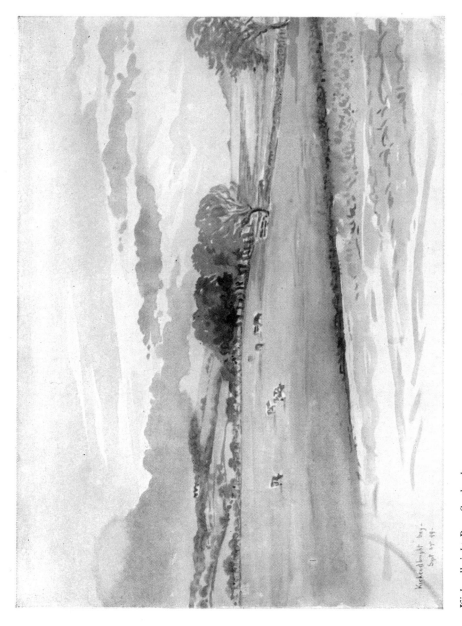

Sept. 27th, 1899

Kirkcudbright Bay, Scotland

86

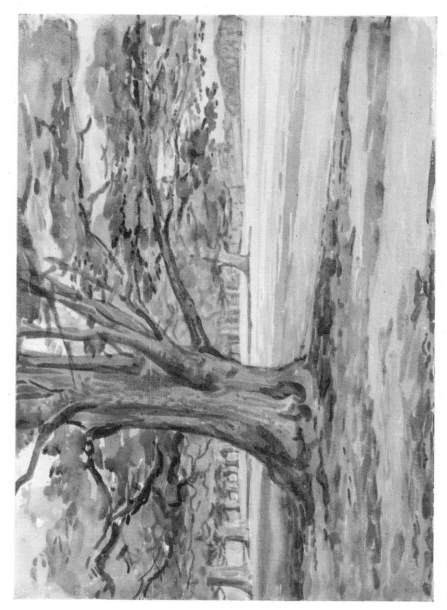

Forest Scene

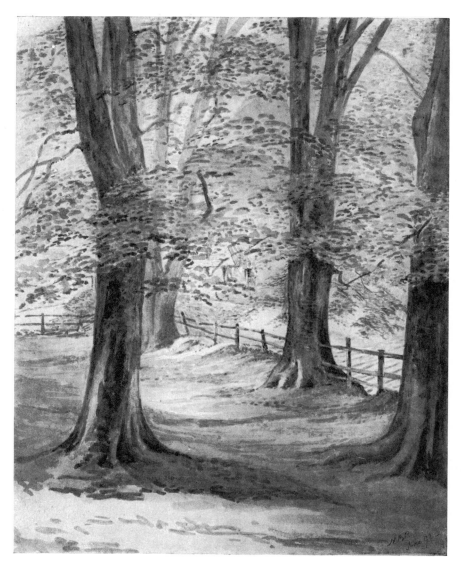

'*A Beech Wood near Inver, Dunkeld*' *June, 1892*

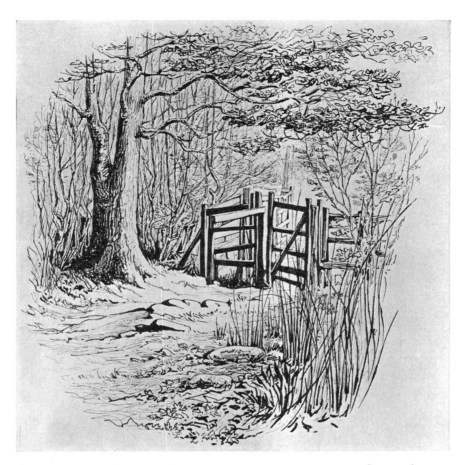

Woodland Sketch, Cumberland *Sept. 17th, 1904*

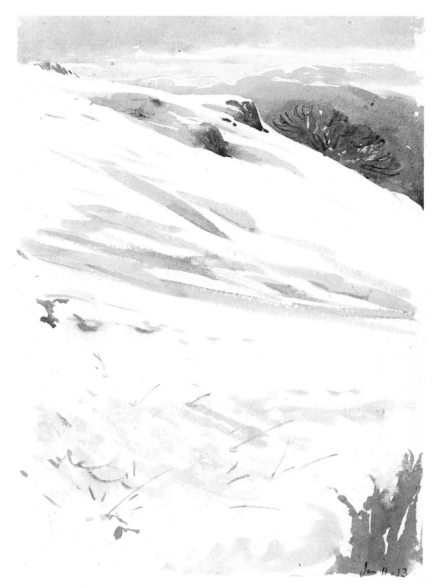

Snow Scene, Sawrey *Jan. 11th, 1913*

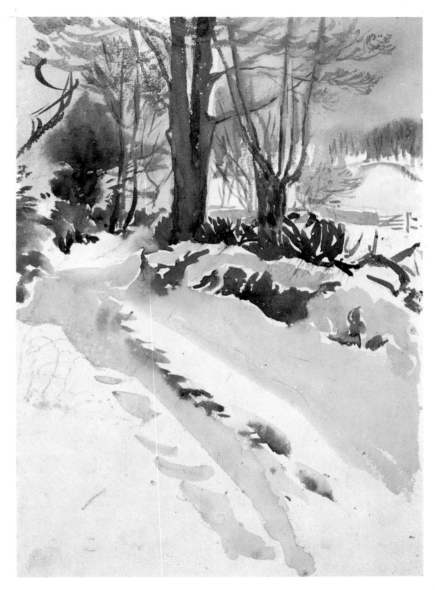

Snow Scene, Sawrey *Jan. 1913*

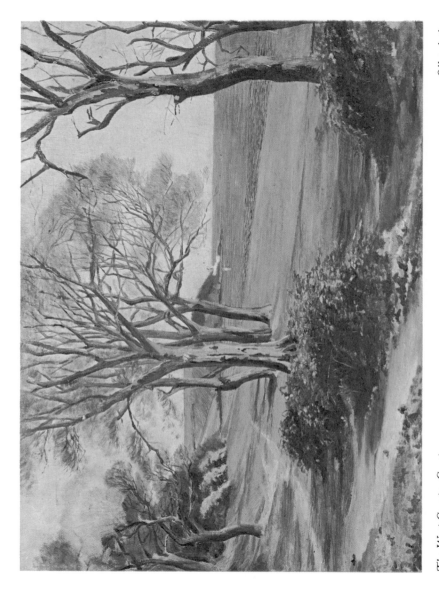

Oil painting

The West Country Coast

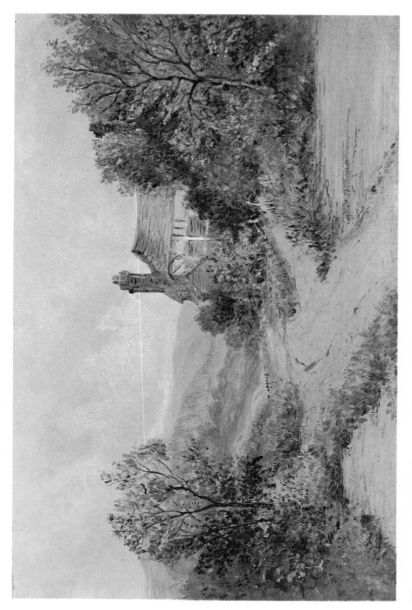

Oil painting

View from top of Swinside Farm across Newlands Valley, Cumberland

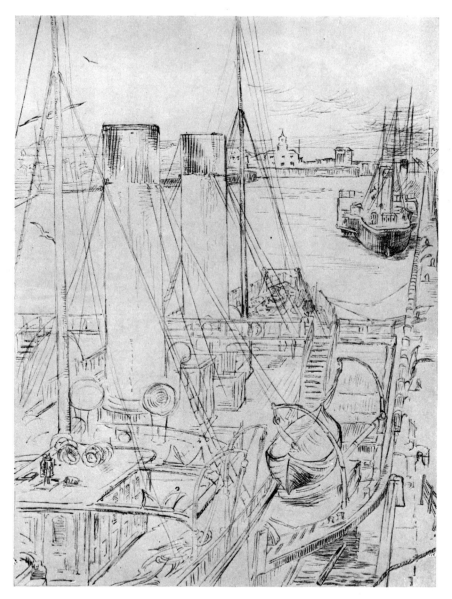

The Paddle Steamer, Holyhead *May, 1889*

4

*Gardens, Plant Studies
and Still Life*

GARDENS AND PLANT STUDIES

Beatrix Potter loved gardens, but at her London home they had nothing worthy of the name. A photograph by Rupert Potter and a painting by Beatrix Potter show that the garden of their London house was little more than a grass plot surrounded by a path and narrow flower bed, the whole enclosed by a brick wall; on one side there were two trees. In her painting the grass is shown white with daisies!

No wonder she loved to stay with her grandmother at Camfield Place in Hertfordshire; and enjoyed the gardens of the houses where the family stayed when on holiday.

During Beatrix Potter's holidays with her parents she mentioned in her Journal some gardens that particularly delighted her – those in the Close at Salisbury 'where the *Ribes* and *Pyrus japonica* are coming into flower, and the walls are covered with Cape jessamine.' She was equally charmed with the Deanery garden at Exeter where 'the pear trees were white as snow' and 'the lilac touched with green, and the air full of the smell of hyacinths'.

Part of the pleasure of staying with her uncle Burton at Gwaynynog, Denbigh, was that they had a large garden 'the prettiest kind of garden, where bright old-fashioned flowers grew amongst the currant bushes.'

When she bought Hill Top Farm and at last had a garden of her own, she became a keen gardener; her letters to Millie Warne were full of allusions to her out-door work. 'My news is all gardening and supplies,' she wrote, and again, 'I am absorbed in gardening. . . . I chose some delightful bushes yesterday, lilac, syringa, rhododendrons and a variety of others – including a red fuschia.' The village people also offered her gifts of plants. 'I have had something out of nearly every garden in the village.'

Gardens figure largely in some of the books – *The Tale of Tom Kitten, The Pie and the Patty-pan, The Tale of the Flopsy Bunnies,* not to mention her first and best-known book *The Tale of Peter Rabbit.* Gardens also figure largely in the paintings from her portfolios, some of which are reproduced here.

There are two pictures of the garden at Tenby, South Wales. It

was while staying here in 1900 that Beatrix Potter had the story of *Peter Rabbit* in mind, and according to her, 'the lily pond in Peter was at Tenby.' In this picture the foliage has been touched up with white oil paint to heighten the effect. It must have been a favourite of Beatrix Potter, for she painted a duplicate which hangs in one of the rooms at Hill Top.

This is another of the pictures criticised by the members of the 'small drawing society' referred to in section 3, and their comments are as follows:

There is a great deal of work in this and it is very well done. I think the outline of the cat is too sharply defined, it does not look fluffy enough *Sphinx*

Charming colouring – but over-worked *Stuffed Monkey*

The round pond and large stones in front are not required. The sketch is more complete without them *O.G.*

Too elaborate – but otherwise beautifully drawn – cats bad *Hoo?*

The other picture of the garden at Tenby was painted the following winter, after a heavy fall of snow. In the foreground, the little birds can all be recognised – robin, blackbird, thrush, blue-tit, house-sparrow, wren and greenfinch.

Another two pictures are of the garden at Lakefield, Sawrey (now Ees Wyke), where Beatrix Potter was staying when she first became acquainted with Hill Top Farm, which is only a short distance away. One of these pictures, 'An English Garden', was also sent round in the drawing society's portfolio. The sheet on which the members' comments were written has been removed, and all that remains is the title, Beatrix Potter's pen-name 'Bunny', and the first part of the opening comment, which reads, 'Wanting in colour and life, the distance is far the best part, drawing is good . . .' This terrace no longer exists as the land has been sold for building purposes.

There is a charming picture of the garden at Harescombe Grange in spring. This part of the garden was known as 'The Nuttery'. Harescombe Grange at Stroud in Gloucestershire was the home of Beatrix Potter's cousin Caroline Hutton, and it was here, where she frequently

stayed, that Beatrix Potter first heard the story about the tailor at Gloucester, which was the origin of her famous story.

Of the pictures of garden flowers, the one of carnations is of particular interest as it was drawn in the garden of Fawe Park, Keswick when Beatrix Potter was preparing backgrounds for *The Tale of Benjamin Bunny*. It was her intention to use this as the setting for the frontispiece, but she later changed her mind.

There are a number of paintings of wild flowers. One is of a group in an outdoor setting, and includes buttercup, cornflower, cow parsley, forget-me-not, honeysuckle, orchis, saw-wort and scabious. The painting inscribed 'Marsh Helleborine, Derwentwater' shows Beatrix Potter's very fine pen-and-ink and colour work.

Two pictures are particularly associated with her books – the picture of the foxgloves with *The Tale of Jemima Puddle-Duck*, and the onions with *The Tale of Benjamin Bunny*, where Benjamin 'suggested that they should fill the pocket-handkerchief with onions, as a little present for his Aunt.'

In her picture bearing the title 'Sweet bay tree', Beatrix Potter has added pencil notes, while arrows point to the direction of the light – 'direct light from this side', and 'against the light. The veins of the leaf are slightly transparent'. Below she has written, 'There has been no sunshine and evergreen leaves show very little transparent light without it.'

Associated with the tree study is an interesting letter written to an artist-friend, suggesting that he might consider studying trees – 'It is useful to understand them and incredible how badly many professional woodland landscape painters don't. I mean they have never considered how the branches grew from a tree trunk. For instance the ash Yggdrasil, the tree of heaven. Every year a new shoot. If you study an ash you will see every branch from the main trunk, or from the stem of the young sapling, has come out in curves; and curved on and on with the weight of foliage. Other species in contrast grow upward. We can tell every tree in winter without reference to foliage by its mode of growth. So study them . . . they will repay . . . they have a nobility of growth which is usually overlooked.'

STILL LIFE

This section contains some fine examples of Beatrix Potter's still-life work.

The baskets and pump were probably drawn during one of her holidays in the West Country, and the chairs and pewter jug at Winchelsea in 1900.

The pen-and-ink drawings of chairs were made at Fawe Park, Keswick, during the summer of 1903.

The vase of daffodils is another of the paintings circulated in the portfolio of the drawing society already mentioned. The member's comments are as follows:

Very pretty and very well painted (no name)
Backgrounds are not supposed to look distinct – very good *Hoo?*

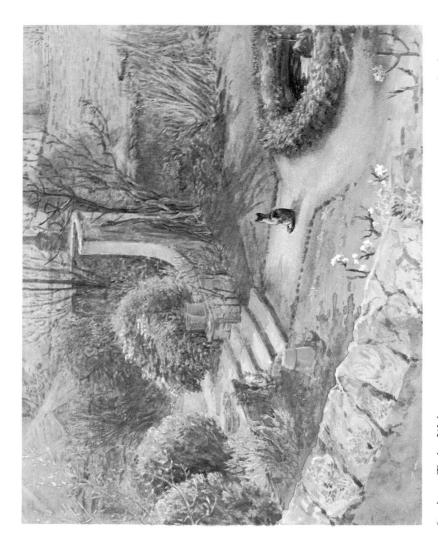

April, 1900

Garden at Tenby, Wales

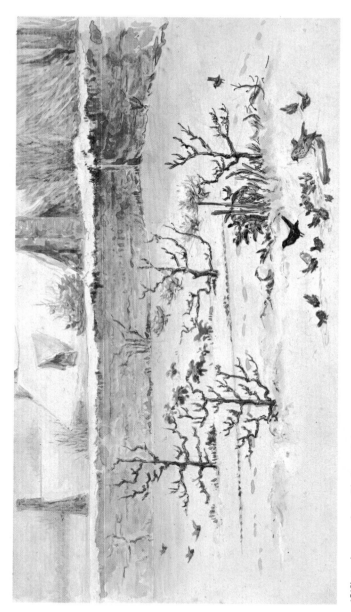

Feb. 1901

'Winter in a garden', Tenby, Wales

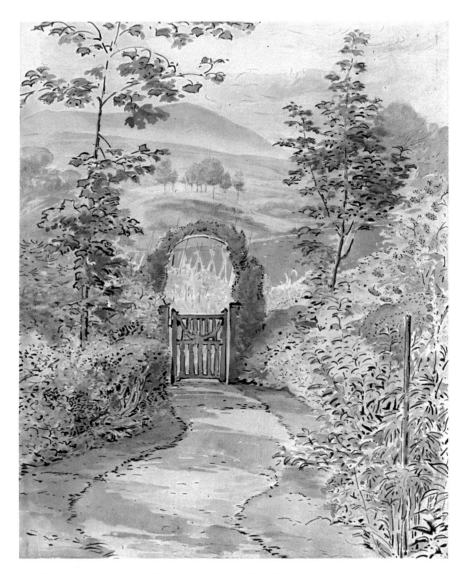

'*An Evening's close*', *Lakefield, Sawrey* (*now 'Ees Wyke*')

'An English Garden', Lakefield, Sawrey (now 'Ees Wyke')

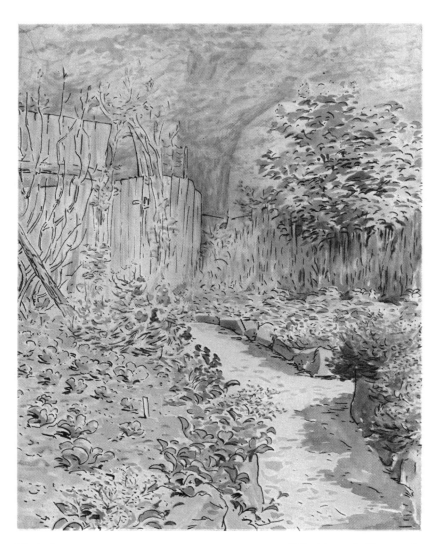

'Spring'

'The Nuttery', Harescombe
Grange, Gloucestershire

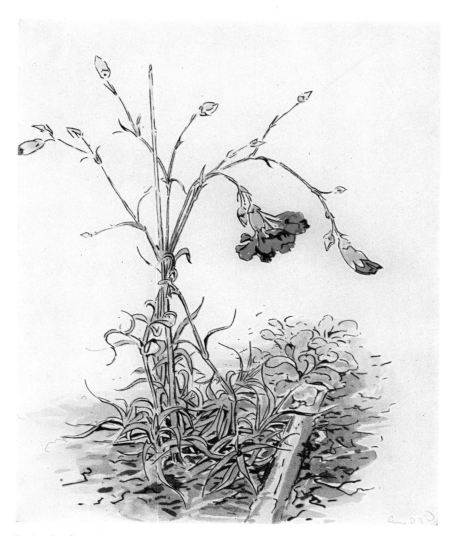

Study of a Carnation *Aug. 23rd, 1903*

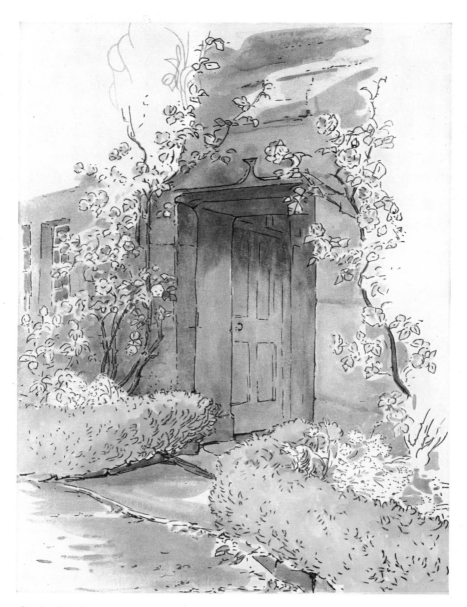

Garden Porch

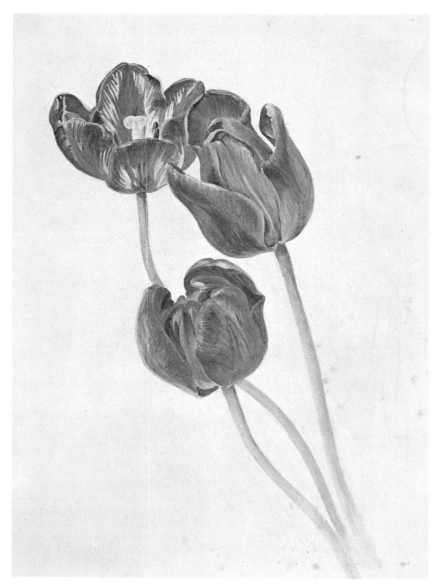

Tulips

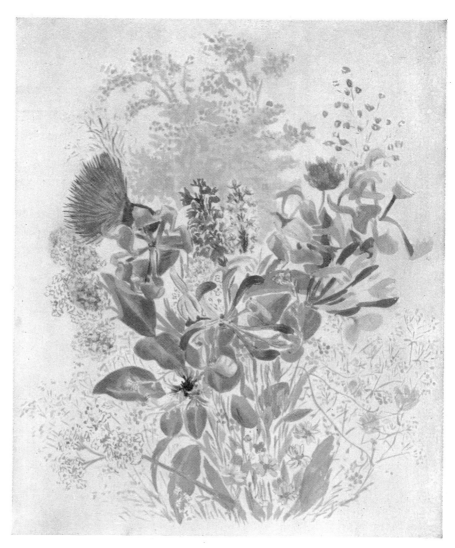

Wild Flowers

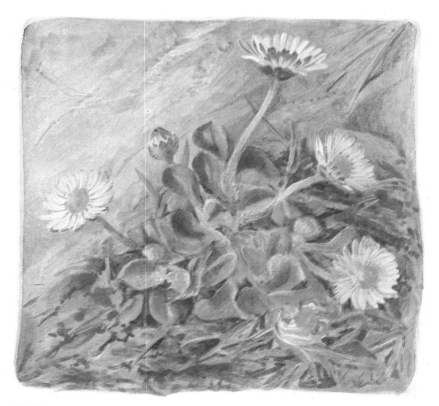

Daisies

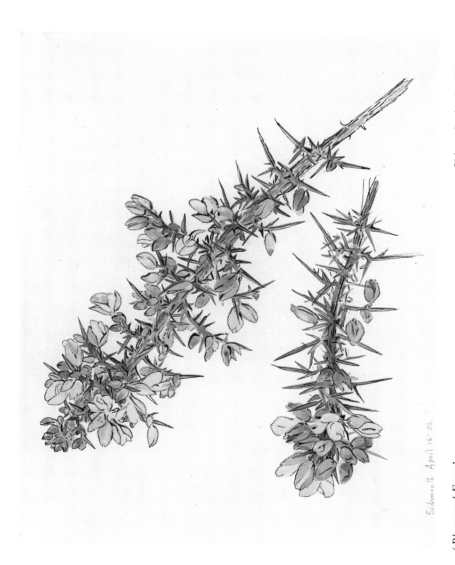

Sidmouth, April 16th, 1902

Sidmouth April 16~ 02

'*Blossomed Furze*'

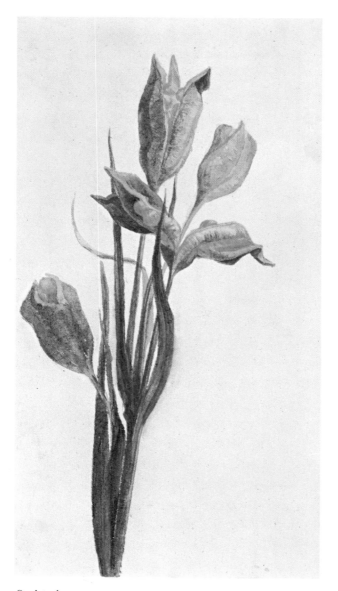

Seed-pods

'*Marsh Helleborine, Derwentwater*'

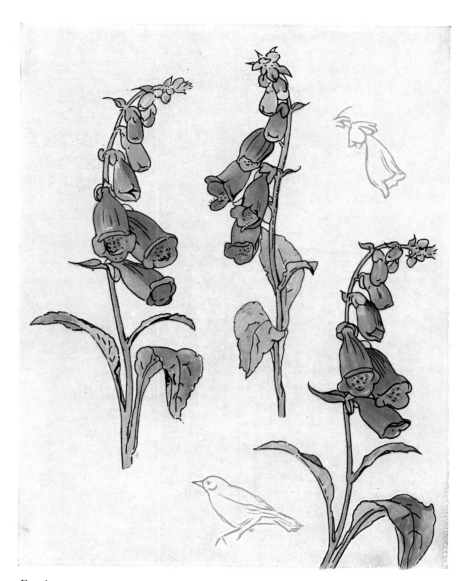

Foxgloves

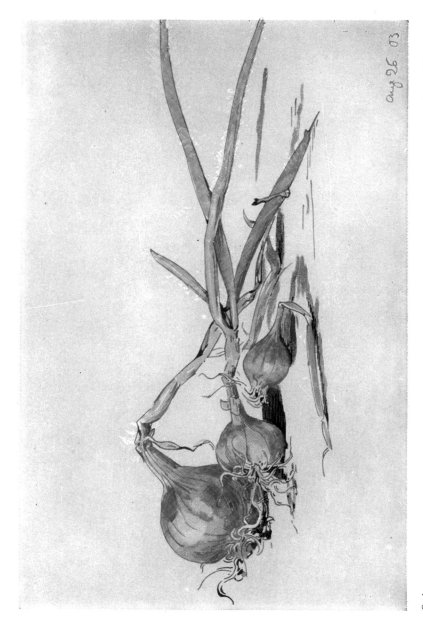

Aug. 26th, 1903

Onions

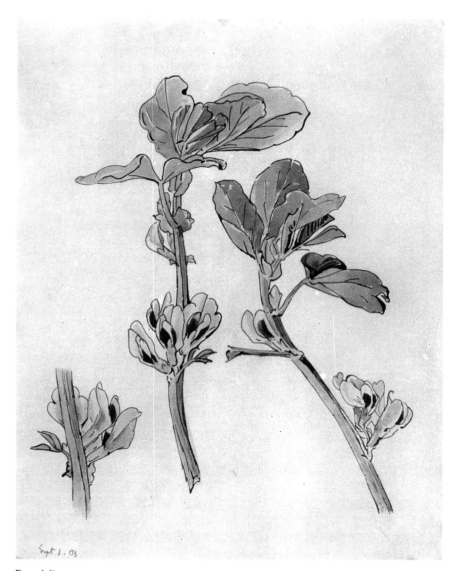

Broad Beans *Sept. 1st, 1903*

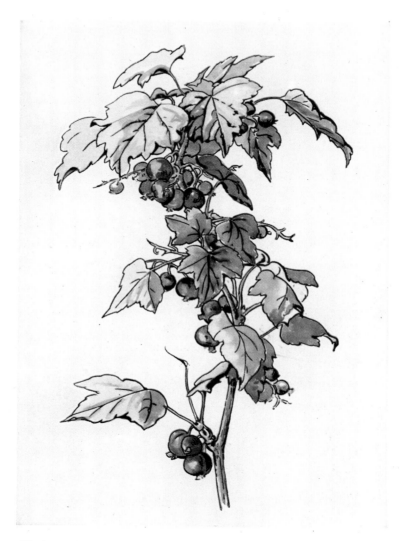

Blackcurrant

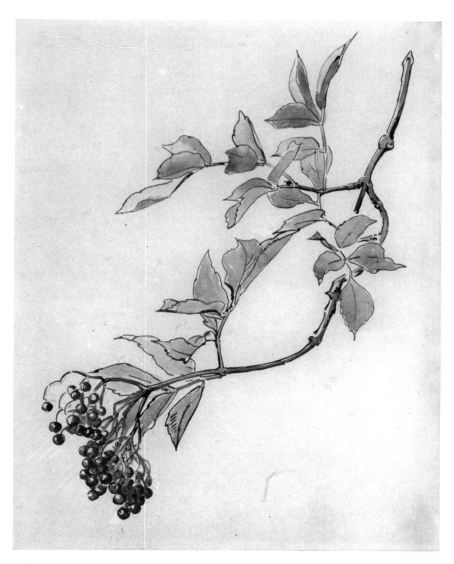

Elderberry

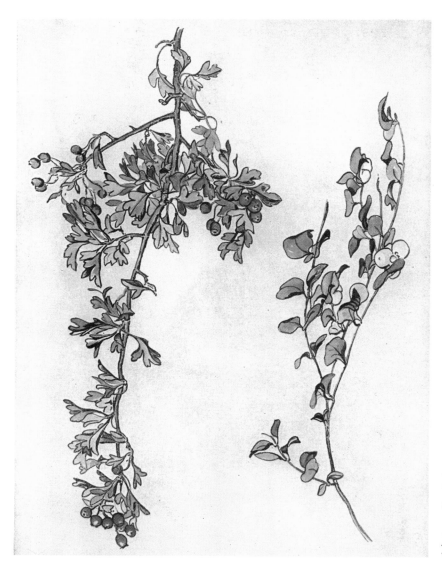

'Autumn Berries'

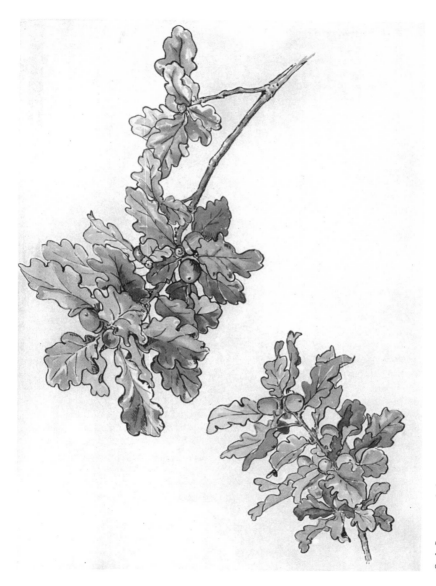

Oak Leaves and Acorns

Feb., 1900

'*Sweet Bay Tree*'

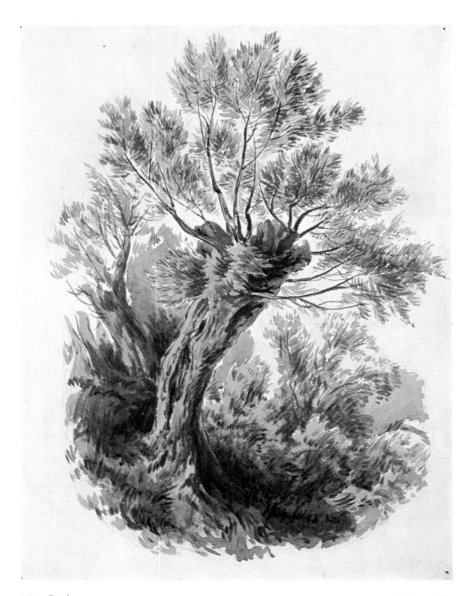

Tree Study *May, 1882*

Leaf Design

Still Life

Sketches made at Winchelsea *February, 1900*

Sketches of Chairs at Fawe Park, Keswick *1903*

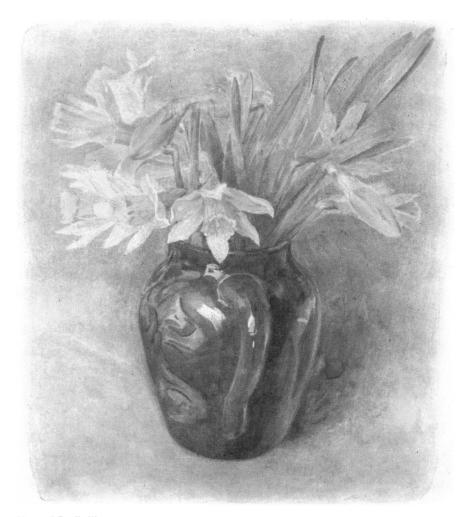

Vase of Daffodils

April, 1900

'*A Study in Reds*'

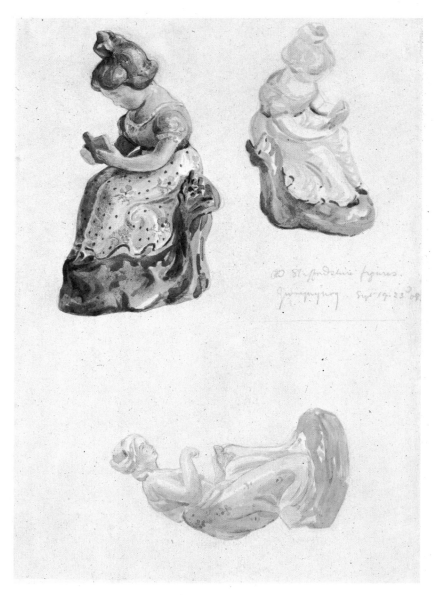

'Old Staffordshire figures, Gwaynynog' *Sept., 1908*

5

Microscopic Work and Drawings of Fungi

MICROSCOPIC WORK

Beatrix Potter tells how she went to Becks in Cornhill one day with Elizabeth her maid and bought a splendid lens for her microscope. This was because her previous one had rolled off the table and the glass had come out without her knowledge. When she discovered this the following day, she wrote, 'I was completely lost, as it was what I had done all my work with.'

The maids had swept and she saw little chance of finding it, though she was 'riddling the ashes à la Cinderella.' No one was more persevering than Beatrix Potter, and the following week we read in her Journal, '8.45, Cinderella found the lens in the *last* spoonful but *one* of the middle-sized ashes out of dust-bin. A satisfactory omen, but it looked scratched.'

Beatrix Potter spent a great deal of time at the Natural History Museum, South Kensington, which was quite close to her home. There she studied spiders and beetles and all kinds of insects, including butterflies and caterpillars.

She was somewhat critical of that 'august Institution'. One day when she went in need of advice, she 'worked into indignation. . . . It is the quietest place I know – and the most awkward. They have reached such a pitch of propriety that one cannot ask the simplest question.' On the other hand she made some witty remarks about the staff who worked there.

'The clerks seem to be all gentlemen and one must not speak to them,' she wrote. 'If people are forward I can manage them, but if they take the line of being shocked it is perfectly awful to a shy person.' Then there was Mr Kirby who stuttered a little, and Mr Pocock 'and a gentleman with his head tied up, who were sufficiently pleased with my drawing to give me a good deal of information about spiders'; while Mr Waterhouse was described as 'so like a frog we had once, it puts me out.' The staff were kind but incredibly slow; 'they do not seem to be half sharp.'

Here in the museum which was at times very empty and quiet, she studied labels on insects and meditated on the habits of spiders – why

do 'spiders (which by the way are not insects) that sit in a web have the long legs in front, whether because they sit in a web, or that they sit in the web because of their legs?' And she pondered on 'the relation of the colour of caterpillars to the perfect insect, and why some not dissimilar insects have quite different caterpillars.'

In this section are paintings of two butterflies, and alongside each is a highly magnified view of the wing scales showing more clearly the beauty of the colouring.

Another of her drawings is of a Ground Beetle. At the top there are two views of the beetle – one from above and one from below – painted twice full size; and below are some highly magnified details of the anatomy of the legs, marked A, B, C and D, as follows:

A. Front leg, highly magnified
B. Tarsus of middle leg, highly magnified
C. Joint of leg, highly magnified
D. Joint of leg, more highly magnified.

Other microscopic work in this section includes highly magnified studies of a beetle, a spider, and three freshwater animals.

DRAWINGS OF FUNGI

Beatrix Potter's study of fungi began about 1887 when she was twenty-one and continued until about 1901. It was from 1893 until 1898 that she made an intensive study of the subject, and it became one of the chief interests of her holidays in Scotland and the north of England to search for specimens of fungi in the woods and surrounding country. In her Journal there are frequent references to these discoveries.

In Birnam near Dunkeld she painted 'several rare species. One with white spikes on the lower side . . . and another, like a spluttered candle.' Lennel in Berwickshire was a paradise for searchers of fungi. One day when Beatrix Potter went to Hatchednize wood 'suspecting funguses from the climate' they 'starred the ground apparently in thousands . . . I found upwards of twenty sorts in a few minutes,' she wrote. In another wood she returned home with her largest fungus 'eight inches across and weighing just under a pound.' Not only did

she find them in the woods, but 'the withered remains of a new fungus, *Gomphidius viscidus*' in a sandstone quarry, and 'gigantic red ones . . . on bleached horse-dung in the bog.'

She searched for fungi in places as far apart as Dunkeld in Scotland, and Sidmouth in Devon; in the garden of her grandmother Potter's house at Camfield Place, and on Edge Common, Stroud, while staying with her cousin Caroline Hutton at Harescombe Grange. She even found them in a coal-cellar in a London road.

The thought of fungi was constantly in her mind, and during an Easter holiday at Swanage in 1896 she wrote in her Journal, after seeing a 'fine meteor', 'I do not often consider the stars, they give me a *tissick*. It is more than enough that there should be forty thousand named and classified funguses.'

During her six years of intensive study Beatrix Potter produced some 250 paintings of fungi. She hoped that one day they would be published. In 1897, in a picture letter to her cousin's little boy, Walter Gaddum, she wrote, 'I have been drawing funguses very hard. I think some day they will be put in a book, but it will be a dull one to read.'

This hope was never fulfilled in her life time, but in 1967 Dr W. P. K. Findlay was so impressed 'on seeing the splendid . . . paintings of fungi . . . by Beatrix Potter' that he used fifty-nine of them to illustrate his book *Wayside and Woodland Fungi*.

An added charm of Beatrix Potter's drawings of fungi is that so many show the fungi in the full beauty of their natural settings. The majority of these paintings, some 270 in all, were bequeathed to the Armitt Library at Ambleside, where they may be seen on request. A few others were not included in the main collection.

Beatrix Potter also undertook microscopic studies of lichens – part fungus, part alga. This led to theories of her own, which were in advance of those of the authorities at the Royal Botanic Gardens at Kew. On account of her youth, and the fact that she was a woman, they did not take her seriously, as is shown by a letter which she wrote to the Director in regard to her research work:

'Uncle Harry (Sir Henry Roscoe) is satisfied with my way of working,' she wrote, 'but we wish very much that someone would take

it up at Kew to try it, if they do not believe my drawings. Mr Massee took objection to *my* slides, but the things exist, and will be all done by the Germans.' The letter ends with a reference to a paper which Beatrix Potter had written 'On the Germination of the Spores of *Agaricineae*' – 'It is rather a long paper to ask you to be kind enough to read.'

On April 1st, 1897 her paper was read at a meeting of the Linnean Society of London by Mr George Massee (at that time women were not allowed to read papers). It was never published because Beatrix Potter asked for its withdrawal, no doubt for further research. Unfortunately the paper has now been lost.

Fungi also appealed to Beatrix Potter's romantic imagination, and once when staying in the Lake District she wrote, 'I think one of my pleasantest memories of Esthwaite is sitting on Oatmeal Crag on a Sunday afternoon, where there is a sort of table of rock with a dip, with the lane and fields and oak copse like in a trough below my feet, and all the little tiny fungus people singing and bobbing and dancing in the grass and under the leaves all down below, like the whistling that some people cannot hear of stray mice and bats, and I sitting up above and knowing something about them.

'I cannot tell what possesses me with the fancy that they laugh and clap their hands, especially the little ones that grow in troops and rings amongst dead leaves in the woods. I suppose it is the fairy rings, the myriads of fairy fungi that start into life in autumn woods.'

Vanessa cardui
Scales on lower side of wing highly magnified

Painted Lady Butterfly

Painted Lady Butterfly.
.Vanessa Cardui.
Scales on lower side of wing highly magnified.

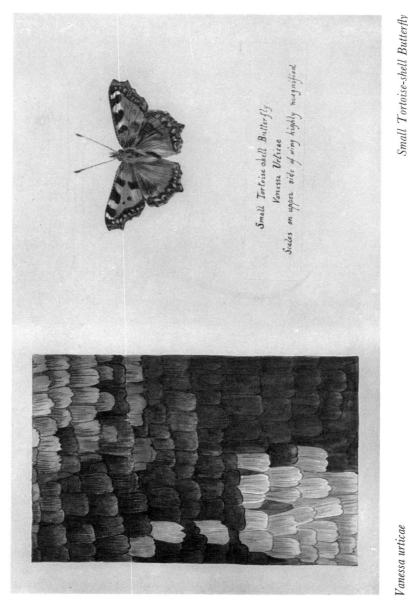

Small Tortoise-shell Butterfly
Vanessa Urticae
Scales on upper side of wing highly magnified

Small Tortoise-shell Butterfly

Vanessa urticae
Scales on upper side of wing highly magnified

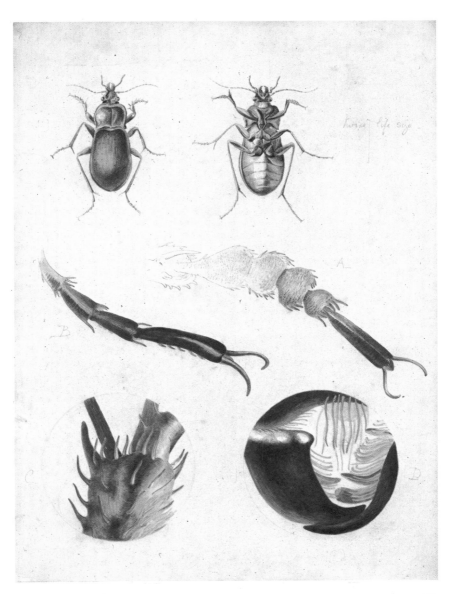

Microscopic Studies of a Ground Beetle *c. 1887*

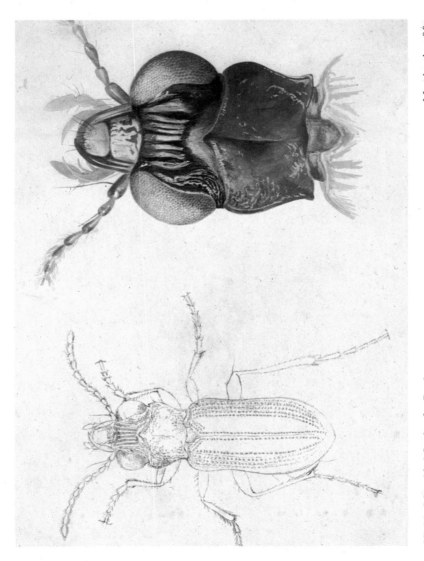

March 4th, 1887

Highly Magnified Study of a Beetle

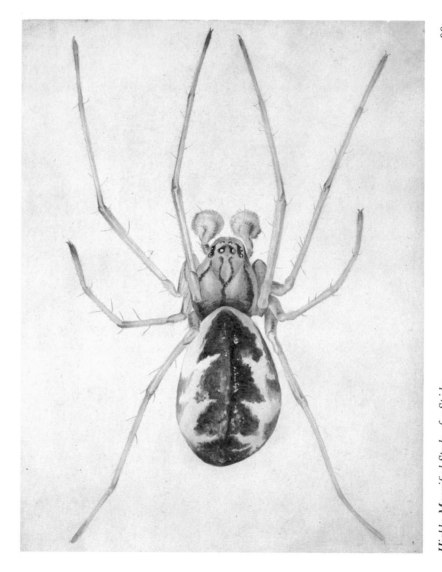

c. 1887

Highly Magnified Study of a Spider

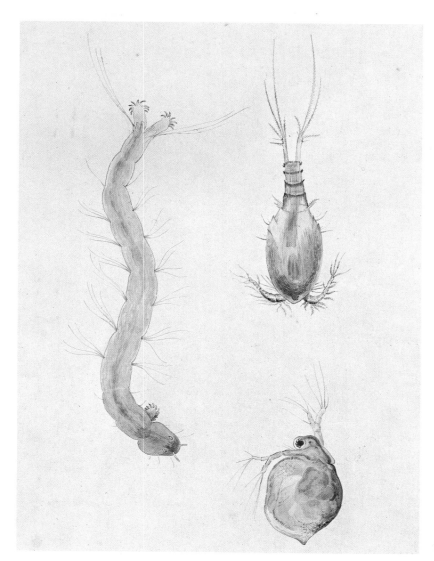

c. 1887

Three Freshwater Animals Highly Magnified

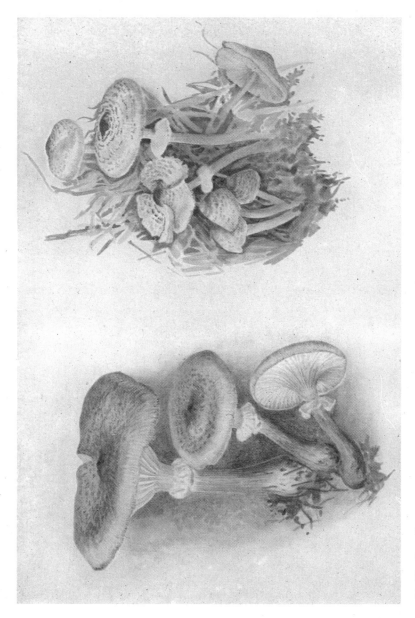

A. (Lepiota) cristatus
Dunkeld, also at Holehird, Windermere. Sept. 9th, 1893

(Ref.: Armitt Library, Vol. 1, No. 14)

Armillaria mellea
Heath Park, Dunkeld. Aug. 17th, 1893

(Ref.: Armitt Library, Vol. 1, No. 16A)

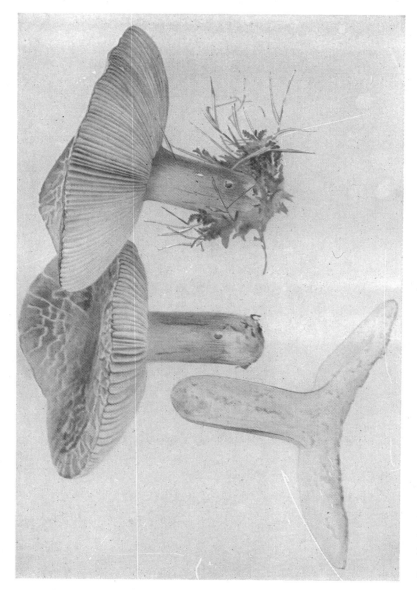

Russula lepida

Hatchednize Wood, Coldstream. Aug. 3rd, 1894

(Ref.: Armitt Library, Vol. 2, No. 29)

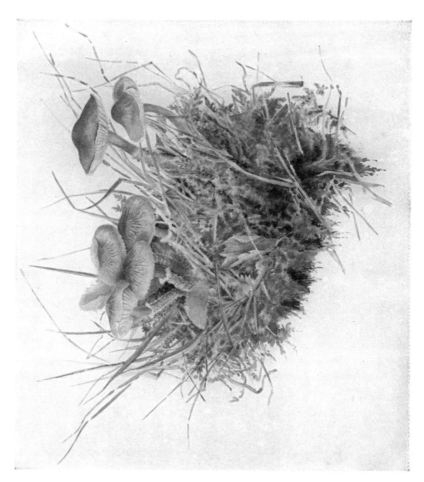

Tomgarrow Strath Braan
Oct. 8th, 1893

A. (Lepiota) granulosus

(Ref.: Armitt Library, Vol. 1, No. 13)

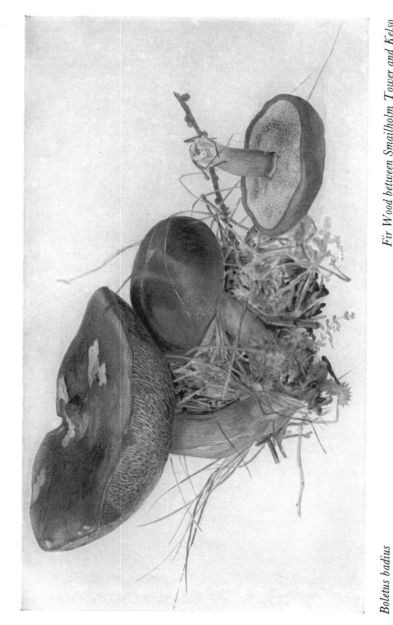

Boletus badius

Fir Wood between Smailholm Tower and Kelso
Sept. 19th, 1894

(Ref.: Armitt Library, Vol. 6, No. 139)

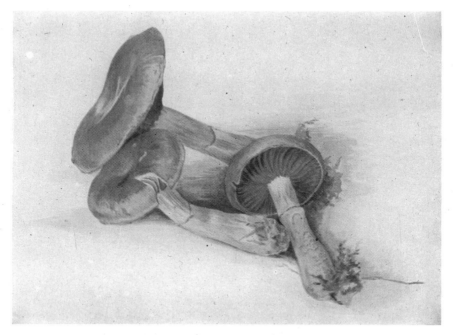

Cortinarius (Telamonia) torvus *Dunkeld. Aug. 25th, 1893*

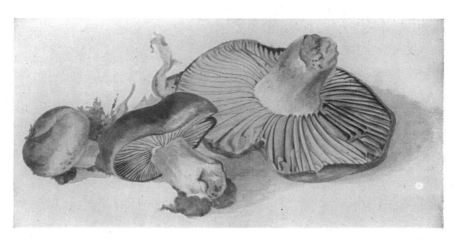

Russula nigricans *Eastwood, Dunkeld and Lennel*
Aug. 28th, 1893

(Ref.: Armitt Library, Vol. 4, No. 109, and Vol. 2, No. 28)

144

6

Animal Studies

ANIMAL STUDIES

Beatrix Potter had a natural gift for drawing animals, and her pictures are both artistic and accurate to the smallest detail. Nearly all of these were drawn from life. She had opportunities to observe the animals closely as she and her brother, Bertram, kept a variety of pets, ranging from rabbits, hedgehogs and mice, to lizards, toads and even snakes.

There was the jay that Bertram took to Oxford 'crammed into a little box, kicking and swearing. Mamma expressed her uncharitable hope that we might have seen the last of it.'

There were the newts that escaped over night and were caught, 'one black newt in school room and another in larder, but nothing seen of poor Sally, who is probably sporting outside somewhere.'

There was Mrs Mouse, 'In many respects the sweetest little animal I ever knew,' and a family of snails, each member of which had its own name – 'Lord and Lady Salisbury, Mr and Mrs Camfield, Mars and Venus.' She also had a little green frog, Punch, for 'five or six years – he has been on extensive journeys,' she wrote.

The tortoise in one of the opening pictures in this section is probably the same one that we see in the drawing of the interior of the school room at 2, Bolton Gardens (Section 2). The weasel was drawn at Camfield Place. Beatrix Potter, like a number of people, saw likenesses to animals in human beings. In her Journal, which being in code was safely hidden from the eyes of her family, she wrote, 'How amusing Aunt Harriet is, she is more like a weasel than ever.'

One afternoon when Bertram came back from Kensington Gardens, he told Beatrix Potter that he had seen 'a very little bat flying at the Round Pond.' She was surprised for it was the first time she had heard of a bat in London. She had seen them at Camfield Place at dusk when they 'hawked up and down between the wall and the kitchen window,' no doubt attracted by flies. Bats, too, flitted round the house on summer evenings at Dalguise in Scotland.

One term when Bertram went back to school he left Beatrix Potter 'the responsibility of a precious bat. It is a charming little creature,' she wrote, 'quite tame and apparently happy as long as it has sufficient

flies and raw meat, I fancy bats are things most people are pleasingly ignorant about, I had no idea they were so active on their legs, they are in fact provided with four legs and two wings as well, and their tail is very useful in trapping flies.'

Three of Beatrix Potter's pictures of bats are reproduced here. The two views of a bat in the first picture were painted when she was eighteen, no doubt at the Natural History Museum, South Kensington. The other two, each within a circle, are part of a larger unfinished sheet on which she has also drawn a skeleton of the body and wings, and two views of the skull.

The squirrels on the log were probably painted from two squirrels which Beatrix Potter bought when working on her pictures for *The Tale of Squirrel Nutkin*; and the guinea-pigs in a basket were almost certainly some she borrowed from a London friend, Miss Paget, and described in her Journal in January 1893.

Perhaps of all her pets, the ones that meant most to her were the rabbits. She had two Belgian rabbits (two bucks in succession), the first called Benjamin Bunny (commonly known as 'Bounce'), the second, Peter. When cold they used to tuck their forepaws backwards under the fur and lie upon them. 'Both were fond of the fire, and one used to lie inside the fender; I have even seen him asleep under the grate on the hot ashes when the fire had gone out,' she wrote.

She found that tame rabbits were 'capable of developing strong character, if taken in hand when young,' and that 'they can be taught tricks, playing tambourine and ringing a bell.'

In this section there is a page of pencil drawings of heads of Benjamin Bunny, made in 1890. Beatrix Potter told how 'he used to bang his hind legs and jump against the wire fender in the school room as he frisked around. A noisy cheerful determined animal, inclined to attack strangers.'

There are two pencil sketches of her second rabbit, Peter, and a painting of him lying in front of the fire guard in one of the rooms at Bolton Gardens. On the back of the painting Beatrix Potter pencilled – 'Peter Rabbit – he had an old quilt made of scraps of flannel and blue cloth which he always lay on.'

Of the other two pictures of rabbits reproduced, one is a painting of four rabbits in their warren (are they Flopsy, Mopsy, Cotton-tail and Peter?) and the other, a pencil drawing of two rabbits and a bird.

Beatrix Potter was very interested in mice. In a letter written in her seventies she said, 'I used to tame house mice – so tame that I could pick them up, with food in my hand.' When in her mid-fifties, she wrote, 'I had many mouse friends in my youth. I was always catching and taming mice, the common wild ones are far more intelligent and amusing than the fancy variety, but strange to say mine never bred in spite of having much liberty and comfortable neat boxes . . . Hunca Munca firmly refused to have any family.' Some charming pictures of mice, drawn from life, are included in this section. The painting of the little wood-mouse was sent in 1886 to a friend as a Christmas present.

There are also a number of miscellaneous sketches of animals – horses, cows, sheep and rams. Beatrix Potter had a particular interest in sheep, and in her later years became a highly successful sheep farmer.

Many years before, in her Journal, she wrote of an encounter with a flock of sheep when she was out driving with her mother in Scotland, over roads 'dappled with footmarks of hundreds of Highland sheep. We met three great flocks of the little creatures, woolly white, freshly washed, bleating and pressing to the side of the road, where they snatch a mouthful as they pass. They are coming down from the hills, already for a week past capped with snow.'

She also told how a week later she saw six rams on a wooden foot bridge, 'great old fellows stalking by themselves.' She saw rams too at Burmouth in Berwickshire 'all over the neighbourhood, in clover fields in solitary state,' and spent one day drawing a ram's head.

On three pages there are studies of cats and kittens. The two pencil drawings were probably studies for her pictures in *The Tale of Tom Kitten*; and the painting of two cats, done at Fawe Park, Keswick, was a study for her picture in *The Tale of Benjamin Bunny*, where the cat sat on the basket.

The picture of the roe-deer and fawn was drawn at the Zoological Gardens, where Beatrix Potter sometimes went to draw animals. She

had also studied roe-deer in their wild state in the woods around Birnam near Dunkeld. She told how she saw a hind running about in the fern like a rabbit. 'When it went back to feed I crept up nearer, but overdid it at last, and it looked up, with a mouthful of wild sage. The plant hung out like a lettuce-leaf in a rabbit's mouth, and it would munch a moment and then stare, and munch again. When its mouthful was finished, it stretched its neck straight out and uttered a long single bleat, which it repeated presently, pumping up the sound from its flanks to judge by the way it heaved, then it took a header over the bank of fern disappearing into the wood with a twinkle of red and white.'

It is believed that the pencil drawing of gazelles was also made at the Zoological Gardens.

The 'strange little red fish' was picked up by Beatrix Potter when walking along the beach at Weymouth one Sunday morning in 1895. It was a boar-fish, and she painted it life-size.

The green lizard, which is to be found in the south of England, was probably brought back from Ilfracombe with Judy, who is painted in the picture of the pineapple (see Section 1).

The last picture in this section was painted while staying with her uncle Sir Henry Roscoe at his country house on the summit of the North Downs, half way between Guildford and Dorking. It was here that Beatrix Potter picked up a dead thrush in the snow, and we see it in various positions – a fine example of her work as a naturalist. Beatrix Potter could see beauty in a creature, even when it was no longer alive.

Weasel *Camfield, May, 1888*

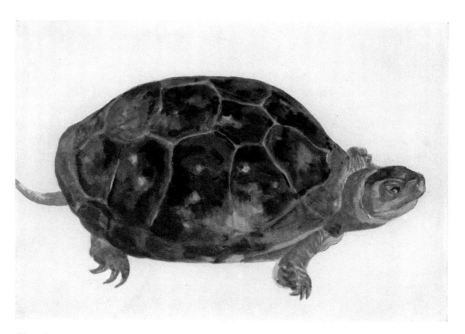

Tortoise

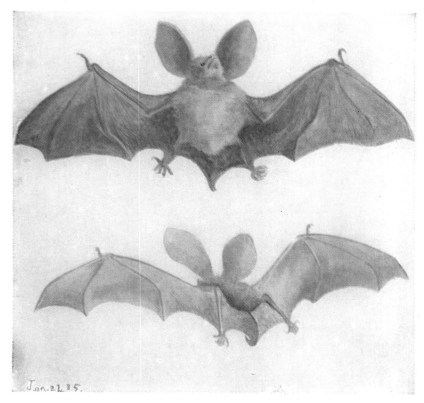

Studies of a Bat *January, 1885*

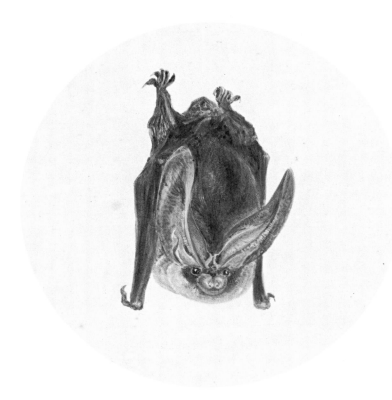

Study of a Bat *April 8th, 1887*

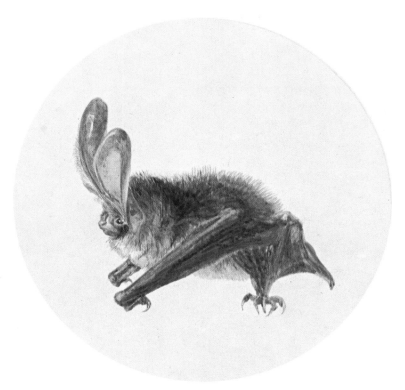

Study of a Bat *April 8th, 1887*

Squirrels on a Log

The Squirrels Discover Mistletoe

Sketches of Squirrels

155

Guinea-pigs

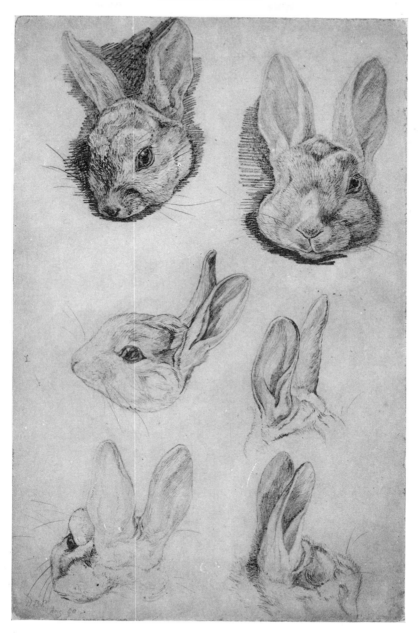

Heads of Benjamin Bunny *August 1890*

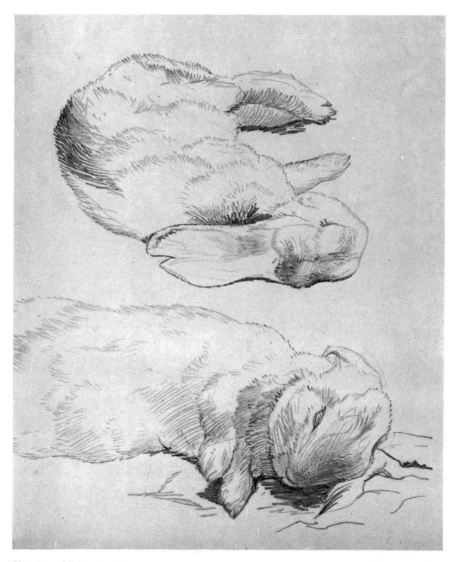

Sketches of Peter Rabbit *February, 1899*

August, 1899

Peter Rabbit

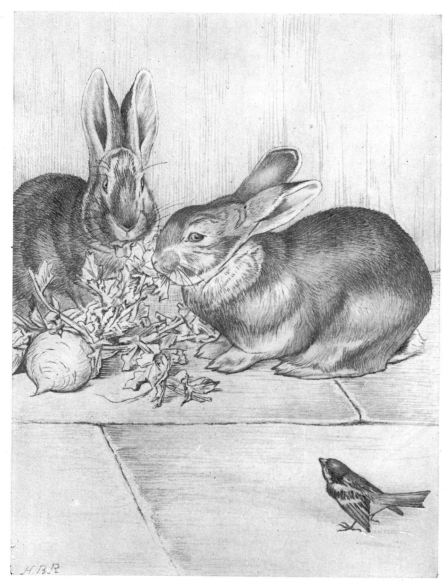

Rabbits and Bird

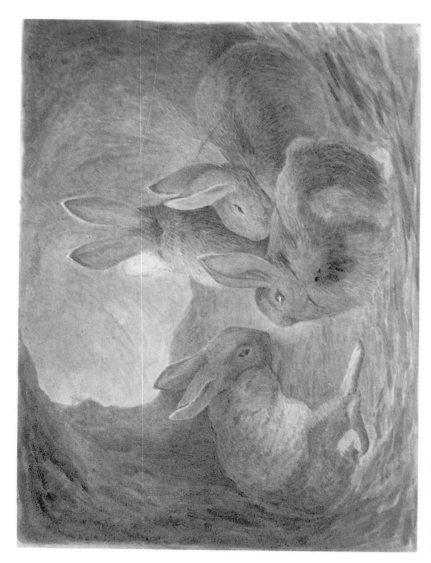

Rabbits in their Warren

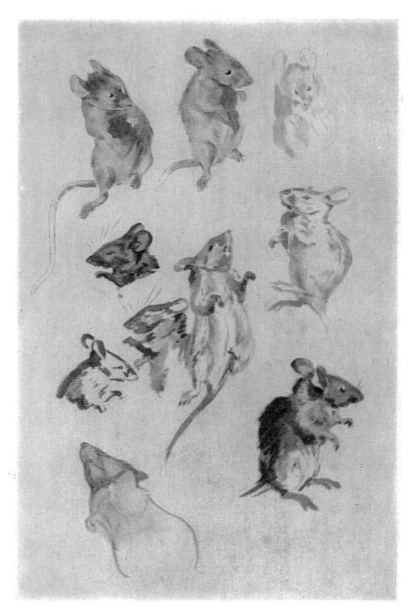

Studies of Mice

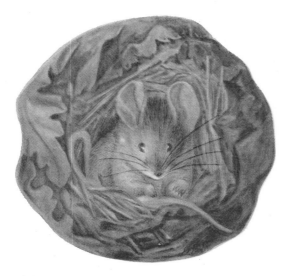

A Mouse in its Nest

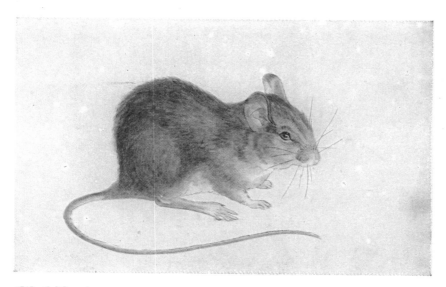

'Wood Mouse' *'Christmas, 1886'*

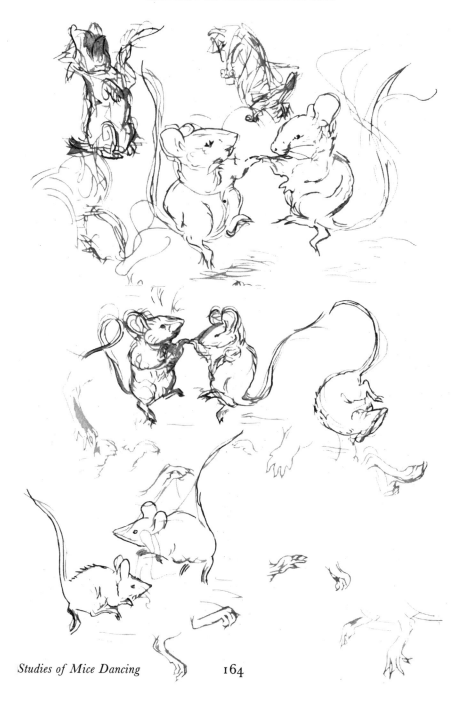

Studies of Mice Dancing 164

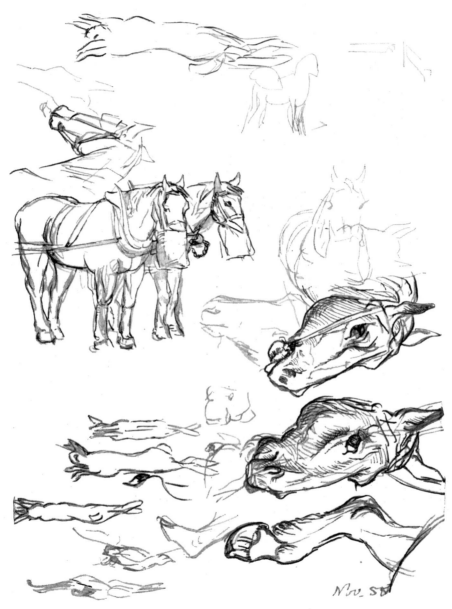

Sketches of Horses *November, 1885*

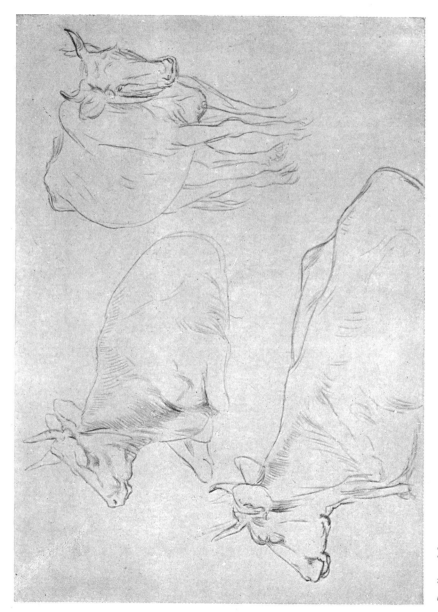

Studies of Cows

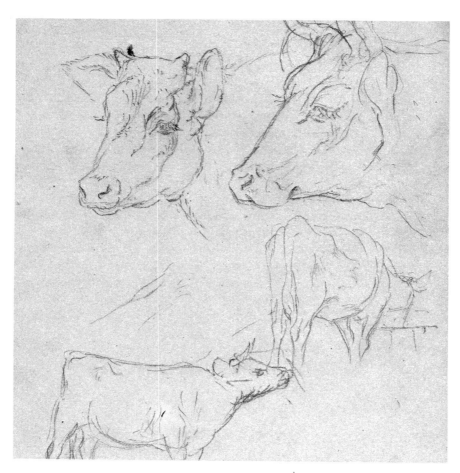

Studies of Cows

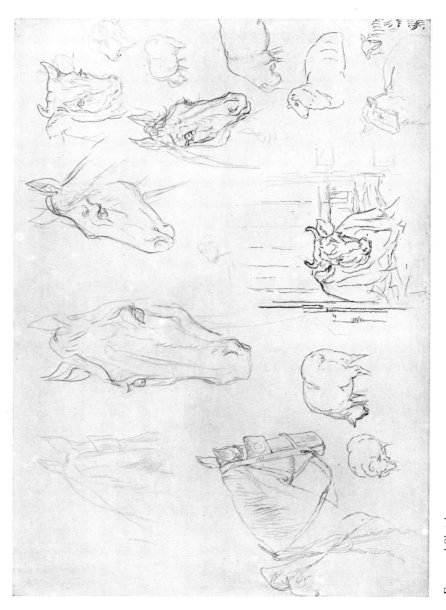

Farmyard Sketches

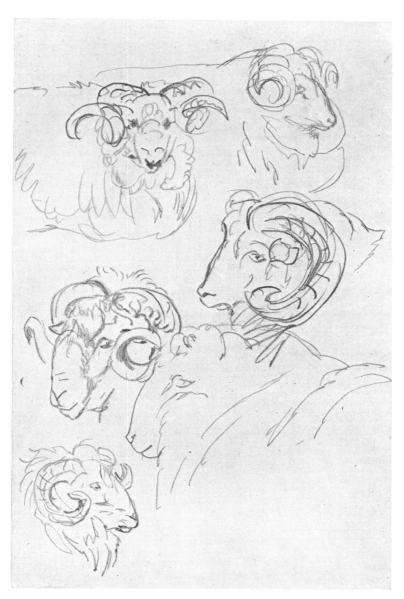

Heads of Rams

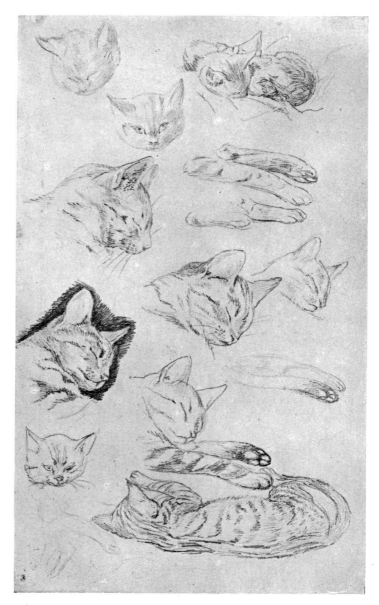

Studies of Cats

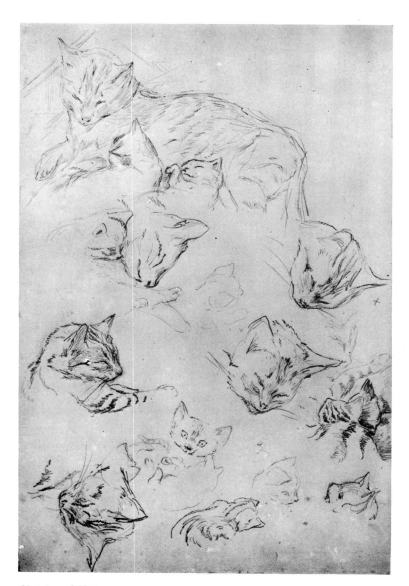

Sketches of Kittens

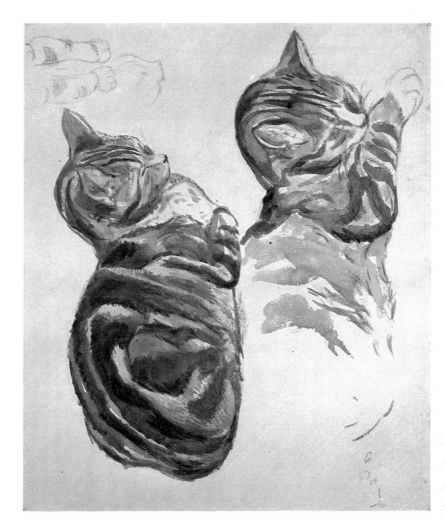

June 2, 1903

Studies of a Cat

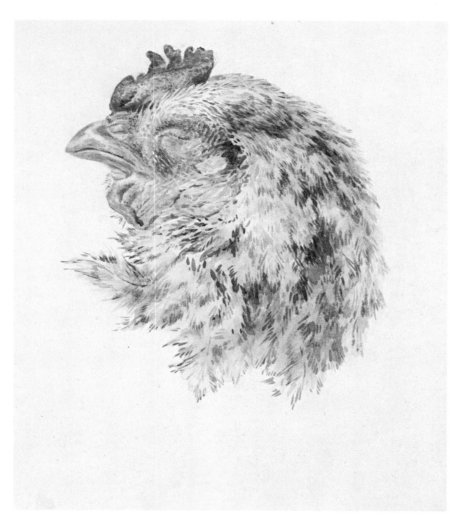

'*Study of head of a dead hen*' *April 6th, 1900*

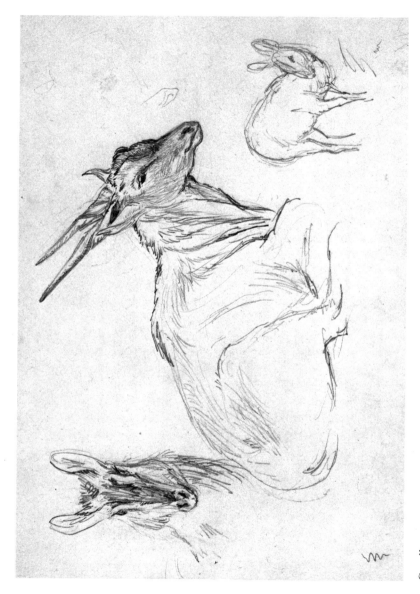

Gazelles

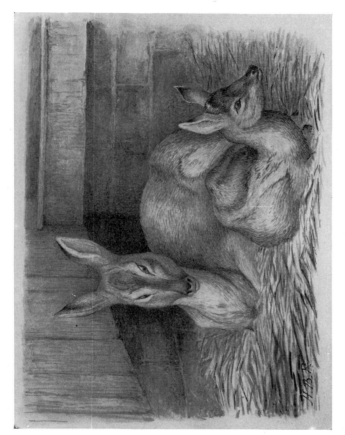

June, 1891

'Roe-deer and Fawn, at Zoological Gardens'

Weymouth April 14th, 1895

Boar-fish

Feb., 1884

Study of a Lizard

Studies of a Dead Thrush 'Picked up in the snow'

Woodcote, 1902

PART TWO

BEATRIX POTTER – HER ART IN RELATION TO HER BOOKS

7

Imaginary Happenings
in the Animal World

IMAGINARY HAPPENINGS IN THE ANIMAL WORLD

Beatrix Potter's animal fantasies date back to her early childhood as can be seen from the picture of rabbits dressed as humans, drawn at the age of nine in one of her early sketch books (see Section 1). It was not until her twenties that she began to develop this particular aspect of her work – the gift of portraying animals as humans. They are never caricatures, but drawn with charm and artistry.

The first four pictures show the successive stages of a rabbits' Christmas party. They are exquisite – some of the finest work Beatrix Potter ever produced. It is interesting to note that the rabbits have decorated their rooms with garlands of holly and cabbage. These pictures were given to Beatrix Potter's aunt Lucy, wife of Sir Henry Roscoe.

The bed in the picture of 'The Rabbit's Dream' was the one in bedroom No. 4, where Beatrix Potter always slept when she stayed at Camfield Place. 'The Rabbit's Potting Shed' was at Bedwell Lodge near Hatfield, and the back passage at Bedwell Lodge (Section 2), was the setting for the picture of 'The Mice in Their Storeroom'. The setting for the pen-and-ink drawing of 'The Cat and the Fiddle' was also at Bedwell Lodge.

Beatrix Potter's tame white rat, Sammy, is shown in the picture 'The Peculiar Dream of Mr Samuel Whiskers.' He is *not* the Mr Samuel Whiskers in her story of *The Roly-Poly Pudding*, but the story was dedicated to him. The dedication reads 'In remembrance of "Sammy", the intelligent pink-eyed representative of a persecuted (but irrepressible) race. An affectionate little friend, and most accomplished thief!'

Dr C! in the picture entitled 'A Visit from the Doctor' was a caricature of the Potter's doctor at Birnam, Dunkeld in 1892. His name was Dr Culbard and he lived close to the bridge over the River Tay. An old inhabitant of Birnam when shown this caricature thought the drawing 'suggested him very well . . . he always wore a light grey suit

and marched up and down his garden smoking a pipe.' He was described in the Journal as 'kind and very fat and snuffy.'

Beatrix Potter made cardboard toys and pictures with parts to open to amuse the children she knew.

On the back of a painting she gave to Noël Moore in 1902 for his 'album of friends' paintings and drawings' he wrote, 'after Beatrix Potter had written to me the first *Peter Rabbit* letter in Sept. 1893, she made me some cardboard toys to amuse me during illness.'

Margaret Hammond, the niece of Beatrix Potter's first governess, was another of the children who received such gifts. Many years later she wrote, 'You ask me to describe the scrap-book Beatrix Potter did for me. It is not easy as it is so many years ago I last saw it. There was a fishing pond made so that the fish (attached to cotton) went down behind a piece of paper. Also Peter Rabbit's greengrocery shop. Himself standing at the door – with hampers of which the lids lifted showing the vegetables therein. There was another, but I cannot remember it – and of course the usual scraps.'

The two examples which are shown, were given to Walter Gaddum, the small son of Beatrix Potter's cousin Edith.

The first, dated 1890, is of a mouse-hole. One mouse is on the floor, the other disappearing through a hole in the wainscot. The wainscot opens out, disclosing a picture of a ladder, down which a third mouse is climbing. The floor lifts up and discloses another picture, which shows the lower part of the ladder and three mice sitting at a table. One is looking up at the new arrivals, the other two are about to eat a pie.

The second picture, dated 1891, is called 'Benjamin Bunny & Son, Greengrocers'. Benjamin Bunny, wearing a grey coat, blue apron and spectacles, stands in front of a counter set out with fruit and vegetables. The lid of the hamper beside him opens, displaying rosy apples. The lid of the barrel also opens and shows a rabbit inside.

A RABBITS' CHRISTMAS PARTY

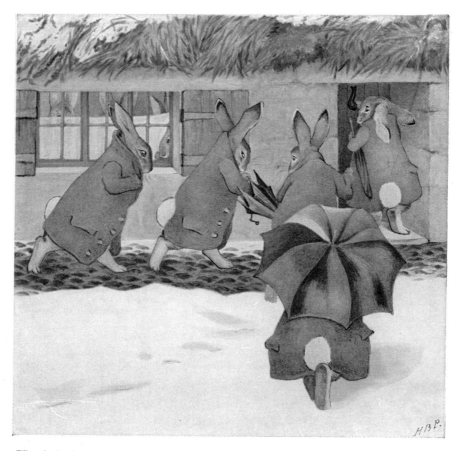

The Arrival

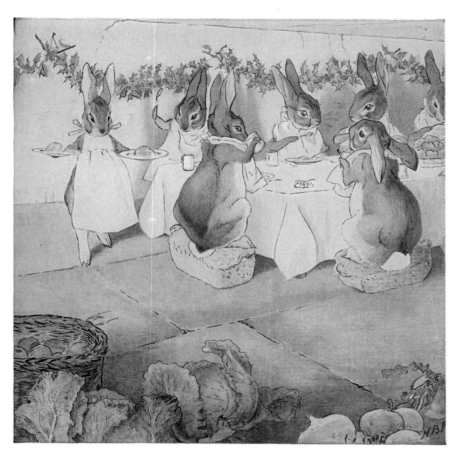

The Meal

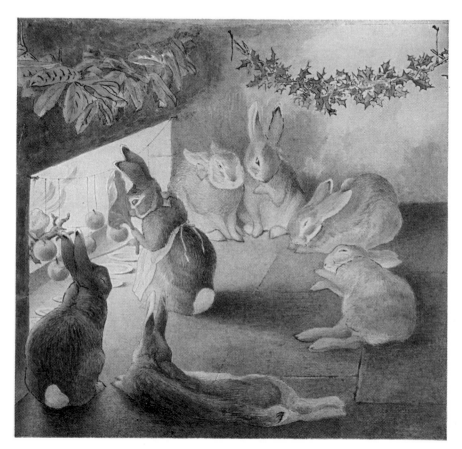

After the Meal

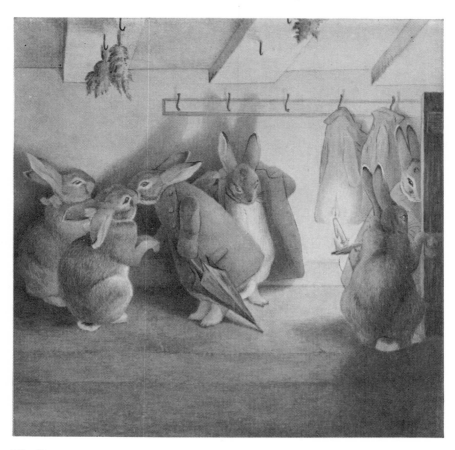

The Departure

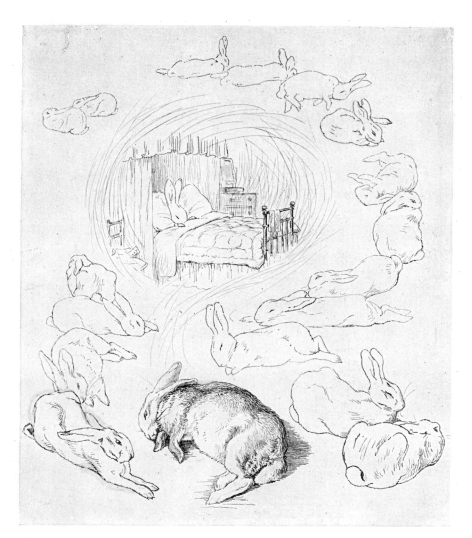

The Rabbit's Dream

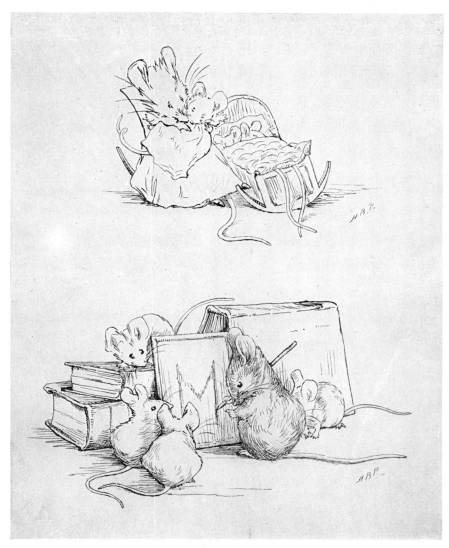

Bedtime (*About 1893*)

Learning to Read
'*This old mouse is teaching its children to read, you see it has made a big M on the slate*'

The Rabbits' Potting Shed *Bedwell Lodge, Hertfordshire, Summer, 1891*

The Mice in Their Storeroom *Bedwell Lodge, Hertfordshire, Summer, 1891*

Summer, 1891

The Cat and the Fiddle

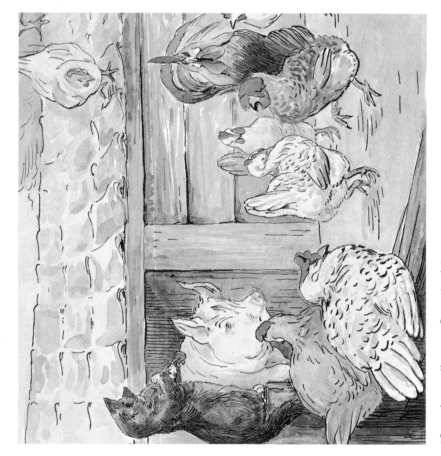

1902

'Come dance a jig to my Granny's pig'

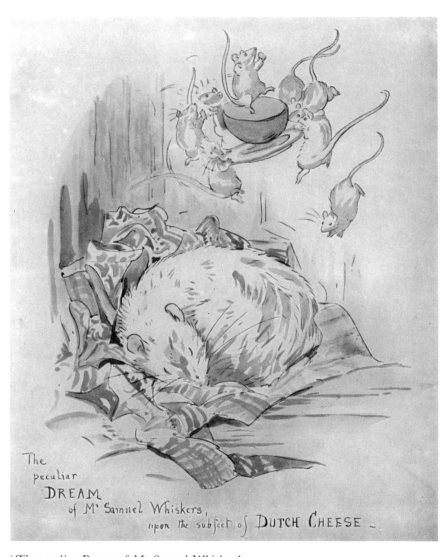

'The peculiar Dream of Mr Samuel Whiskers'

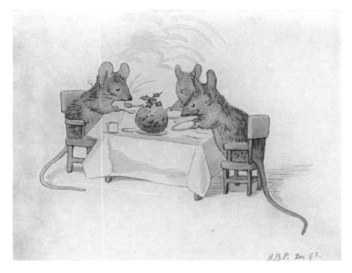

The Christmas Dinner *Dec., 1893*

Mrs Mouse Goes Shopping

The Day's News

A Visit from the Doctor (*Dr Culbard, Birnam*)

Aug., 1892

Sketch of a Rabbits' Party (*Rough sketch*)

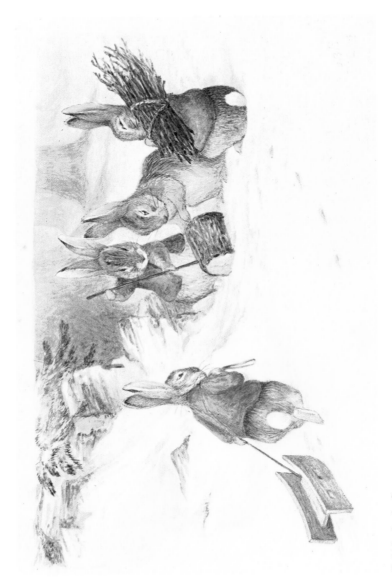

Rabbits in the Snow

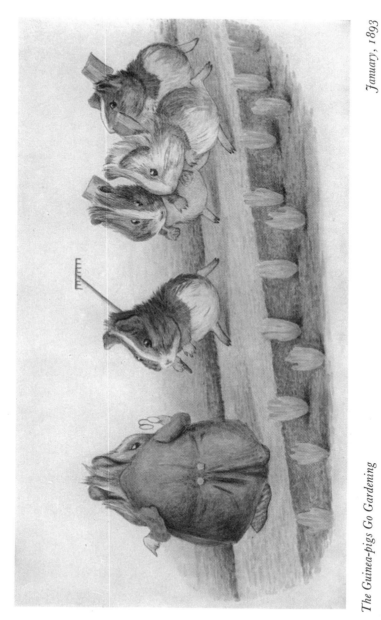

January, 1893

The Guinea-pigs Go Gardening

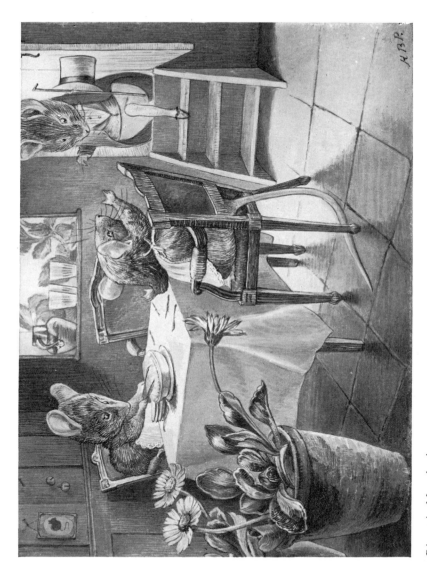

Dinner in Mouseland

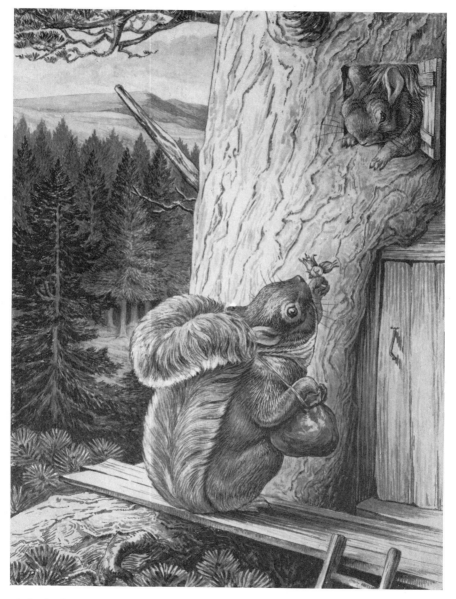

A Squirrel's Gift

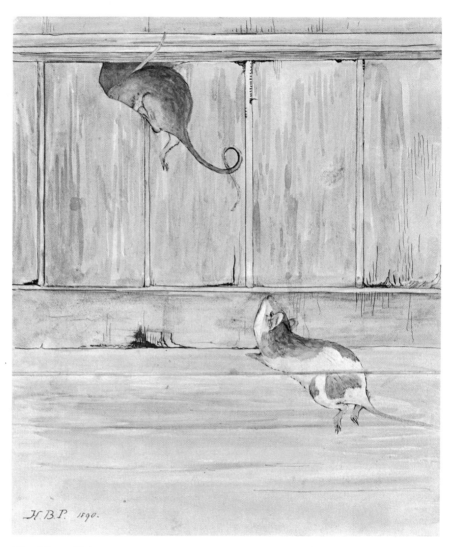

The Mouse Hole *1890*

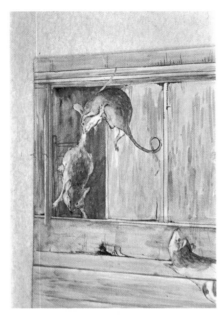

Going down the mouse hole . . .

to their supper under the floorboards

The Greengrocer's Shop in which the lids of the basket and barrel open 1891

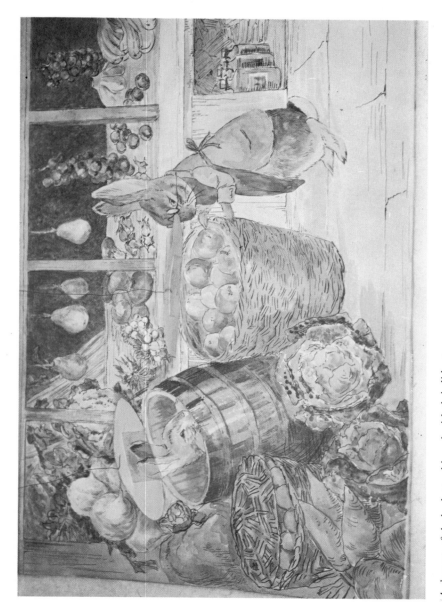

A close-up of the basket and barrel with their lids open

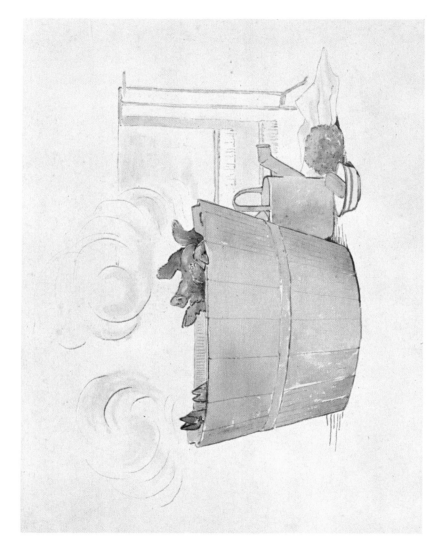

The Little Black Pig has a Bath

8

Early Ideas for
Illustrated Books

EARLY IDEAS FOR ILLUSTRATED BOOKS

Beatrix Potter began by drawing illustrations for fairy tales, stories and rhymes. Some of these were planned in booklet form as she hoped one day they would be published. This hope was never realised, but a few of the pictures were used later in her books – one of the paintings illustrating the verse 'Three little mice sat down to Spin' was redrawn for *The Tailor of Gloucester,* while others were used in *Appley Dapply's Nursery Rhymes* and *Cecily Parsley's Nursery Rhymes.*

When Beatrix Potter was staying at Lennel, Berwickshire in 1894, she told how she used to lie in bed in the early morning memorising plays by Shakespeare. In her schedule of memory work, some ten plays are mentioned. One of these is *A Midsummer-Night's Dream,* and an illustration inspired by three lines of a song spoken by a fairy to Puck at the beginning of Act 2, Scene 1, is reproduced.

The group of pictures that follow are based on fairy tales. In the case of two of these there is a central picture pasted on card, with flower surrounds and German text. In *Little Ida's Flowers* by Hans Anderson the title is 'Nun tanzen sicherlich alle Blumen drinnen!' (Now for sure all flowers dance therein).

In the illustration for *The Sleeping Beauty,* which Beatrix Potter called 'The doves asleep upon the house tops', the German text under the picture, when translated, reads:

> And this sleep spread itself
> over the whole Castle, and the
> doves slept on the roof.
> The wind died down and in the trees
> no little leaves stirred any more.

Beatrix Potter was particularly interested in the story of *Cinderella.* In later years she wrote her own version at considerable length, and in great detail. It is interesting that in the two pictures reproduced, the coach is drawn by rabbits instead of horses! On the back of a similar picture she wrote 'Cinderella's Coach going to fetch her from the Ball. Intended for moonlight.'

The drawing of Puss-in-Boots is either a design for a book cover or for a title page.

At one time Beatrix Potter hoped to publish the rhyme *Three little mice sat down to spin* in the form of an illustrated booklet. In addition to the six paintings, one for each line of the verse, and the coloured title page, the pages of text are shown alongside the corresponding picture, each with appropriate pen-and-ink sketches by way of decoration, and one line of the verse.

Before painting these pictures, she prepared detailed pen-and-ink 'outlines' of each, to be used as a guide.

This booklet was carefully planned, each page being numbered in the order in which it was to appear in the booklet, and on the end page there was to be a pen-and-ink drawing of a spinning-wheel and distaff. These paintings are amongst some of Beatrix Potter's finest work.

Uncle Remus must have been a favourite story of the Potters, for on one occasion when John Bright the statesman was staying with them at Dalguise, they introduced it to him. In her Journal Beatrix Potter wrote, 'Mr. Bright was very much taken with *Uncle Remus*. When papa showed it to him he used to read it aloud till the tears ran down with laughing.'

Between 1893 and 1896 she made a series of pencil drawings to illustrate *Uncle Remus*, each on a card mount, with pen-and-ink drawings and a few lines of text in the margins. A number of these drawings are shown. Because some of the text is difficult to read on account of its reduced size, it is given below:

> *Brer Fox and Brer Rabbit*
> 'Mighty funny, Brer Fox look
> like dead, yit he don't
> do like he dead . . .
>
> *The awful fate of Mr Wolf*
> 'Is de dogs all gone, Brer Rabbit?'
> 'Seem like I hear one un um
> smelling' roun' de chimbley-cornder
> des now' . . .
> 'W'at dat I hear, Brer Rabbit?'
> 'You hear de win' a blowin', Brer
> Wolf.'

Brer Rabbit rescues the Terrapin or Tortoise
Brer Rabbit come out of the bushes en make his way into Brer
Fox's house, he ketch hold of de bag and sorter feel it . . .
'Ow! go way! Lem' me alone! Tu'n me loose! Ow!'
Brer Rabbit jump back 'stonished.
'Ef I a'int make no mistakes, dat is nobody in
de roun' worl' but ole
Brer Terrypin.'

Brer Fox goes a-hunting
Brer Fox tu'n im over, he did, 'en 'zamine 'im 'en say –
'Dish yer rabbit dead. He look like he bin dead long
time . . . He's de fattes' rabbit wat I ever see, but he bin
dead too long. I fear'd ter take 'im home', sezee.

Brer Rabbit steals Brer Wolf's fish
Brer Rabbit dunno
nothin at all 'bout
no fishes . . .
Brer Wolf say he's
obliged to believe
Brer Rabbit's got
those fishes . . .
Brer Rabbit deny it
up an' down . . .

It is interesting to know that a duplicate of *Brer Fox and Brer Rabbit*
hangs in the entrance hall at Hill Top, Sawrey.

Beatrix Potter was attracted to Edward Lear's verses, *The Owl and
the Pussy-cat.* These she illustrated and made into a small booklet, but it
was never published. It is reproduced in this section.

From time to time Beatrix Potter sold an occasional drawing, but it
was not until 1890 that any of her work was actually published.

An idea to sell a set of designs to the trade arose from the success
of some Christmas cards she had painted, which 'were put under the
plates at breakfast and proved a five minutes wonder. I referred to
them the other day and found my uncle had forgotten their existence,
but he added with laughable inconsistency that any publisher would
snap at them.'

It was a disappointment when the first firm to whom they were offered, sent them back by return of post – but the German firm of Hildesheimer & Faulkner to whom they were offered next, immediately recognised their merit and paid the £6 for which Beatrix Potter had asked.

She told in her Journal how on the excitement of receiving the cheque – 'My first act was to give Bounce (what an investment that rabbit has been in spite of the hutches), a cupful of hemp seeds, the consequence being that when I wanted to draw him next morning he was partly intoxicated and wholly unmanageable. Then I retired to bed, and lay awake chuckling till two in the morning, and afterwards had an impression that Bunny came to my bedside in a white cotton night cap and tickled me with his whiskers.'

In due course these and other designs were published by Hildesheimer & Faulkner as Christmas and New Year cards, while some were used to illustrate a set of verses by F. E. Weatherly, published in a small booklet called *A Happy Pair* which sold for 4½d.

One of the designs for this booklet is reproduced here, together with the corresponding outline drawing. This painting, though not the illustration used, is one of three submitted, all of which are very similar, but in each one the rabbits wear different coloured clothes.

It is interesting that on another outline drawing, Beatrix Potter has marked the view point by a small cross in the upper left-hand corner, from which a series of perspective lines are faintly drawn.

Beatrix Potter had been brought up on Lewis Carroll's *Alice in Wonderland* so it is not surprising to find that some of her pictures are illustrations for this book. Two are shown.

The painting called 'Toad's Tea-Party' was originally intended for a book of rhymes to be published in 1905. This project, however, was abandoned when Norman Warne died in August of that year. The verse which the picture illustrates was written by Beatrix Potter.

In the picture story about a guinea-pig Beatrix Potter, with few words and economy of lines, shows her skill as a caricaturist. It is a delightful example of her dry sense of humour.

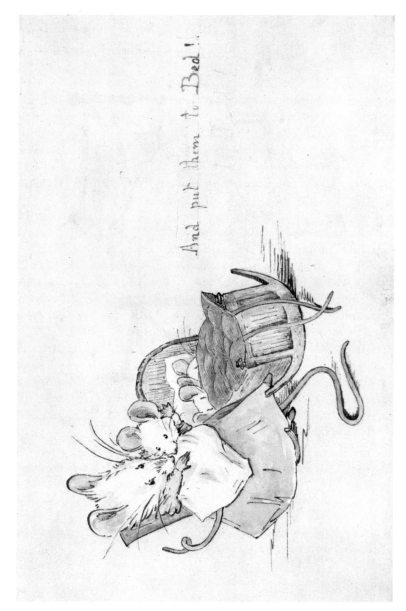

One of the illustrations for 'There was an old Woman who lived in a Shoe'

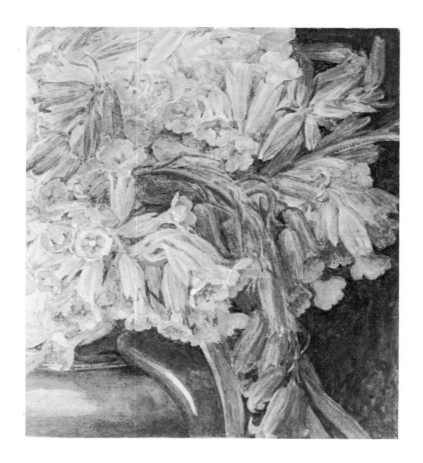

The cowslips tall her pensioners be:
In their gold coats spots you see:
Those be rubies, fairy favours,
 Midsummer Night's Dream

An illustration for Little Ida's Flowers by Hans Anderson

'The Doves asleep upon the roof-top'
An illustration for the Sleeping Beauty

April, 1899

A Cinderella Fantasy

Cinderella's Carriage

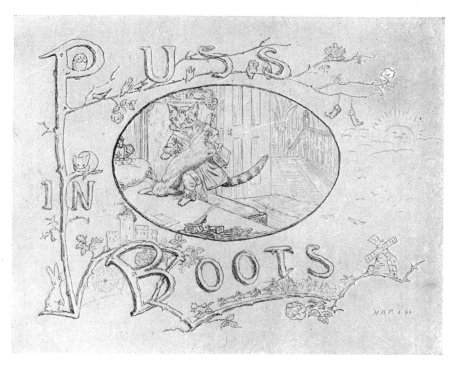

Design for a Book Cover, or Title Page *June, 1894*

"I have brought you, sire, this rabbit, from the warren of my lord the marquis of Carabas, who commanded me to present it to your majesty, with the assurance of his respect."

AN UNPUBLISHED BOOKLET

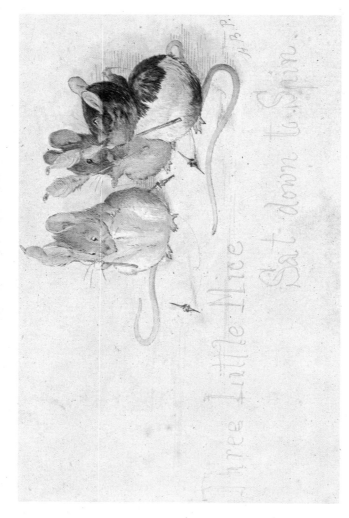

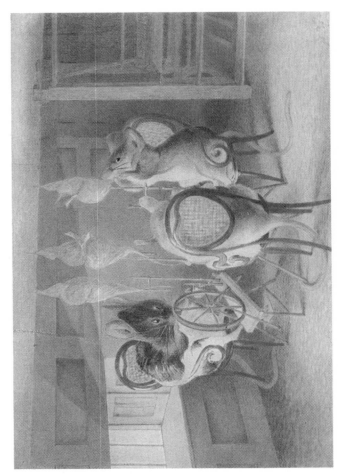

'Three little mice sat down to spin,

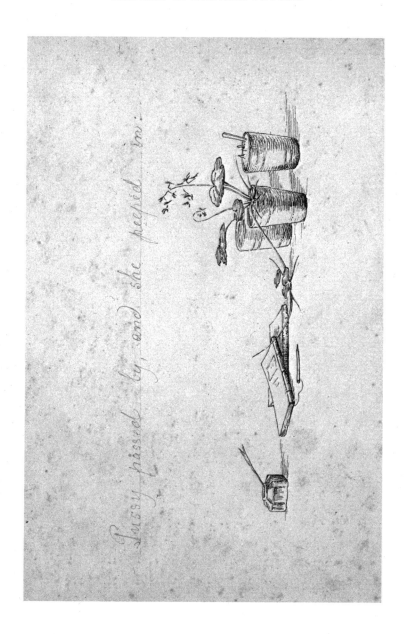

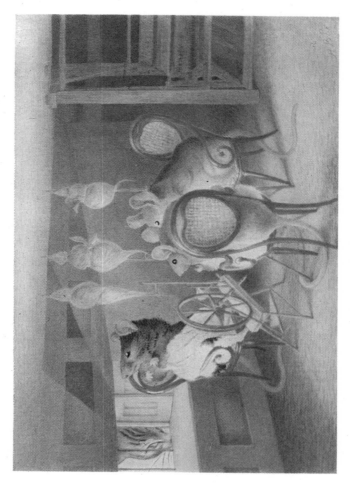

Pussy passed by and she peeped in

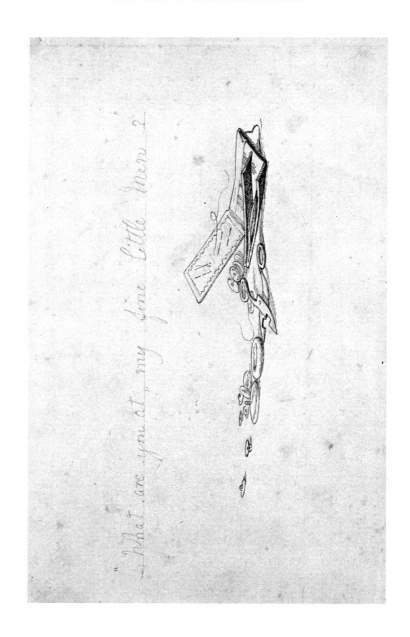

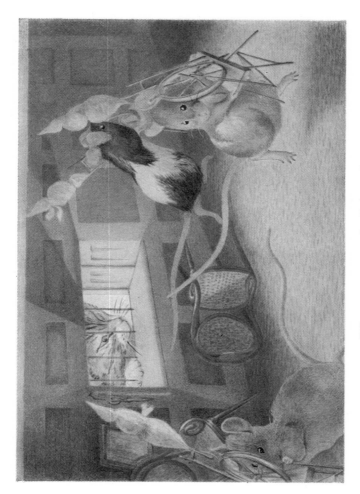

What are you at, my fine little men?

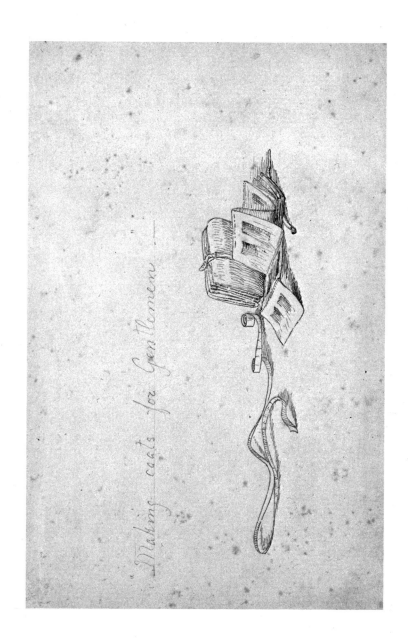

"Making coats for Gentlemen ——"

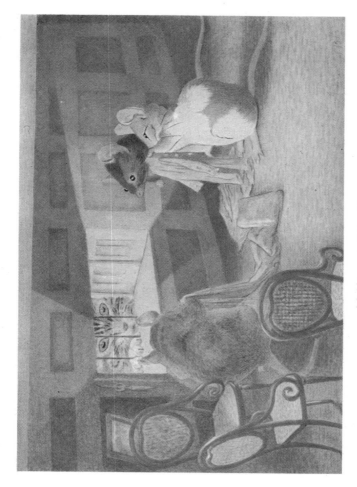

Making coats for gentlemen.

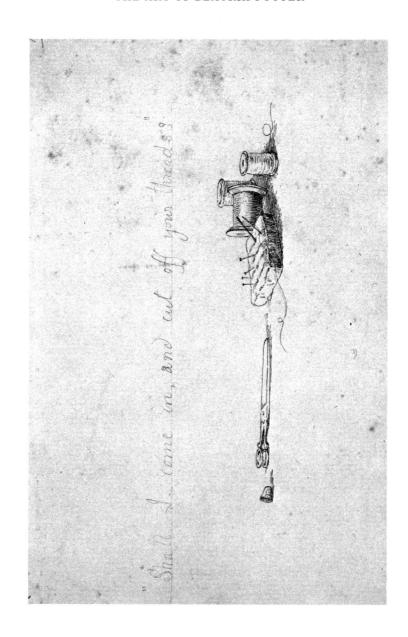

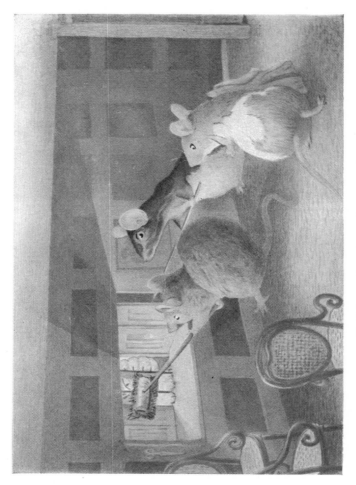

Shall I come in and cut off your threads?

"Oh no! Miss Pussy, you'd bite off our heads!"

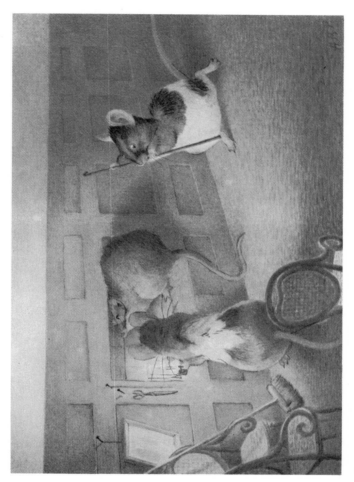

Oh, no, Miss Pussy, you'd bite off our heads!'

A SERIES OF DRAWINGS TO ILLUSTRATE
'UNCLE REMUS'

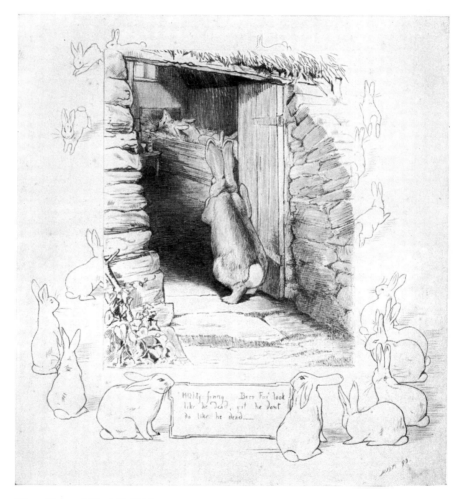

'Brer Fox and Brer Rabbit' *1893*

232

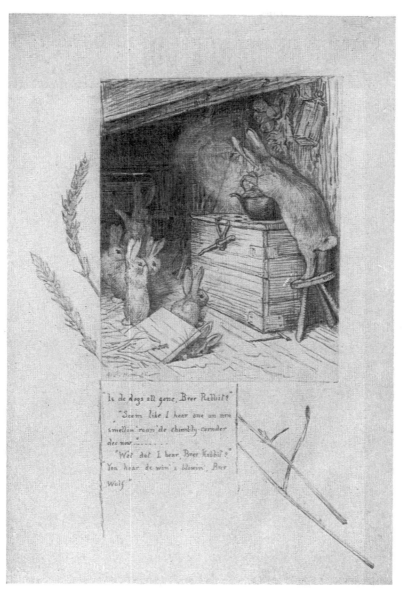

'*The awful fate of Mr Wolf*' *March, 1895*

233

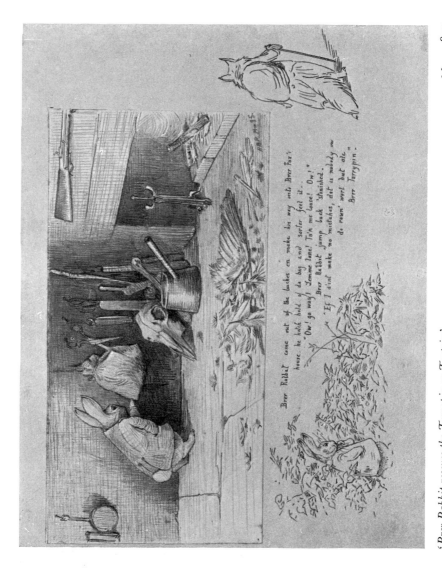

May, 1895

'Brer Rabbit rescues the Terrapin or Tortoise'

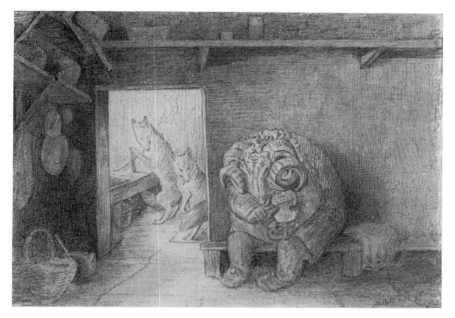

*'Ole Mr Benjamin Ram keep on chunin' up – Plank! – Plink! – Plunk! – Plank!
Miss Wolf drap her knife an' listen —'*

Sept., *1895*

Mr Benjamin Ram, going to play the fiddle at a ball, loses his way.
He discovers too late that he has asked for shelter at a house inhabited
by wolves. They receive him effusively & promise him a good supper,
but he hears them sharpening a knife. He thinks he will play
a last tune on his fiddle, the wolves are completely puzzled, & bolt.
Original. drawn by Beatrix Potter.

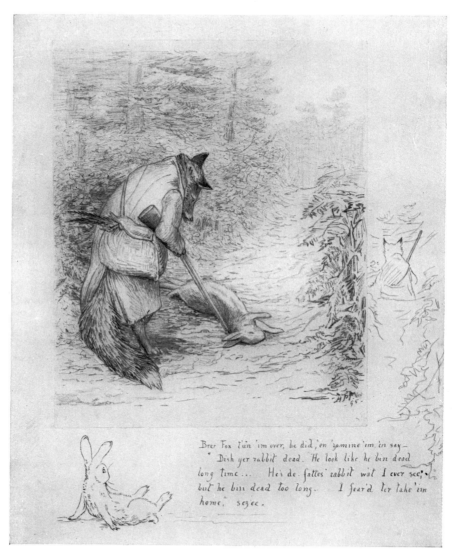

Brer Fox t'un 'im over, he did, 'en 'zamine 'im, en say—
"Dish yer rabbit dead. He look like he bin dead
long time... He's de fattes' rabbit wat I ever see,
but he bin dead too long. I fear'd ter take 'im
home," sezee.

'Brer Fox goes a-hunting, but Brer Rabbit bags the game' *Nov., 1895*

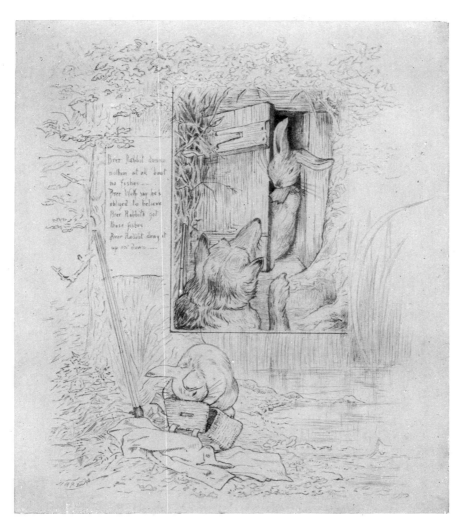

Brer Rabbit steals Brer Wolf's Fish *Jan., 1896*

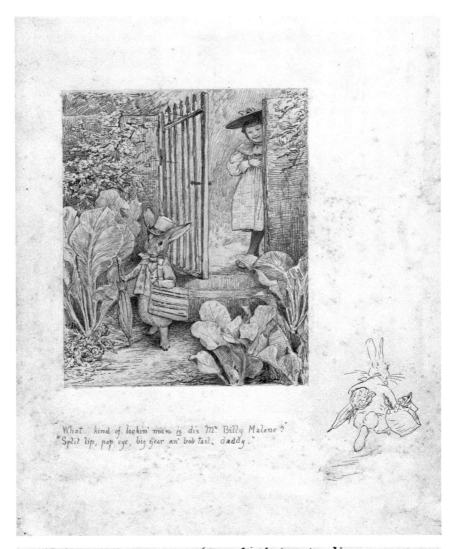

"What kind of lookin' man is dis Mr Billy Malone?"
"Split lip, pop eye, big gear an' bob tail, daddy."

Brer Rabbit personates 'Mr Billy Malone' & persuades
the little girl to let him into her daddy's garden.
Original, drawn by Beatrix Potter.

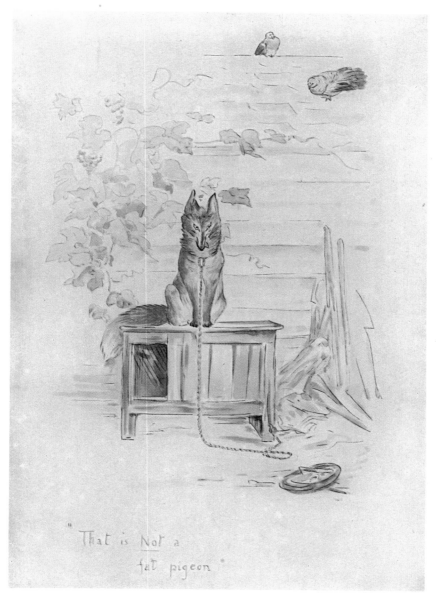

'The Fox and the Grapes'

Designs for Letters of the Alphabet (*About 1893*)

AN UNPUBLISHED BOOKLET

The Owl and the Pussy-cat went to sea.
 In a beautiful pea-green boat,
They took some honey
 and plenty of money,
Wrapped up in a £5 note.

The Owl looked up to the stars above
 And sang to a small guitar
"Oh dear sweet Pussy
 Oh Pussy my love!
What a beautiful Pussy you are
 you are!
What a beautiful Pussy you are!"

They sailed away, for a year and a day,
To the land where the Bong Tree
grows—

And there in

a wood,

A Piggy wig stood,

With a ring at the end of his nose —

his nose!

With a ring at the end of his nose!

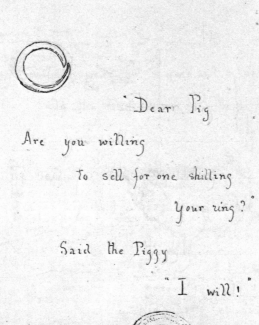

'Dear Pig

Are you willing

to sell for one shilling

Your ring?"

Said the Piggy

"I will!"

So they sailed away

And were married next day —

By the Turkey who lives on the hill —

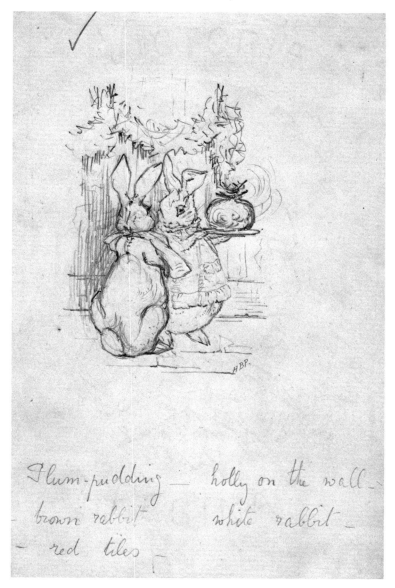

Sketch for Hildesheimer & Faulkner for a Christmas and New Year Card
1890

A Preliminary Sketch for 'A Happy Pair,' to illustrate a set of verses by F. E. Weatherly

One of the illustrations submitted in June 1890 for 'A Happy Pair' – a similar picture was used.

(The first of her work to be published)

'THE WHITE CAT'

'Kittens collecting game for the White Cat's Supper'

'Kittens collecting game for the White Cat's Supper'

'The little lizard, Bill, supported by two guinea-pigs'

From 'Alice in Wonderland'

March, 1893

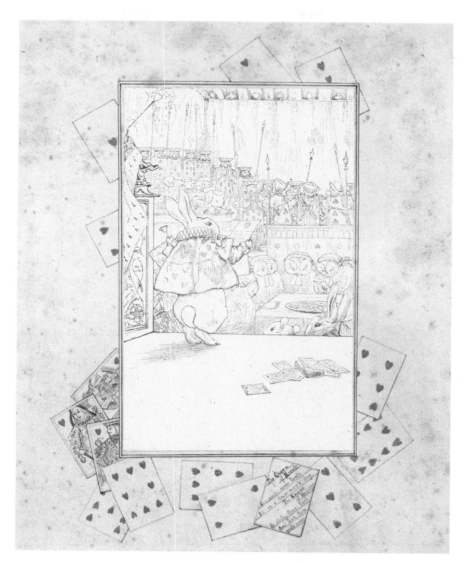

The Trial of the Knave of Hearts

From 'Alice in Wonderland'

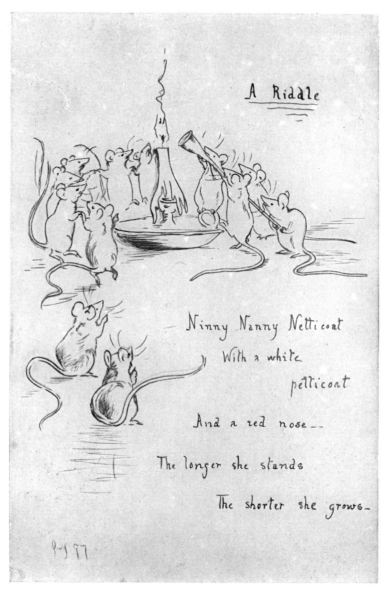

A Riddle . . .

. . . The Answer *August, 1897*

Preliminary Sketch for 'Toads' tea-party'

If acorn cups were tea-cups
What should we have to drink?
Oh honey-dew for sugar
In a cuckoo-pint of milk,
Set out upon a toadstool
On a cloth of cob-web silk,
With pats of witches' butter
And a tansey cake, I think!

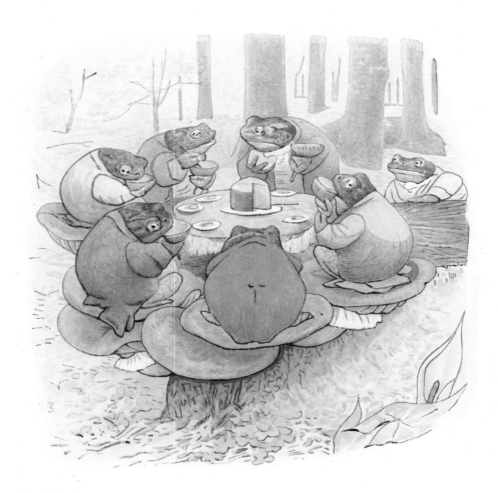

Toads' tea-party

A PICTURE STORY ABOUT A GUINEA-PIG

The perfidious friend assures the guinea-pig it 'won't hurt.'

The guinea-pig has doubts —

but they are over-borne

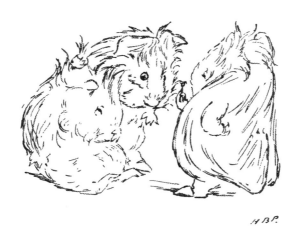

The friend and the dentist take a professional interest in the tooth, but none whatever in the victim —

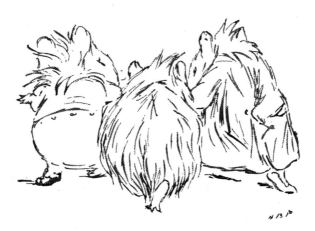

and go off discussing the successful operation

9

*Her Books – Some Preliminary
Sketches and Finished Work*

HER BOOKS – SOME PRELIMINARY SKETCHES AND FINISHED WORK

In this section examples are shown of Beatrix Potter's finished work, reproduced on a larger scale than in the books, so that her fine workmanship can be appreciated – there are also a number of preliminary sketches and background drawings.

Beatrix Potter had a unique advantage over almost every other writer of children's books, in that she could not only write her books but illustrate them as well, and she was equally gifted both as writer and artist.

Her first book was not published until her mid-thirties, so that many years of unconscious preparation both in writing and drawing had equipped her for her life work.

Her knowledge of animals came from close study of her numerous pets, of farmyard animals, of wild creatures in fields and woods, and from frequent visits to the Zoological Gardens. Due to this careful study and observation, her animals are always true to nature and to their animal characteristics.

In later years, when commenting on one of Kenneth Grahame's books, Beatrix Potter wrote, 'Yes – Kenneth Grahame ought to have been an artist – at least all writers for children ought to have sufficient recognition of what things look like – did he not describe "Toad" as combing his *hair*? A mistake to fly in the face of nature – a frog may wear goloshes, but I don't hold with toads having beards or wigs! so I prefer Badger.'

Much of the charm of Beatrix Potter's pictures comes from the fact that they were painted for love. She was completely absorbed in her work: 'I painted most of the little pictures mainly to please myself,' she wrote, 'the more spontaneous the pleasure, the more happy the result.'

PETER RABBIT (1902)

Of the backgrounds in *The Tale of Peter Rabbit*, Beatrix Potter wrote – 'Peter was so composite and scattered in locality that I have found it

troublesome to explain its various sources . . . the fir tree and some wood backgrounds were near Keswick . . .'

The sketch of Peter Rabbit's fir tree was used as background for a picture which appeared in the first four printings. After this it was withdrawn to make room for the coloured pictorial end-papers which were first introduced in 1903.

On the next three pages are some of her rough pencil sketches for the book pictures, including one of Mr McGregor. On one occasion, seeing a gardener at work and thinking he might be Mr McGregor, a small child confided in Beatrix Potter that she was afraid of him – Beatrix Potter replied 'He's not too bad – after all he was only doing his duty in looking after his lettuces and cabbages.'

Finally there is a reproduction of one of the book pictures with the corresponding rough sketch on the facing page. Underneath, in facsimile, is the text associated with this picture, taken from the actual manuscript submitted to Warnes when asking them if they would accept the story.

END-PAPERS

In 1903 Beatrix Potter painted her first coloured pictorial end-paper, which was used for the fifth printing of *The Tale of Peter Rabbit,* and for the first printings of *The Tale of Squirrel Nutkin* and *The Tailor of Gloucester.* It appeared twice at the front and twice at the back.

From then onwards new characters were added as they appeared in the different stories, and the end-papers were used in pairs.

Her second and third designs are reproduced, and it is interesting to note that Mrs Tiggy-Winkle is concealing the title of her book because it had not yet been published.

SQUIRREL NUTKIN (1903)

In a presentation copy of *The Tale of Squirrel Nutkin,* Beatrix Potter wrote 'Backgrounds of these pictures were made on the shores of Derwentwater, Cumberland. Skiddaw appears in the one with the new-laid egg. The island was St Herbert's.'

The two background paintings reproduced are from one of Beatrix Potter's sketch books, and on the facing pages, the corresponding book pictures are shown. Two other book pictures are also reproduced.

Mrs Florence Sadler tells how when she was a child she was taken to lunch with Beatrix Potter at Fawe Park, Keswick, by Canon Rawnsley. When the meal was over Beatrix Potter invited her to 'Squirrel Watch' on St Herbert's Island if she could manage to be *very* quiet. 'We were rowed across the lake and had a lovely afternoon,' she said. 'I was *enthralled* watching her sketching. I had never seen a live red squirrel before, so that was an added joy.'

THE TAILOR OF GLOUCESTER (1903)

A facsimile page from the manuscript of Warne's edition of *The Tailor of Gloucester* is shown, together with the corresponding water-colour sketch from this manuscript.

Three book pictures, and a duplicate of another one with slight variations, are also shown. The paintings of the embroidery designs were copied from specimens at the Victoria and Albert Museum, which were laid out for Beatrix Potter in a little office. Here she was allowed to work at any time she wished; they were then returned safely to their show cases. In spite of the similarity of the eighteenth-century work, it is possible to identify the embroidery designs painted by Beatrix Potter, because of the accuracy of her details and colouring.

Most of the original paintings from *The Tailor of Gloucester* may be seen at the Tate Gallery, London.

BENJAMIN BUNNY (1904)

The summer months of 1903 were spent at Fawe Park, Keswick, and it was here that Beatrix Potter painted a large number of pictures of the garden, to be used as backgrounds for *The Tale of Benjamin Bunny*.

These were taken back to Bolton Gardens and worked from during the winter months. In a letter to Norman Warne she wrote, 'I think I have done every imaginable rabbit background and miscellaneous

sketches as well — about 70.' Several of these garden backgrounds are reproduced in this section.

The study of a carnation (Section 4), was at one time to have been used for the frontispiece — with Benjamin and Peter standing underneath. A rough pencil sketch was prepared and the book drawing actually started, but before it was finished Beatrix Potter changed her mind and painted instead a picture of old Mrs Bunny knitting in her warren, with her rabbit children beside her.

These background studies can be clearly identified with the pictures in the book.

TWO BAD MICE (1904)

The pictures in this book are exceptionally fine, and four of them have been selected for reproduction.

It is interesting to know that the doll's food which Beatrix Potter copied when painting the pictures, was bought from Hamleys of Regent Street, and may be seen in the doll's house at Hill Top, Sawrey.

This doll's house is not the one used as a model for the book pictures. The original doll's house was made by Norman Warne for his small niece Winifred, and Beatrix Potter worked from photographs which he took for her; these still exist amongst her papers at Hill Top. The original doll's house was sold, and later given to a children's home. No trace of it now remains.

MRS TIGGY-WINKLE (1905)

The sketches of Lucie are of interest as Beatrix Potter seldom drew human figures; they were drawn from life. Lucie was one of the two small daughters of the Vicar of Newlands, who was a friend of the Potters.

Beatrix Potter's pet hedgehog, called Mrs Tiggy-Winkle, was used as a model for the book drawings. Mrs Tiggy-Winkle sometimes slept for four days at a stretch, and would drink out of a doll's tea-cup when invited out to tea.

The little door in the back of the hill, which is referred to in a note

at the end of the book, appears to have had its origin in a painting of the hillside path at Kilbarrow, Grasmere.

The Mrs Tiggy-Winkle in the story was inspired by Kitty Macdonald, the Potter's old washerwoman at Dalguise. Of her, Beatrix Potter wrote in 1892, 'She is a comical, round little old woman, as brown as a berry and wears a multitude of petticoats and a white mutch. Her memory goes back for seventy years and I really believe she is prepared to enumerate the articles of her first wash in the year '71.'

THE PIE AND THE PATTY-PAN (1905)

On several occasions when staying in the village of Near Sawrey, Beatrix Potter made sketches of the cottages and gardens – to be used later as backgrounds for her story of Duchess and Ribby.

Of one of these visits an old inhabitant wrote – The Potters 'came with their servants, their carriage and pair, and Miss Potter with her pony and phaeton . . . Miss Potter was about the village sketching everywhere and often came to our house.'

The painting of the garden which is reproduced, is the one at Buckle Yeat, quite close to Hill Top (see photograph, Fig. 18). This picture was used as background for 'The Invitation' where Duchess is seen reading the letter from Ribby inviting her to tea.

Duchess was one of two black Pomeranian dogs belonging to Mrs Rogerson, who lived at Lakefield Cottage. The other dog was called Darkie. Beatrix Potter used Darkie as a model when painting the pictures, because Darkie was the more handsome of the two; but it was the character and intelligence of Duchess which she had in mind when writing the story.

Mr Warne questioned whether a Pomeranian dog could possibly have such a fine mane as Beatrix Potter had painted, so she photographed the dogs and sent him a copy to prove that she was right.

In the other background painting it will be seen that the doorway was copied from the old post office (see photographs, Figs. 19 and 20). The tiger lilies were copied from the approach to Ginger and Pickles' shop.

MR JEREMY FISHER (1906)

When Beatrix Potter was staying at Eastwood, Dunkeld, on the bank of the river Tay in 1893, she wrote her first version of *The Tale of Mr Jeremy Fisher*. This was sent as a picture letter to Eric Moore, the day after the *Peter Rabbit* picture letter had been sent to his brother Noël.

When the story was first published in 1906, she had changed the setting to Esthwaite Water; and instead of rowing in a boat on the river Tay, Mr Jeremy Fisher sailed on Esthwaite Water, sitting on a picturesque water-lily leaf. The painting of water lilies which is shown, is a background study for this book.

It is amusing to hear that when Beatrix Potter was working on the paintings for *The Tale of Mr Jeremy Fisher*, Fruing Warne questioned the accuracy of the frog's colouring, so she brought the live Jeremy to the office in a jam-jar to disprove the criticism that he was too yellow in the picture!

PANORAMIC BOOKS (1906)

At the end of 1906 two stories were published in panoramic form – *The Story of a Fierce Bad Rabbit* and *The Story of Miss Moppet*. A third story in panoramic form, *The Sly Old Cat,* had also been prepared, but it was not published at the time because the shops refused to stock these panoramic books as they became so easily damaged by the public when opening and closing them.

Two facing pages from the manuscript of *The Sly Old Cat* are shown. Although the water-colour sketches were not specially prepared for the block-maker, they have the life and expression and all the charm and spontaneity so characteristic of Beatrix Potter's preliminary work.

TOM KITTEN (1907)

The setting for this book is the house and garden at Hill Top, which Beatrix Potter had recently bought. The garden was a particular delight to her, and the path leading up to the house, bordered by beds filled with brightly coloured flowers, can be seen in two of the three pictures reproduced (see photograph, Fig. 2).

The other picture shows Mrs Tabitha Twitchit receiving guests at the door of the entrance hall (see photograph, Fig. 3).

JEMIMA PUDDLE-DUCK (1908)

The Tale of Jemima Puddle-Duck has for its background the farm at Hill Top. Jemima was one of the ducks that lived there. Margaret Lane tells how Beatrix Potter's cousin Caroline Hutton (the late Mrs Clark), 'was with her at Hill Top Farm when *Jemima Puddle-Duck* was being written, and went round about with her to find a suitable spot for the nest.'

The backgrounds of many of the pictures show the beautiful farm-land and surrounding country, which has scarcely changed since the days when these pictures were painted (see photographs, Figs. 9 to 13). Foxgloves still flower beside the old stone walls, in the woods, and in the grass that borders the country lanes. Three of the book pictures are shown.

THE ROLY-POLY PUDDING (1908)

The pictures in this book were drawn shortly after Beatrix Potter had purchased Hill Top Farm, and show her delight in the quaint old farm house. The rooms and staircase can easily be recognised, but the kitchen range, which appears in some of the pictures, was later removed. 'I have not meddled with the fireplace,' she wrote when she first bought the house. 'I don't dislike it, and besides it is wanted for the next book.'

In the picture of the stairs with their graceful balustrades, Mrs Tabitha Twitchit is seen standing on the landing half way up, with her back to the grandfather clock. In both the original book drawing, and in the duplicate painting which has been reproduced, the head of the cat has been pasted on. As this occurs in both pictures, it was possibly done to obtain greater relief, and not because she was dissatisfied with the first face, if it ever existed.

Of the painting of the old chimney, Beatrix Potter wrote, 'The outside view of the old chimney with landscape is pretty . . . I remember I put it in because there was such a string of sooty inside pictures.'

The winding lane in the distance is called Stoney Lane. At the top

there is a tarn which belonged to Beatrix Potter, and here, after her marriage to William Heelis, they would often row in their boat on summer evenings after the day's work was done.

THE FLOPSY BUNNIES (1909)

The market-garden scene has been chosen to represent this book because of the dry humour of the wording on the notice-board. This picture was shortly replaced by one *without* a notice-board because of the intended translation of the story into French, when it seemed desirable to omit all wording from the pictures.

The original paintings from *The Tale of the Flopsy Bunnies* may be seen on request at the British Museum, London.

GINGER AND PICKLES (1909)

Margaret Lane tells how this book 'celebrates the actual little village shop and with such appreciative feeling that its pages almost smell of candles and tea.'

The shop stood at the centre of the small group of cottages which make up the heart of the village of Near Sawrey. Later it changed from a shop to a guest-house, though still bearing signs of the past; for example the old meat hooks in the ceiling of the little back room where Ginger and Pickles made up their accounts were still visible in 1952. Now it is a private house.

Beatrix Potter sometimes felt that when she copied a picture from a sketch in her original manuscript, she could not always recapture the charm of the original, and in one or two instances suggested that the earlier sketch should be used for the printed book. At least one of the sketches in the manuscript of *Ginger and Pickles* has been used in this way. 'I think the drawing of Lucinda and Jane had better be used,' she said, 'as I don't believe I can hit it off again.'

It is interesting to compare her background painting of the interior of the shop with the corresponding book picture – both are reproduced. One other book picture is shown – where 'it takes five mice to carry one seven inch candle.'

MRS TITTLEMOUSE (1910)

Mrs Tittlemouse was a wood-mouse, and is described by Beatrix Potter as 'a most terribly tidy particular little mouse, always sweeping and dusting the soft sandy floors' of her burrow.

The picture chosen to represent this book shows Mrs Tittlemouse opening one of her store-room cupboards.

TIMMY TIPTOES (1911)

It is believed that this book was written primarily for American children, who would be familiar with both chipmunks and bears. They would also be familiar with grey squirrels like Timmy Tiptoes and his wife Goody Tiptoes. In the picture chosen Silvertail, the most forgetful squirrel in the wood, is trying to find his store of nuts.

MR TOD (1912)

Mr Tod lived in 'an earth amongst the rocks at the top of Bull Banks, under Oatmeal Crag,' where Beatrix Potter must have often seen him in winter and early spring.

The picture chosen shows Peter and Benjamin peeping through the window of Mr Tod's house in their search for the missing baby rabbits.

PIGLING BLAND (1913)

Beatrix Potter kept pigs on her farm at Hill Top. In a letter to Millie Warne she wrote, 'I have done a little sketching when it does not rain, and I spent a very wet hour *inside* the pig sty drawing the pig. It tries to nibble my boots which is interrupting'; and again 'Have spent some hours inside the pig sty to-day, drawing the little pigs before they cease to be interesting.'

The picture chosen of Aunt Pettitoes is very similar to the one in the book. It shows her feeding her family of eight – 'four little girl pigs called Cross-patch, Suck-suck, Yock-yock and Spot; and four little boy pigs, called Alexander, Pigling Bland, Chin-chin and Stumpy.'

The other picture shown is a water-colour sketch of the interior of a cottage at Far Sawrey, which Beatrix Potter used as a guide when drawing Mr Piperson's kitchen range.

APPLEY DAPPLY (1917)

The picture of the little mice in a shoe, which illustrates the verse 'The little old woman who lived in a shoe,' was painted on a sheet from an unfinished manuscript of a book of rhymes – this book was planned for 1905, but was abandoned when Norman Warne died in August of that year. The painting now appears in the current printing of *Appley Dapply's Nursery Rhymes*.

The picture of the little mouse knitting also illustrates this verse, and appears in the current edition of *Appley Dapply*.

JOHNNY TOWN-MOUSE (1918)

The Tale of Johnny Town-Mouse is Beatrix Potter's version of Aesop's Fable of *The Town Mouse and the Country Mouse*. The settings for the book pictures are in Hawkshead and Near Sawrey.

The two pictures reproduced, although not taken from the book, are symbolic of this fable. They depict the discomfort of the country mouse when dining in the sophisticated style of the town mouse; and the town mouse arriving in his best clothes, only to find the country mouse's home is a mere hole in the hillside!

CECILY PARSLEY (1922)

Pressed by Warnes for still another book, Beatrix Potter used material prepared many years earlier.

There was the small booklet illustrating the Cecily Parsley rhyme, dated January 1897, which she re-arranged for the present book.

Another picture and its preliminary pencil sketch have been reproduced, illustrating the verse 'How do you do, Mistress Pussy?'

There is also a picture with the title 'Guinea-pig's Garden'. In January 1893, Beatrix Potter borrowed some guinea-pigs from her London friend, Miss Paget, and used these as models.

273

Finally there is the painting illustrating a verse about Little Tom Tinker's dog.

LITTLE PIG ROBINSON (1930)

Although *The Tale of Little Pig Robinson* was the last book in the series, it was actually the first to be written, and was started at Falmouth in the 1890s, though not finished until just before publication. The backgrounds are nearly all from the West Country, and include scenery from Teignmouth, Sidmouth and Lyme Regis.

In the picture which has been chosen there are some delightful expressions on the faces of the animals in the crowded street.

THE FAIRY CARAVAN

The frontispiece to this book has been reproduced. It was originally intended for Beatrix Potter's 1905 book of rhymes, and illustrated her verse:

> Tabitha Twitchit is grown so fine
> She lies in bed until half past nine.
> She breakfasts on muffins, and eggs and ham,
> And dines on red-herrings and rasp-berry jam!'

In *The Fairy Caravan* this picture is called 'Louisa Pussy-cat Sleeps Late', and of it, Beatrix Potter wrote in 1929:

The bed with green damask curtains was my grandmother's best bed when she set up housekeeping 90 years ago. When I was a little girl it was a 'second best' bed, in the green room. How often I have sat up in that bed listening to the nightingales! When her furniture was dispersed and divided after her death, aged 90 – I asked for the bed, to keep it, because the green curtains were full of pretty dreams. The browny red table cloth is a paisley shawl that belonged to my other grandmother – we used it for a table cloth. The cat was drawn from our Tomasine. The old frame is also in our dining room, only it is a picture of birds.

PETER RABBIT (1902)

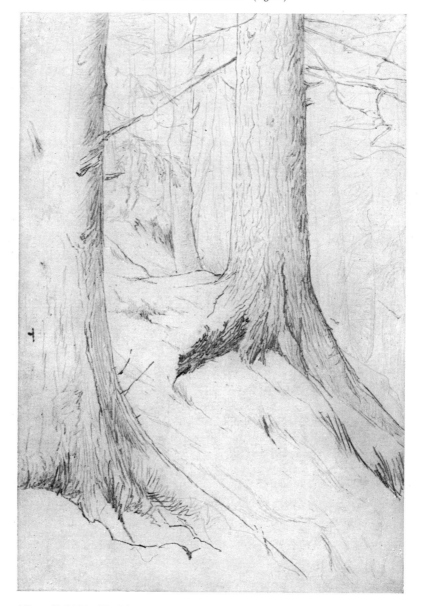

'Peter Rabbit's Fir Tree' *(near Keswick)*

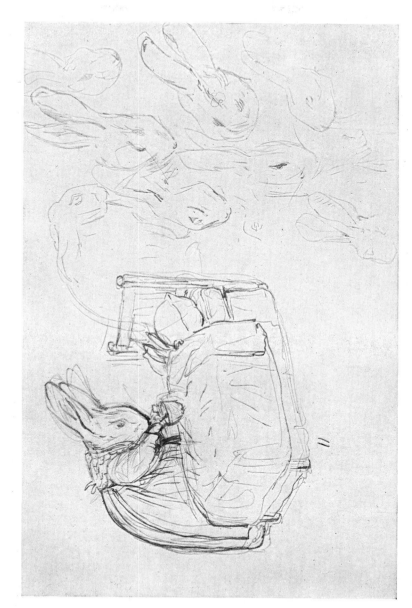

A Preliminary Sketch for Frontispiece

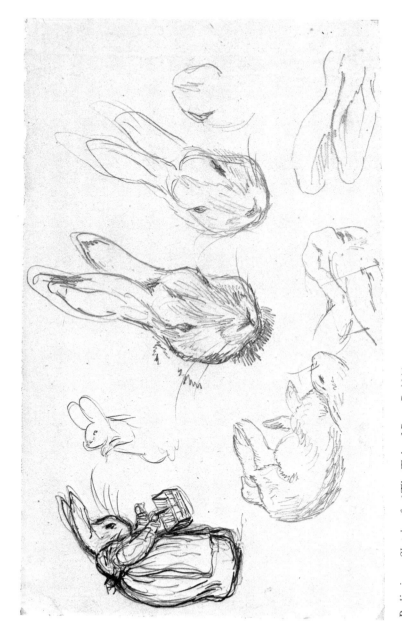

Preliminary Sketches for 'The Tale of Peter Rabbit'

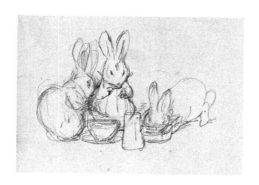

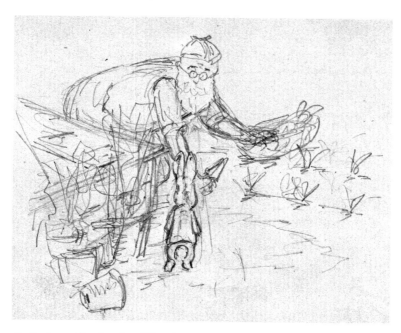

Preliminary Sketches for 'The Tale of Peter Rabbit'

'Rough Sketch'

Then old Mrs Rabbit took
a basket and her umbrella,
and went through the wood
to the baker's; she bought a
loaf of brown bread and 5
currant buns.

'*Then old Mrs Rabbit took a basket and her umbrella, and went through the wood . . .*' *Original

* The term 'Original' indicates that this drawing was the one reproduced in the book.

Beatrix Potter's Second Design in Her Series of End-papers

Beatrix Potter's Third Design in Her Series of End-papers

SQUIRREL NUTKIN (1903)

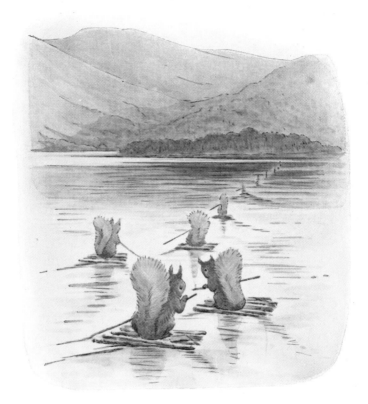

'*They made little rafts out of twigs, and they paddled away over the
water to Owl Island to gather nuts*' *Duplicate Original*

* The term 'Duplicate Original' indicates that this drawing was similar to, but
not the actual one used in the book

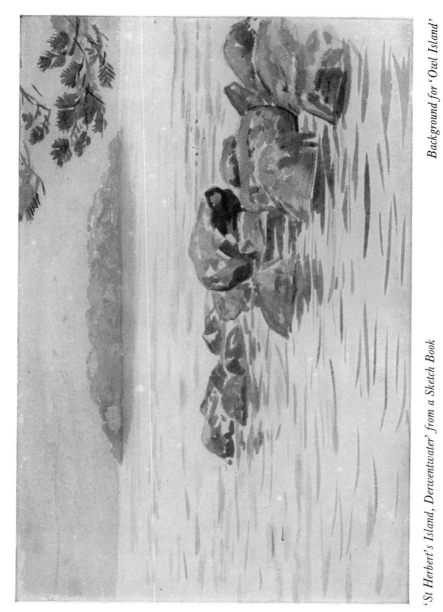

Background for 'Owl Island'

'St Herbert's Island, Derwentwater' from a Sketch Book

285

Background Sketch

Where 'The squirrels filled their little sacks with nuts'

*'The squirrels filled their little sacks with nuts, and
sailed away home in the evening'*

Original

'*The squirrels brought a present of six fat beetles . . .Each beetle was wrapped up carefully in a dock-leaf, fastened with a pine-needle-pin*'
Original

'Nutkin gathered robin's pin-cushions off a briar bush' *Original*

TAILOR OF GLOUCESTER (1903)

Facsimile from the Original Manuscript　　　　　*Unfinished*

the tailor was so poor he only rented
the kitchen. He lived there with his
cat; it was called Simpkin.

Now all day long while the tailor
was out at work, Simpkin kept house
all alone; and he also was fond
of the mice, though he gave them
no satin for coats!

"Miaw"? said the cat when the tailor
opened the door, "Miaw?"

The tailor replied— "Simpkin, we shall
make our fortune, but I am worn
to a ravelling. Take this groat
(which is our last fourpence) and
Simpkin, take a china pipkin; buy a
penn'orth of bread, a penn'orth of milk and
a penn'orth of sausages. And O Simpkin,
with the last penny of our fourpence

Facsimile from the Original Manuscript (Warne's Edition)

A Little Lady Mouse *Original*

'*Everything was finished except just one single cherry-coloured button-hole*'
Original

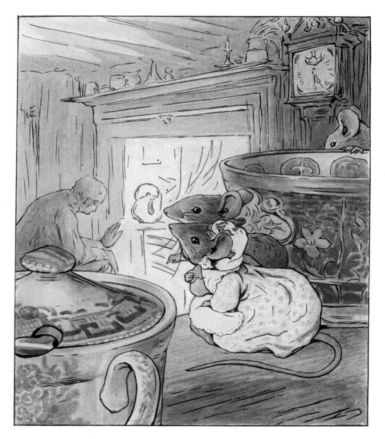

'*The tailor sat down, close over the fire, lamenting — . . . The little mice
came out again, and listened to the tailor . . .*'

Duplicate Original

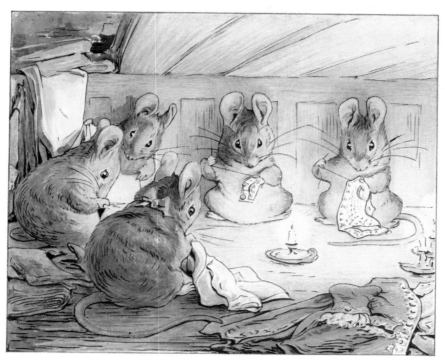

'There was a snippeting of scissors, and snappeting of thread' *Original*

Six Sketches Used for the Background in

BENJAMIN BUNNY

'The proper way to get in, is to climb down a pear tree' *Sept. 8th, 1903*

'The lettuces certainly were very fine' *July 28th, 1903*

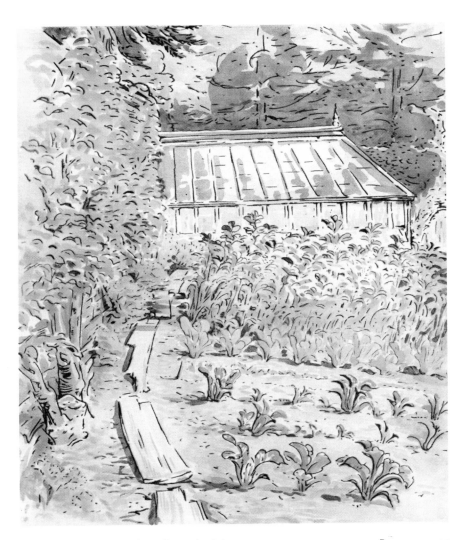

'They went along a little walk on planks' *Summer, 1903*

'They went along a little walk on planks, under a sunny red-brick wall'
Original

'They got amongst flower-pots, and frames and tubs' *Sept. 1903*

The Corner of the Garden where Benjamin and Peter Hid under the Basket
Sept. 11th, 1903

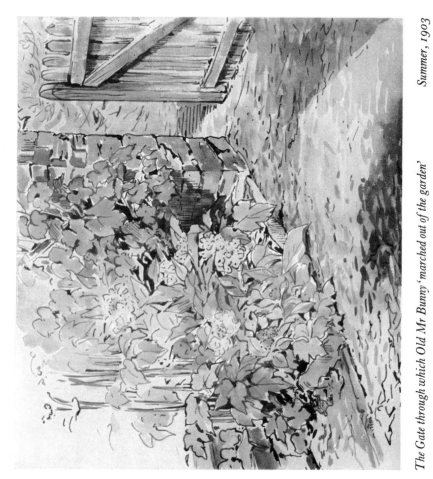

Summer, 1903

The Gate through which Old Mr Bunny 'marched out of the garden'

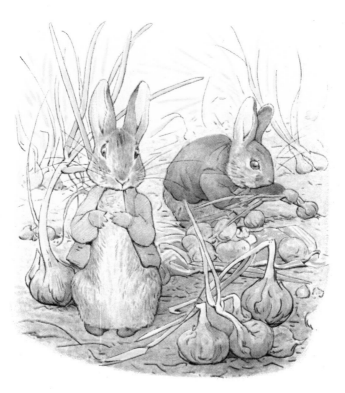

'He suggested that they should fill the pocket-handkerchief with onions' *Original*

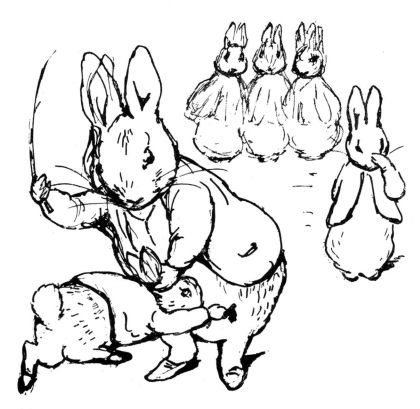

Old Mr Bunny Whips His Nephew Peter

* This picture appears in the second edition of 'Peter Rabbit's Painting Book', 1917, with the title 'When Peter and little Benjamin get home they are whipped'

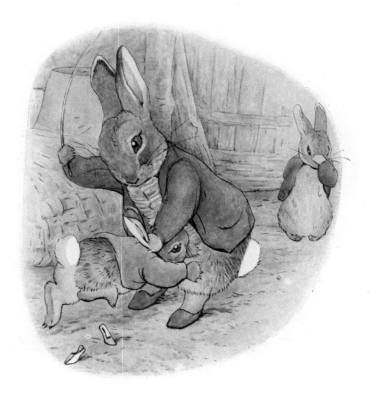

'*Old Mr Bunny . . . took out his son Benjamin by the ears, and whipped him with a little switch. Then he took out his nephew Peter*'
Original

TWO BAD MICE (1904)

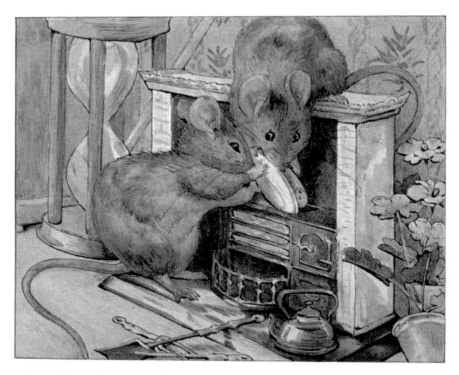

'*As the fish would not come off the plate, they put it into the red-hot crinkly paper fire in the kitchen*'
Original

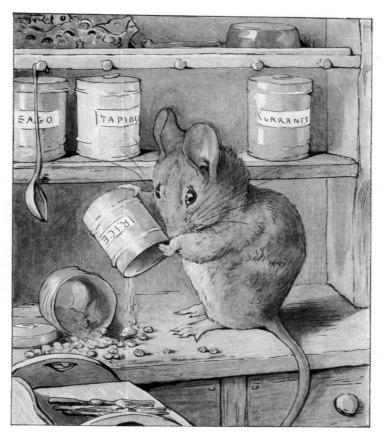

'*She found some tiny canisters upon the dresser, labelled – Rice-Coffee-Sago – but when she turned them upside down, there was nothing inside except red and blue beads*' *Original*

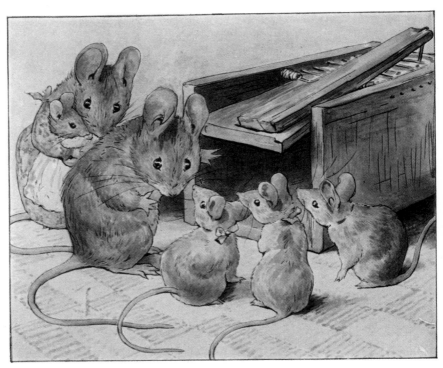

'But the nurse said – "I will set a mouse trap!"' *Original*

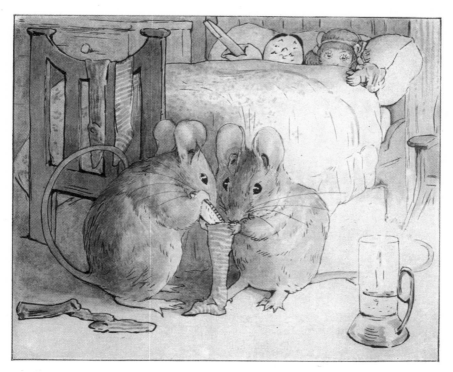

'*He found a crooked sixpence . . . he and Hunca Munca stuffed it into one of the stockings
of Lucinda and Jane*' Original

MRS TIGGY-WINKLE (1905)

Rough Sketches of Lucie and the Little Door in the Back of the Hill

Kelbarrow, Grasmere *Aug. 1st, 1899*

Was this painting used as background for 'that door into the back of the hill called Cat Bells'?

Mrs Tiggy-Winkle with an Iron in Her Hand *Original*

'*And she hung up all sorts and sizes of clothes*' *Original*

THE PIE AND THE PATTY-PAN (1905)

The Garden of 'Buckle Yeat', Sawrey, Used as Background for 'The Invitation'

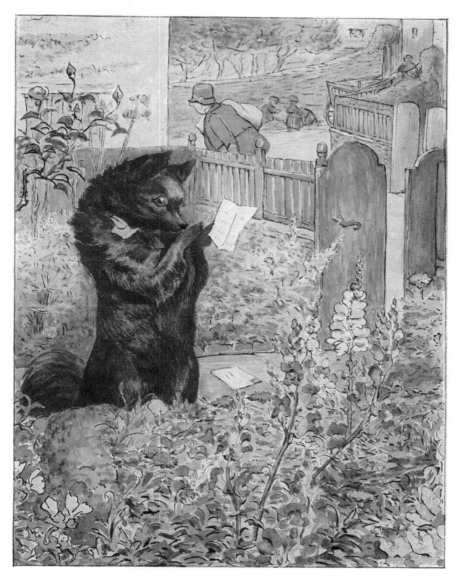

'*The Invitation*' *Original*

Background Sketch Used for 'The Veal and Ham Pie'

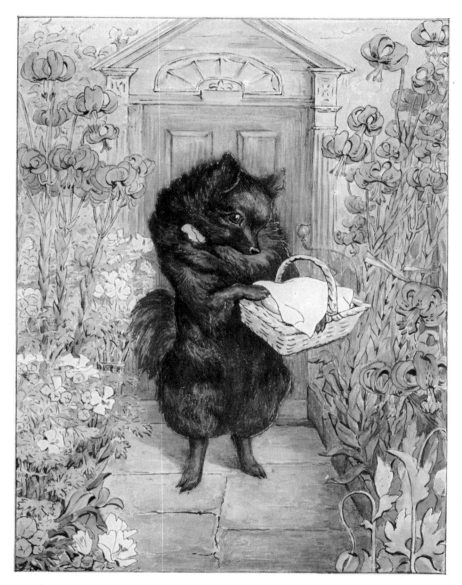

'*The Veal and Ham Pie*' *Original*

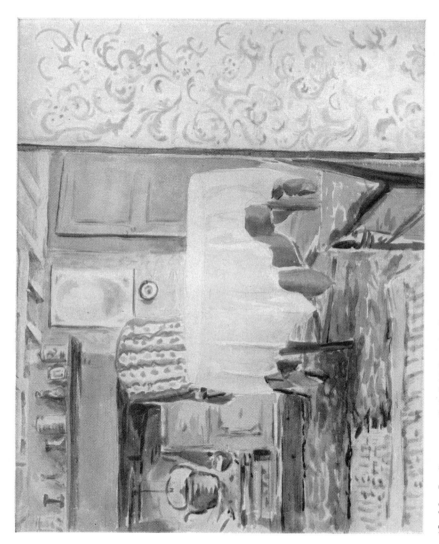

'In Mrs Lord's cottage. Lakefield Cottage, Sawrey, used for Pie and Patty-pan'

An Unpublished Drawing of Duchess and Ribby at Lakefield Cottage, Sawrey

MR JEREMY FISHER (1906)

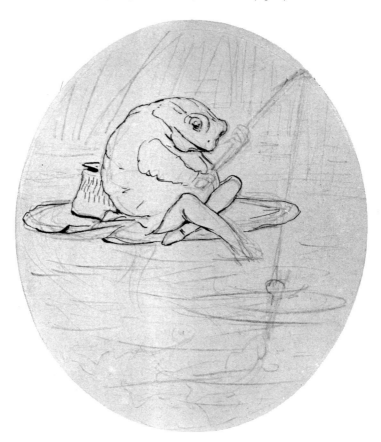

Preliminary.Sketch of Mr Jeremy Fisher

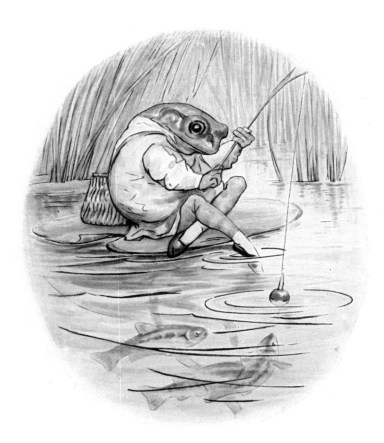

'For nearly an hour he stared at the float'　　　　　　　　*Original*

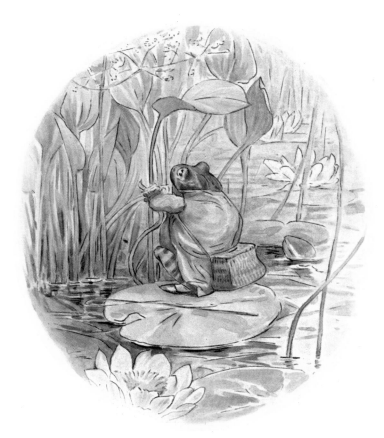

'*The boat was round and green, and very like the other lily-leaves*'
Original

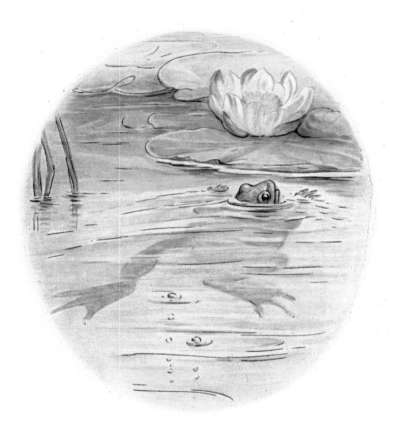

'*Mr Jeremy bounced up to the surface of the water, like a cork . . .*'
Original

Water-lilies on Esthwaite Water where Mr Jeremy Fisher Lived

Facsimile from the Original Manuscript of 'The Sly Old Cat'
(In panoramic form, March 20th, 1906)

TOM KITTEN (1907)

'*Tabitha Twitchit came down the garden and found her kittens on the wall with no clothes on*' *Original*

'*Mrs Tabitha Twitchit . . . fetched the kittens indoors, to wash and dress them*' *Original*

Mrs Tabitha Twitchit Receives Friends to Tea *Original*

' "I wish to hatch my own eggs; I will hatch them all by myself," quacked
Jemima Puddle-Duck' Original

'She rather fancied a tree-stump amongst some tall fox-gloves' *Original*

Jemima and the Gentleman with Sandy Whiskers *Original*

THE ROLY-POLY PUDDING (1908)

'*The visitor was a neighbour, Mrs Ribby; she had called to borrow some yeast*'
Original

' "I'm in sad trouble, Cousin Ribby," said Tabitha, shedding tears. "I've lost my dear son Thomas . . ." ' *Original*

'Mrs Tabitha Twitchit searching for her son Thomas' *Duplicate Original*

'*They had been obliged to put Tom Kitten into a hot bath to get the butter off*' *Original*

'The chimney stack stood up above the roof like a little stone tower'
Original

THE FLOPSY BUNNIES (1909)

'Benjamin used to borrow cabbages from Flopsy's brother, Peter Rabbit,
who kept a nursery garden' Original (Early printings only)

GINGER AND PICKLES (1909)

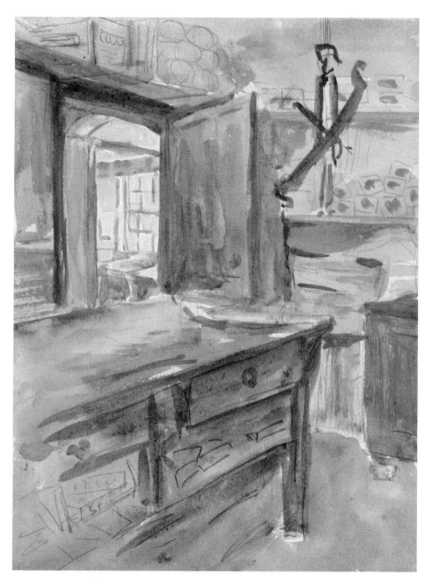

Old Mr John Taylor's Shop, Sawrey

Water-colour used as background for the Village Shop

The Village Shop *Original*

'Mr John Dormouse and his daughter began to sell peppermints and candles'
<div align="right">*Original*</div>

MRS TITTLEMOUSE (1910)

'Such a funny house! There were yards and yards of sandy passages, leading to storerooms and nut-cellars and seed-cellars, all amongst the roots of the hedge'

Original

TIMMY TIPTOES (1911)

'Silvertail digs for nuts'　　　　　　　　　　　　　*Original*

MR TOD (1912)

'*They crept up to the bedroom window*' *Original*

PIGLING BLAND (1913)

'*And they drink bucketfuls of milk*' *Duplicate Original*

Water-colour used as Background for the Kitchen Scenes in Pigling Bland ('Spout House', Far Sawrey)

APPLEY DAPPLY (1917)

I think if she lived in
a little shoe-house —
That little old woman was
surely a mouse!

You know the old woman
Who lived in a shoe?
And had so many children
She didn't know what to do?

From a page of the original 'Appley Dapply' Rhyme Book of 1905 which was never published

JOHNNY TOWN-MOUSE (1918)

The
Town Mouse
and
the Country Mouse

'*The Town Mouse and the Country Mouse*' *Unpublished*

'*The Country Mouse and the Town Mouse*' *Unpublished*

Original Version of the Opening Pages of

CECILY PARSLEY

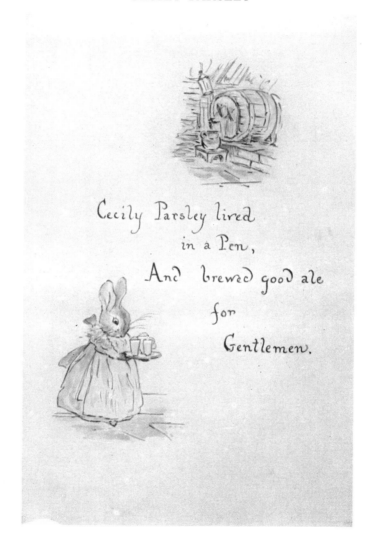

Cecily Parsley lived
in a Pen,
And brewed good ale
for
Gentlemen.

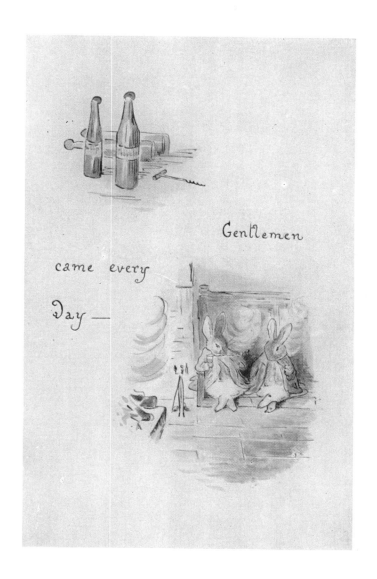

Gentlemen

came every

Day —

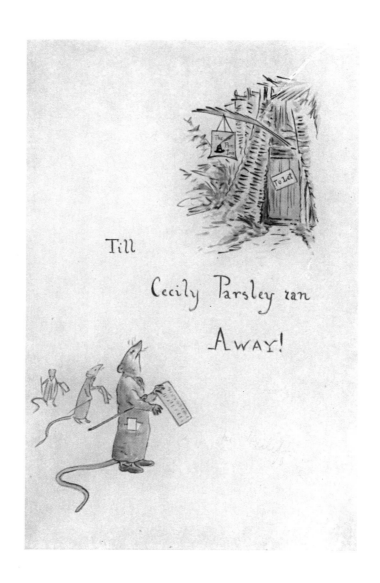

Till

Cecily Parsley ran

Away!

January, 1897

353

Preliminary Sketch for 'How do you do, Mistress Pussy?'

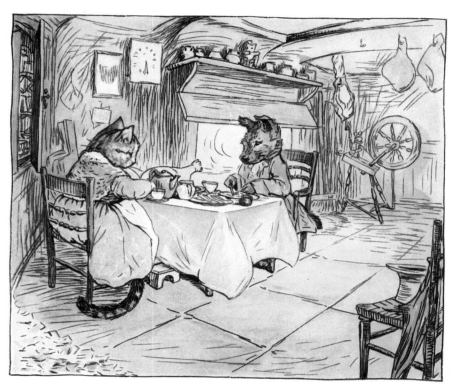

'How do you do, Mistress Pussy?
Mistress Pussy, how do you do?'
'I thank you kindly, little dog,
I fare as well as you!''

Original

355

Preliminary Sketch for The Guinea-pigs' Garden

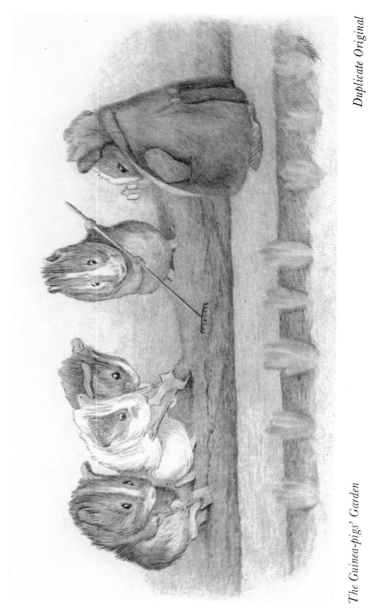

Duplicate Original

The Guinea-pigs' Garden

357

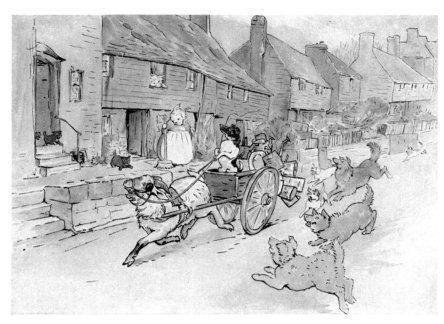

Bow, wow, wow!
Whose dog art thou?
'I'm little Tom Tinker's dog,
Bow, wow, wow!'

Original

LITTLE PIG ROBINSON (1930)

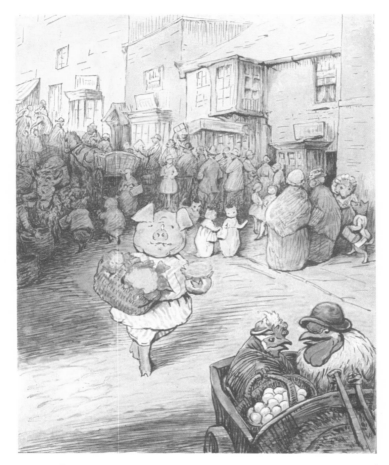

'There were crowds in the street, as it was market day' *Original*

THE FAIRY CARAVAN

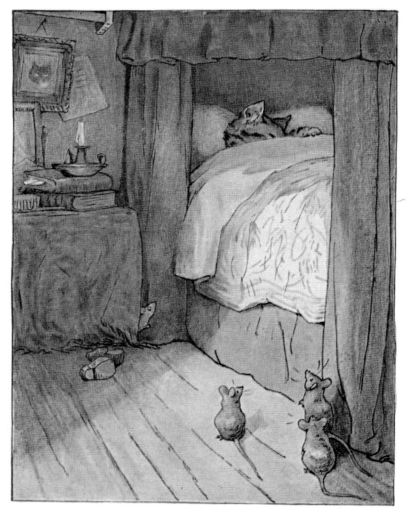

'Louisa Pussy-cat sleeps late' *Original*

10

Miscellany

MISCELLANY

Dinner Cards

At the beginning of this section eight dinner cards are shown from a set of fifteen. They were made for Stephanie Hyde-Parker, and used at Melford Hall, Suffolk.

On each Beatrix Potter has painted one of her animal characters and written appropriate remarks below. Although not noticeable, there are two diagonal slots at the top right-hand corner through which a narrow strip can be inserted, bearing the name of the person whose seat is indicated. Also a strip along the top is made to fold over, so that the card will lie in an inclined position on the dinner table.

Table Mats

Four circular table mats from a set of twelve are shown, telling the story of Jemima Puddle-Duck in an abridged form. Each painting is based on one in the book, but additional details have in some cases been added to fill in the circular space, which also includes the text, written in a neat fine script.

The central panel, painted on linen, has been attached to a silk background by an embroidery stitch, and the mat is surrounded by a silk fringe. The overall diameter of each mat is approximately $7\frac{3}{4}$ inches.

Greeting Cards

From about 1925 onwards, Beatrix Potter designed Christmas Cards for the Invalid Children's Aid Association, a society in which she became interested. 'The proceeds go towards maintaining 2 beds in a children's hospital,' she wrote.

Three of the designs for these cards are shown. The Christmas tree design was used for her 1932 card. It is interesting that in 1929 she described this tree in *The Fairy Caravan*, as will be seen from the corresponding page of manuscript reproduced in facsimile.

Also, in a letter written to a child who had collected money for the Society, Beatrix Potter again describes this tree:

My Dear little friend,

Cousin Benjamin and I do not often write letters, but I do want to thank you for all that you have done for the little invalid children; it is splendid!

Today Benjamin Bunny and I have been choosing our Christmas tree. We went to a wood where there are nut bushes and cherry trees and oak coppice; and in a cleared space amongst the oaks we found a plantation of young fir trees. We chose a lovely little tree four feet high. Said Benjamin, standing on his hind legs – I'm afraid it is too high, Peter; we could not reach the top to tie on apples and nuts and fairy candles'. But I said – 'It is just right Benjamin, Twinkleberry will climb up and help us; not Nutkin, he would crack the nuts'.

You know we do not move our tree; we leave it growing in the wood. When Christmas-tide is over, it looks like any other little fir tree. But you should see it on Christmas Eve! All aglow with fairy lights, and hung up with hips and haws and holly berries and nut crackers, and mouse toffee in silver paper, and garlanded with chains of sparkling icicles. Then all of us little animals dance round, around, around, while Cock Robin sings over-head and Prickle-pin plays the bag-pipes. And we shout and sing so loud that you may hear us through the dark, wishing you all a merry Christmas and a Happy New Year.

from your affectionate

Peter Rabbit (and Beatrix Potter)

The picture of two rabbits under an umbrella was painted as far back as 1894, and this design was used in 1925 for the first Christmas card for the Invalid Children's Aid Association. The picture of Father Christmas in his sledge was never used.

The Little Box

This little box was given by Beatrix Potter to her mother, Christmas 1899. The little mice etc. are painted in water colour, cut out, and pasted on. The box, which is made of beech wood, cost 6¾d!

When sorting through her mother's possessions after her death, Beatrix Potter came across this little box and gave it to her next door neighbour, Margaret Hammond, for many years one of her closest friends.

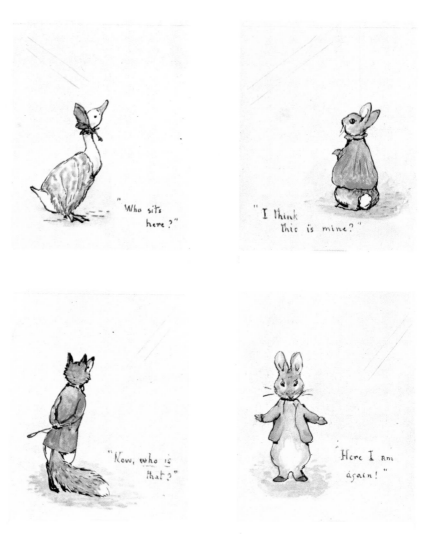

Dinner Cards Used at Melford Hall, Suffolk

Dinner Cards Used at Melford Hall, Suffolk

FOUR JEMIMA PUDDLE-DUCK TABLE MATS
FROM A SET OF TWELVE

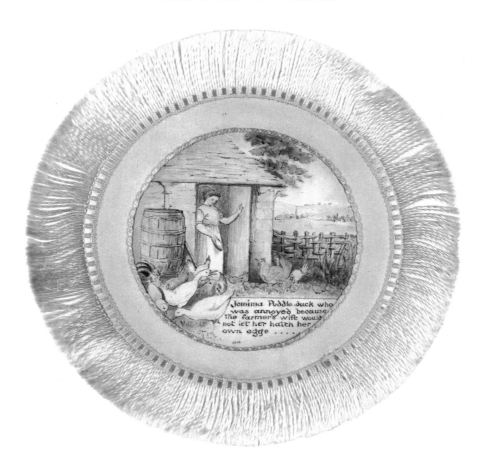

The Farm where Jemima Lived

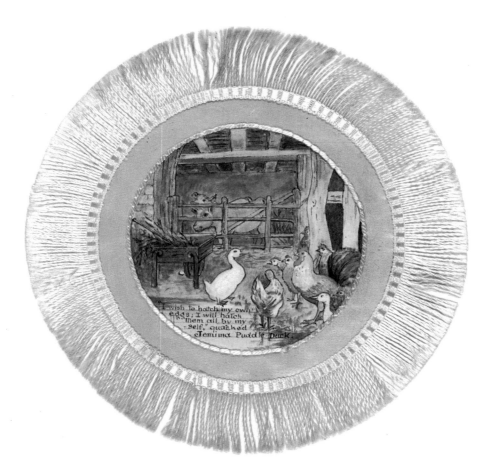

'I wish to hatch my own eggs'

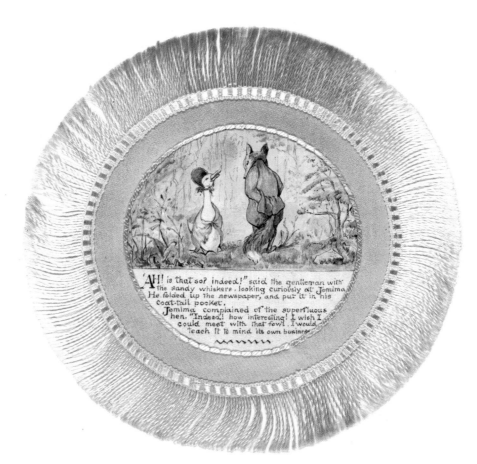

"AH! is that so? indeed!" said the gentleman with the sandy whiskers, looking curiously at Jemima. He folded up the newspaper, and put it in his coat-tail pocket.

Jemima complained of the superfluous hen. "Indeed! how interesting! I wish I could meet with that fowl. I would teach it to mind its own business."

Jemima and the Gentleman with the Sandy Whiskers

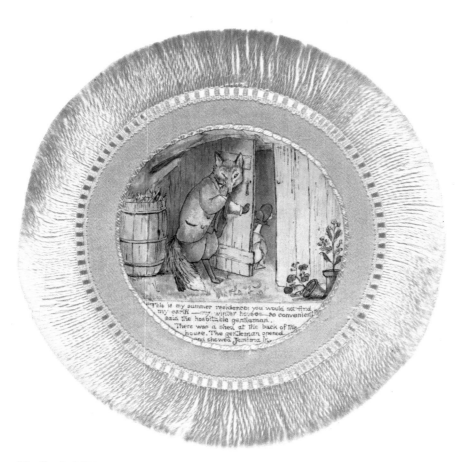

The Sandy Whiskered Gentleman Opened the Door of the Shed and Showed Jemima in

'*They trod a circle on the snow around the Christmas Tree*'
(Design for a Christmas Card for the Invalid Children's Aid Association)

Between the stream and the tree where the, hens were roosting, there was a white untrodden slope. Only one tree grew there, a very small spruce, a little Christmas tree some four foot high. As the night grew darker — the branches of this little tree became all tipped with light, and wreathed with icicles and chains of frost. Brighter and brighter it shone, until it seemed to bear a hundred fairy lights.

Not like the yellow gleam of candles; but a clear white incandescent light. Small voices and music began to mingle with the sound of the water. Up by the snowy banks, from the wood and from the meadow beyond, tripped scores of little shadowy creatures, advancing from the darkness into the light. They trod a circle on the snow around the Christmas tree, dancing gaily hand-in-hand. Rabbits, voles, squirrels and wood-mice — even the half blind mole, old Samson Velvet; danced hand-in-paw with a wood mouse and a shrew — whilst a hedgehog played the bag-pipes beneath the fairy spruce.

From 'The Fairy Caravan' pages 127–128
Facsimile from the Original Manuscript

*Design for a Christmas Card for the Invalid Children's
Aid Association*

Design for a Christmas Card *Unfinished*

Beatrix Potter gave this little box to her mother, Christmas, 1899. The figures of mice are painted in water colour, cut out, and pasted on the box *Full size*

II

*Photographs of Hill Top and Sawrey Associated
with Beatrix Potter and Her Work*

PHOTOGRAPHS OF HILL TOP AND SAWREY ASSOCIATED WITH BEATRIX POTTER AND HER WORK

These photographs of Hill Top and Sawrey were taken in the late spring of 1952 when the village had changed little since Beatrix Potter lived there.

They are of interest because her work is often bound up so closely with the places in which she lived. This is particularly true of Sawrey. After she bought Hill Top Farm her work took on fresh colour from her surroundings. The buttercup meadow across the road, the winding lane up the hillside, the cottage doorways and their colourful gardens – all were used as background material for her book pictures.

The interior of the quaint old farmhouse was depicted in *The Roly-Poly Pudding*; the beautiful garden at Hill Top in *The Tale of Tom Kitten*; the farmyard in *The Tale of Jemima Puddle-Duck*; while the village of Near Sawrey was used for backgrounds in *The Pie and the Patty-pan* and *Ginger and Pickles*.

In the frontispiece to *The Tale of Pigling Bland*, he and Alexander are seen standing at the cross-roads in front of the sign post, which points on the left to the road leading to Lakeside, and on the right to Hawkshead.

The photograph of Beatrix Potter was taken by an American gentleman who visited her at Hill Top about 1907. In the unfinished manuscript of a sequel to *The Fairy Caravan*, she described the porch in which she is standing as, 'made of great slabs of Brathay slate, on either side a slate six foot high, with two smaller slates for the roof, and honeysuckle and cabbage roses hanging over'.

A stroll through the village of Near Sawrey, recognising a door here, a garden there, a pair of pattens outside the porch of a country cottage, and a little further on, lilies on Esthwaite Water, brings her books vividly to life; and for those unable to visit Sawrey for themselves, it is hoped that these photographs will make the books an even greater delight.

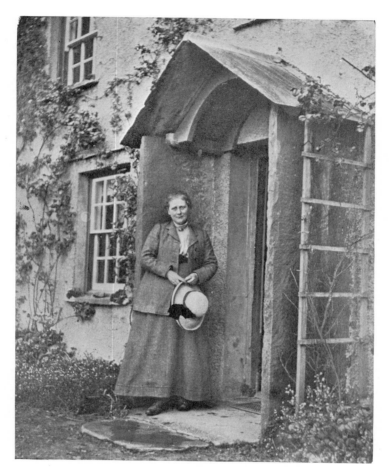

Beatrix Potter at Hill Top *(About 1907)*

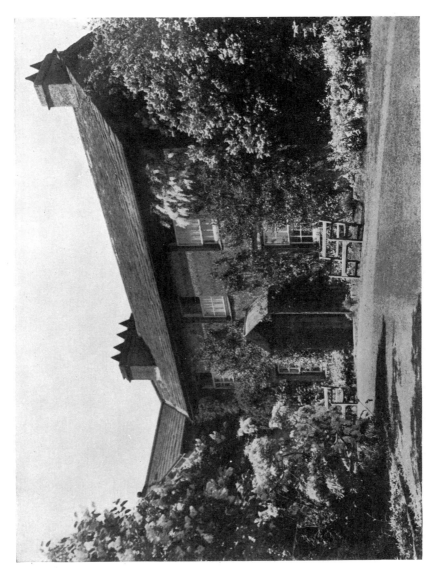

Fig. 1 Hill Top, Sawrey, in the Late Spring

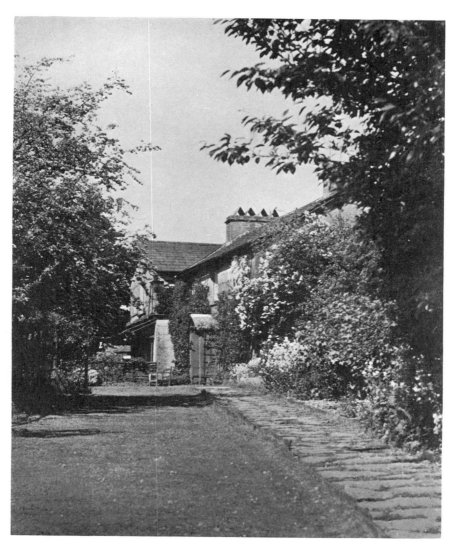

Fig. 2 The Path Leading to Hill Top

Fig. 3 Interior – Hill Top

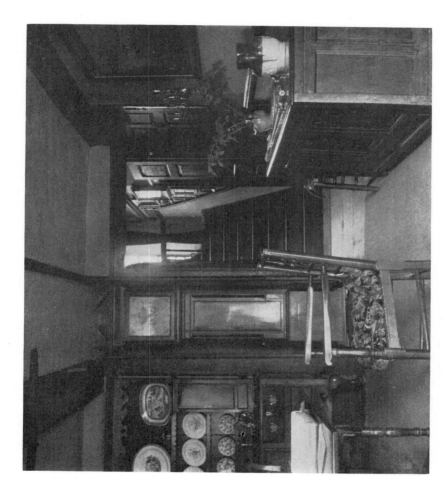

Fig. 4 Interior – Hill Top

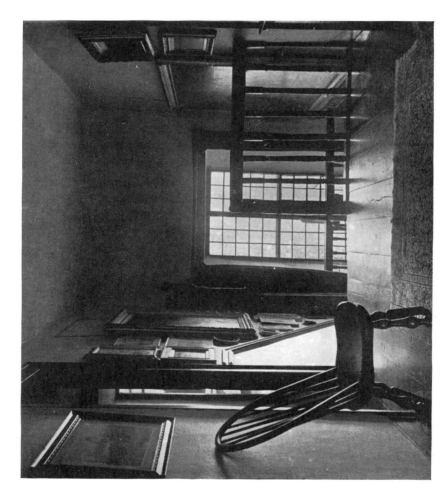

Fig. 5 Interior – Hill Top

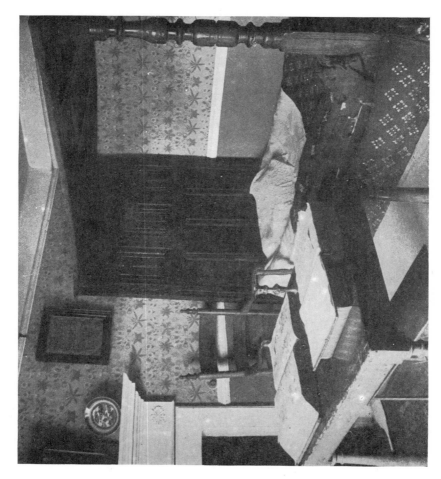

Fig. 6 Interior – Hill Top

Fig. 7 The Gate, Looking from the Porch of Hill Top

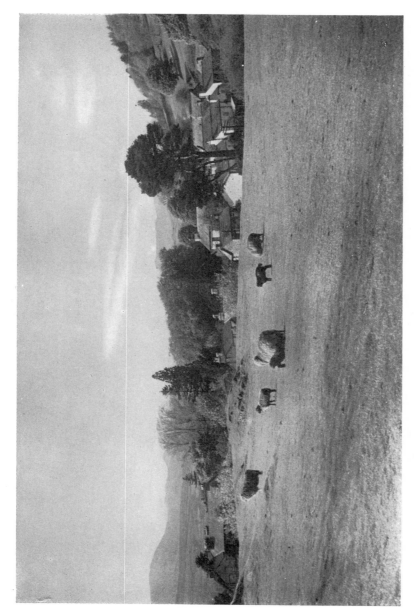

Fig. 8 Sheep at Hill Top Farm

385

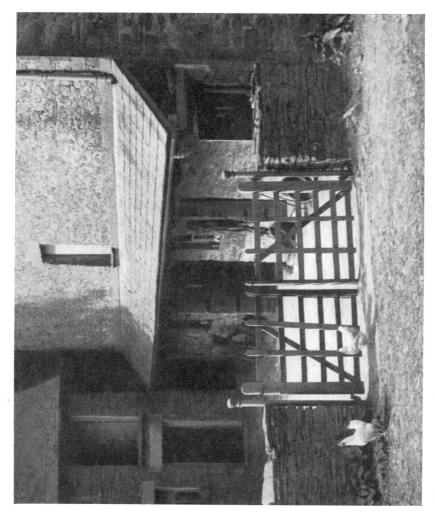

Fig. 9 The Farmyard at Hill Top

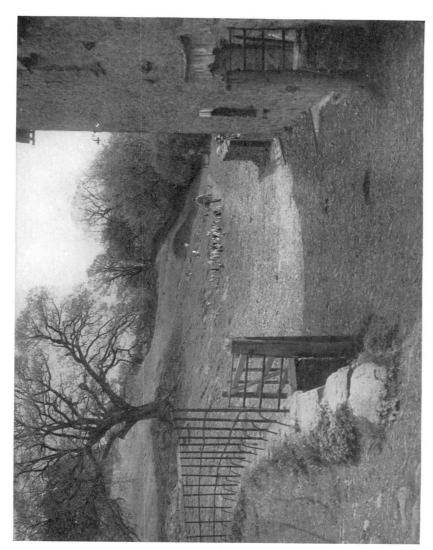

Fig. 10 The Cart Road Leading over the Hill, at Hill Top Farm

Fig. 11 The View from Hill Top Farm Looking towards the Wood

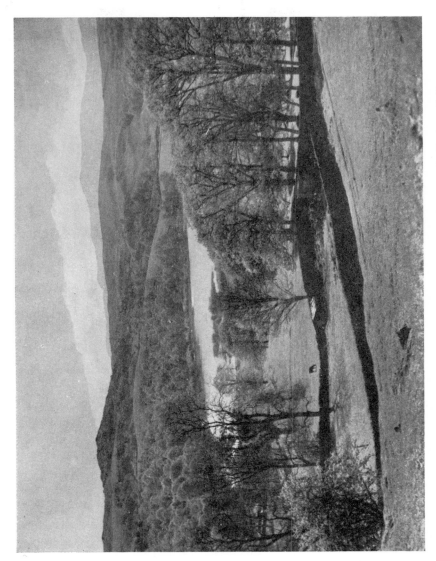

Fig. 12 The View from Hill Top Farm Looking beyond Esthwaite Water to the Coniston Fells

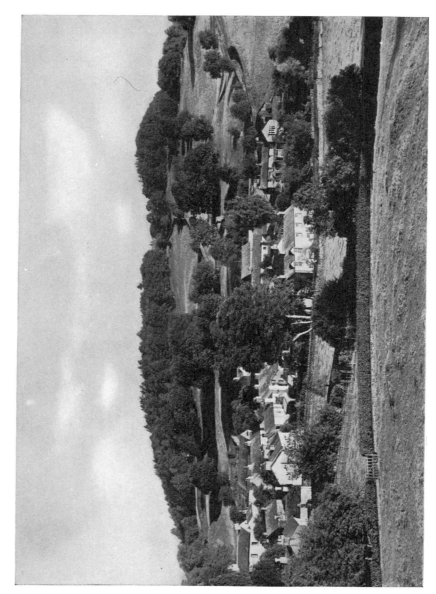

Fig. 13 The Village of Near Sawrey as Seen from Hill Top Farm

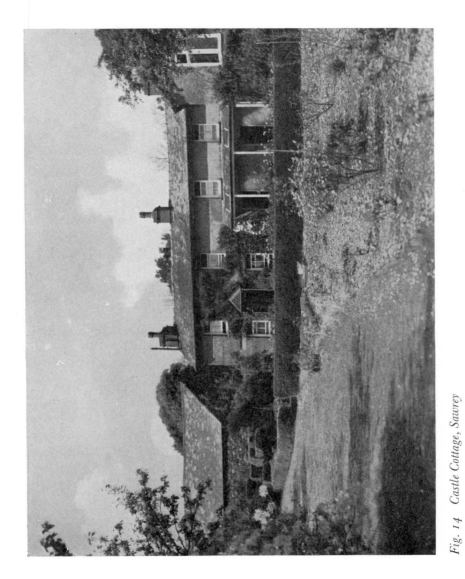

Fig. 14 Castle Cottage, Sawrey

(The low hedge in the foreground has been planted since the death of Mrs Heelis)

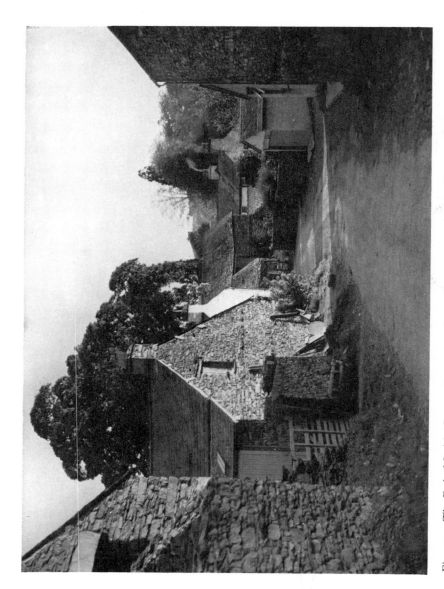

Fig. 15 The End of Smithy Lane – Approach to Castle Cottage

Fig. 16 The Village Street – Otherwise 'Smithy Lane'

Fig. 17 The Village of Near Sawrey

Fig. 18 A Garden in Sawrey

Fig. 19 The Sawrey Post Office of Earlier Times

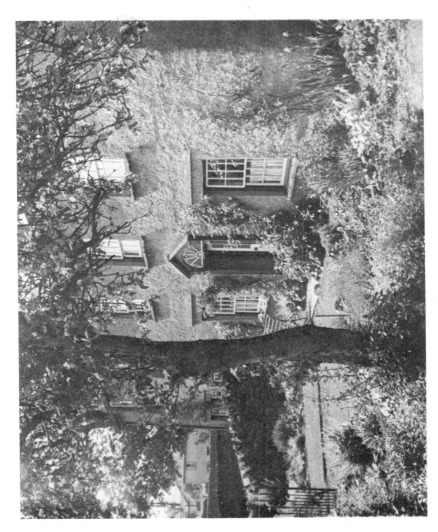

Fig. 20 The Sawrey Post Office of Earlier Times

397

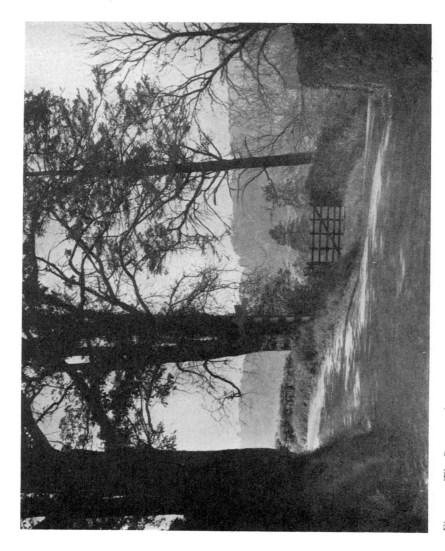

Fig. 21 The Cross-roads

(On the left the road leads to Lakeside, and on the right to Hawkshead)

APPENDIX

THE BEATRIX POTTER BOOKS

(Published by F. Warne & Co Ltd, unless otherwise stated)

26 *Cecily Parsley's Nursery Rhymes* (first published in a smaller 1922
 format)

27 *Jemima Puddle-Duck's Painting Book* 1925

28 *Peter Rabbit's Almanac for 1929* 1928

29 *The Fairy Caravan* (privately printed, 100 copies) 1929

30 *The Fairy Caravan* (David McKay, Philadelphia) 1929
 First English edition, July 1952

31 *The Tale of Little Pig Robinson* (David McKay, Philadelphia) 1930

32 *The Tale of Little Pig Robinson* (first published in the larger 1930
 format)

33 *Sister Anne* (David McKay, Philadelphia) 1932

34 *Wag-by-Wall* (limited edition, 100 copies) 1944

35 *Wag-by-Wall* (The Horn Book, Boston) 1944

36 *The Tale of the Faithful Dove* (limited edition, 100 copies) 1955

37 *The Art of Beatrix Potter* (reproductions of her drawings and 1955
 paintings)

38 *The Tale of the Faithful Dove* (F. Warne & Co. Inc., New 1956
 York)

39 *The Journal of Beatrix Potter, 1881–1897* (transcribed from 1966
 her code-written manuscript)

40 *The Tailor of Gloucester* – a facsimile of the original manu- 1968
 script and illustrations (limited edition, 1500 copies,
 F. Warne & Co. Inc., New York)

41 *The Tailor of Gloucester* – from the original manuscript 1968
 (F. Warne & Co. Inc., New York)

42 *The Tailor of Gloucester* – from the original manuscript (the 1969
 English edition)

43 *The Tale of the Faithful Dove* – with illustrations by Marie 1970
 Angel (F. Warne & Co. Inc., New York)

44 *The Tale of the Faithful Dove* – with illustrations by Marie 1971
 Angel (English edition)

45 *The Writings of Beatrix Potter* – a history of, including un- 1971
 published work

46 *The Sly Old Cat* 1971

47 *The Tale of Tuppenny* – with illustrations by Marie Angel 1973
 (F. Warne & Co. Inc., New York)

48 *The History of The Tale of Peter Rabbit* (adapted from Leslie 1976
 Linder's *Writings of Beatrix Potter*, and containing the
 text and illustrations of the privately printed edition)

THE BEATRIX POTTER BOOKS PRINTED
IN BRAILLE
(The Royal Institute for the Blind)

Peter Rabbit, Mrs Tiggy-Winkle, Tom Kitten, The Flopsy Bunnies, 1921
Pigling Bland, Johnny Town-Mouse
The Journal of Beatrix Potter has been tape-recorded by The 1970
British Talking Book Service for the Blind

THE BEATRIX POTTER BOOKS PRINTED IN i.t.a.
Peter Rabbit, Benjamin Bunny, Two Bad Mice, Mrs Tiggy-Winkle, 1965
Mr Jeremy Fisher, Tom Kitten, Jemima Puddle-Duck, Flopsy
Bunnies, Mrs Tittlemouse
Timmy Tiptoes 1966

THE BEATRIX POTTER BOOKS
TRANSLATED INTO OTHER LANGUAGES

French	*Pierre Lapin* (Peter Rabbit)	1921
	Noisy-Noisette (Squirrel Nutkin)	1931
	Le Tailleur de Gloucester (Tailor of Gloucester)	1967
	Jeannot Lapin (Benjamin Bunny)	1921
	Poupette-à-L'Epingle (Mrs Tiggy-Winkle)	1922
	Jérémie Pêche-à-la-Ligne (Mr Jeremy Fisher)	1940
	Toto le Minet (Tom Kitten)	1951
	Sophie Canétang (Jemima Puddle-Duck)	1922
	La Famille Flopsaut (Flopsy Bunnies)	1931
	Madame Trotte-Menu (Mrs Tittlemouse)	1975
	Deux Vilaines Souris (Two Bad Mice)	1975
	Petit Jean des Villes (Johnny Town-Mouse)	1976
	Mademoiselle Moppette (Miss Moppet)	1976
Dutch	*Het Verhaal van Pieter Langoor* (Peter Rabbit)	1912
	(Published under licence by Nijgh & Van Ditmar's Uitgevers-Maatschappij, Rotterdam)	
	Benjamin Knabbel (Benjamin Bunny)	1946

Twee Stoute Muisjes (Two Bad Mice)　1946
Jeremias de Hengelaar (Mr Jeremy Fisher)　1946
Tom Het Poesje (Tom Kitten)　1946
Het Verhaal van Kwakkel Waggel-Eend (Jemima 　1912
Puddle-Duck)
(Published under licence by Nijgh & Ditmar's
Uitgevers-Maatschappij, Rotterdam)
De Kleine Langoortjes (Flopsy Bunnies)　1946
(The following twelve titles have been published
under licence by Uitgeverij Ploegsma, Amster-
dam)
Het Verhaal van Pieter Konijn (Peter Rabbit)　1968
Het Verhaal van Eekhoorn Hakketak (Squirrel Nutkin)　1969
Het Verhaal van Benjamin Wollepluis (Benjamin 　1969
Bunny)
Het Verhaal van Twee Stoute Muizen (Two Bad Mice)　1969
Het Verhaal van Vrouwtje Plooi (Mrs Tiggy-Winkle)　1969
Het Verhaal van Jeremias Hengelaar (Jeremy Fisher)　1970
Het Verhaal van Poekie Poes (Tom Kitten)　1970
Het Verhaal van Jozefien Kwebbeleend (Jemima Puddle-　1968
Duck)
Het Verhaal van De Wollepluis-Konijntjes (Flopsy 　1969
Bunnies)
Het Verhaal van Minetje Miezemuis (Mrs Tittlemouse)　1970
Het Verhaal van Timmie Tuimelaar (Timmy Tiptoes)　1968
Het Verhaal van Diederik Stadsmuis (Johnny Town-　1969
Mouse)

Welsh　*Hanes Pwtan y Wningen* (Peter Rabbit)　1932
Hanes Benda Bynni (Benjamin Bunny)　1948
Hanes Meistres Tigi-Dwt (Mrs Tiggy-Winkle)　1932
Hanes Dili Minllyn (Jemima Puddle-Duck)　1924
Hanes Meistr Tod (Mr Tod)　1963

German　*Die Geschichte des Peterchen Hase* (Peter Rabbit)　1934
(Style 1, English type; style 2, Gothic type)

	Die Geschichte von den zwei bösen Mäuschen (Two Bad Mice)	1939
	Die Geschichte von Frau Tiggy-Winkle (Mrs Tiggy-Winkle)	1948
	Die Geschichte von Samuel Hagezahn (Samuel Whiskers, or The Roly-Poly Pudding)	1951
	Die Geschichte Der Hasenfamilie Plumps (Flopsy Bunnies)	1947
	Die Geschichte von Herrn Reineke (Mr Tod)	1951
	(The following titles have been published under licence to Diogenes Verlag AG Zürich)	
	Die Geschichte von Peter Hase (Peter Rabbit)	1973
	Die Geschichte von den beiden bösen Mäusen (Two Bad Mice)	1973
	Die Geschichte von Stoffel Kätzchen (Tom Kitten)	1973
	Die Geschichte von Bernhard Schnauzbart (Samuel Whiskers)	1973
	Die Geschichte von Herrn Gebissig (Mr Tod)	1973
	Die Geschichte von Schweinchen Schwapp (Pigling Bland)	1973
Italian	*Il Coniglio Pierino* (Peter Rabbit)	1948
Spanish	*Pedrin El Conejo Travieso* (Peter Rabbit)	1931
Swedish	*Sagan om Pelle Kanin* (Peter Rabbit)	1948
	Sagan om Kurre Nötpigg (Squirrel Nutkin)	1954
	Den lillae grisen Robinsons äventyr (Little Pig Robinson, no illustrations)	1938
	(The following four titles are being published under licence by Bonniers Förlag, Stockholm)	
	Sagan om Pelle Kanin (Peter Rabbit)	1972
	Sagan om Benjamin Kanin (Benjamin Bunny)	1972
	Sagan om Flopsijs Ungar (Flopsy Bunnies)	1972
	Sagan om Tom Titten (Tom Kitten)	1972
	Sagan om Två Busiga Möss (Two Bad Mice)	1974
	Sagan om Moses Metare (Mr Jeremy Fisher)	1974
	Sagan om Fru Muslina (Mrs Tittlemouse)	1974

Sagan om Linus Lantmus och Stefan Stadsmus (Johnny 1974
Town-Mouse)

Norwegian	*Fortellingen om Nina Pytt-And* (Jemima Puddle-Duck)	1948
	(The following four titles are being published under licence by Gyldendal Norsk Forlag, Oslo)	
	Eventyret om Petter Kanin (Peter Rabbit)	1972
	Eventyret om Benjamin Kanin (Benjamin Bunny)	1972
	Eventyret om Vipsen-Kaninene (Flopsy Bunnies)	1972
	Eventyret om Tom Kattepus (Tom Kitten)	1972
	Eventyret om To Slemme Mus (Two Bad Mice)	1974
	Eventyret om Jeremias Fisker (Jeremy Fisher)	1974
	Eventyret om Fure Tittemus (Mrs Tittlemouse)	1974
	Eventyret om Jon Bymus (Johnny Town-Mouse)	1974
Danish	*Tom Kitte* (Tom Kitten)	1946
	(The following four titles are being published under licence by Gyldendal Forlag, Copenhagen)	
	Historien om Peter Kanin (Peter Rabbit)	1972
	Historien om Benjamin Langøre (Benjamin Bunny)	1972
	Historien om de små Langører (Flopsy Bunnies)	1972
	Historien om Tom Kispus (Tom Kitten)	1972
	Historien om to uartige mus (Two Bad Mice)	1974
	Historien om hr. Joakim Fisker (Mr Jeremy Fisher)	1974
	Historien om fru Vimsemus (Mrs Tittlemouse)	1974
	Historien om Johnny Bymus (Johnny Town-Mouse)	1974
Afrikaans	*Die Verhaal van Pieter Konyntjie* (Peter Rabbit)	1929
	Die Verhaal van Bennie Blinkhaar (Benjamin Bunny)	1935
	Die Varhaal van Die Flopsie-Familie (Flopsy Bunnies)	1935
	Die Verhaal van Mevrou Piekfyn (Mrs Tittlemouse)	1935
	(The following titles have been published under licence by Human & Rousseau Publishers (Pty.) Ltd, Cape Town)	
	Die Verhaal van Diederik Dorpsmuis (Johnny Town-Mouse)	1970
	Die Verhaal van Gertjie Kat (Tom Kitten)	1970

Die Verhaal van Tys Toontjies (Timmy Tiptoes)　　1971

Die Verhaal van Meraai Plassie-Eend (Jemima Puddle-　1971
Duck)

Die Verhaal van Doppertjie (Squirrel Nutkin)　　1972

Die Verhaal van Joachim Visser (Jeremy Fisher)　　1972

Die Verhaal van Ta' Pinkie-Winkie (Mrs Tiggy-　1975
Winkle)

Die Verhaal van Die Twee Stout Muise (Two Bad Mice)　1975

Latin　　*Fabula de Petro Cuniculo* (Peter Rabbit)　　1962

Fabula de Jemima Anate-Aquatica (Jemima Puddle-　1965
Duck)

Japanese　　(The following titles have been published under
licence by Fukuinkan-Shoten, Tokyo)

The Tale of Peter Rabbit　　1971

The Tale of Benjamin Bunny　　1971

The Tale of the Flopsy Bunnies　　1971

The Tale of Tom Kitten　　1972

The Story of Miss Moppet　　1972

The Story of a Fierce Bad Rabbit　　1972

The Tale of Two Bad Mice　　1972

The Tale of Mrs Tittlemouse　　1972

The Tale of Johnny Town-Mouse　　1972

The Tale of Squirrel Nutkin　　1972

The Tale of Jemima Puddle-Duck　　1972

The Tale of Ginger and Pickles　　1972

The Tailor of Gloucester　　1973

The Tale of Mr Tod　　1973

The Tale of Samuel Whiskers　　1973
or *The Roly-Poly Pudding*